LIFE : THE SECOND DECADE

A NEW YORK GRAPHIC SOCIETY BOOK
LITTLE, BROWN AND COMPANY, BOSTON

MADE POSSIBLE BY UNITED TECHNOLOGIES CORPORATION

LIFE

THE SECOND DECADE 1946–1955

This publication has been made possible by the
generosity of United Technologies Corporation.

This book accompanied an exhibition made possible jointly
by Time Inc. and United Technologies Corporation.
The exhibition was organized and circulated by
The International Center of Photography, New York City.

Designed by Derek Birdsall and produced by Birdsall & Co.

Design consultant for Time Inc. Gilbert Lesser

Typeset in Monophoto Modern, 7
Printed and bound in Great Britain by Balding + Mansell Limited
on Parilux Matt cream paper using Inmont printing inks.

For millions of Americans of my generation, LIFE was not just a magazine. Each week it was an *event*. LIFE brought us the news from around the world, but so much more: large ideas, small pleasures, laughs, tears, terrors, delights, and always those stunning photographs.

These pictures from the great newsmagazine's second decade will make it clear why LIFE has meant so much to America for so long. We are proud to present them.

Harry J. Gray
Chairman and Chief Executive Officer
United Technologies Corporation

A FEAST OF PHOTOGRAPHY

During the years in which the photographs in this book were taken, 1946–1955, the three major magazines being published by Time Incorporated were TIME, LIFE and FORTUNE. Photographs taken for these magazines were pooled in the Life Picture Collection.

The photographs in this exhibition were selected from that Collection. They were not chosen as a review of photojournalism, nor as a guide to world events of the period. This is, rather, a selection of some of the most remarkable, compelling or delightful images of that time, regardless of subject matter. Since LIFE was dedicated to covering national and world events, however, many of these pictures do reflect the decade's history. Another major area of the magazine's concern – the human condition – is reflected in many more.

These were happy and serene years for much of America and those qualities are seen in many of these pictures. One can hardly call a period which contained the Korean War, the beginnings of racial violence and the McCarthy hearings a happy decade, but in comparison with some others, it was a lighthearted time.

It was also part of the period when contemporary photography was being taken seriously for the first time. I had come to New York in 1948 from the Rhode Island School of Design to throw in my lot with the staff of the Life Picture Collection, and so I was on hand when many of these photographs first arrived in the Collection. They were among the hundreds of new pictures that came to file each week. Many of them had just been published in LIFE but hundreds more had never been published anywhere. The organization of the Picture Collection was still evolving, and when I realized that no one person had the job of looking at each photograph as it came to file, I gladly volunteered for that duty – and kept at it for the next 30 years.

The prime reason for reviewing the new work was to spot important subject matter not indicated by a story's title and therefore not caught by the Collection's cataloging system. It was important to the department's role as the major picture research tool for Time Inc. magazines that its records be complete.

I learned a good deal from this review of incoming material. I learned the rewards of looking into a photograph as well as at it. I learned that people respond to a photograph on many different levels and that the same picture can evoke opposite reactions, both valid, in two different people. I often had cause to remember the Japanese maxim that a

print is never finished by the printmaker. The picture is completed by what each beholder brings to it from his own experience. This is just as true of a photograph as it is of a print, a lithograph or a painting.

I continued to enjoy this feast of photography until 1978 when I left the staff of the Picture Collection to become Time Inc.'s Director of Vintage Prints. This has given me the opportunity, through a series of exhibitions, to share with a wider audience some of the memorable pictures I first saw during those wonderful years.

For the purposes of this exhibition, I looked again at each of the approximately 156,000 photographs the Picture Collection still has on file from that decade. The difficulty of choosing 200 from that number cannot be exaggerated; nor can my regret at having to leave out so many important images.

Some of the photographs in this selection are personal in feeling, some are global, some are beautiful, some are frightful. But there are qualities they all share and there is a certain harmony among them. I have sometimes been asked how I choose a photograph. I find that a difficult question to answer because so much about photography is personal and subjective. I have often watched myself as I go through a drawer of prints to see if I can tell why I put a particular four or five pictures to one side. There is no hesitation in my reaction to a photograph. My response is as immediate as the action of the flag on the line of an ice fisherman when the bait is taken. But the elements that cause that reaction are more difficult to pinpoint. These elements vary from person to person, illustrating again the truth of the Japanese printmaker's maxim.

In the hands of the artist, photography can be many things. It can be as subtle as a poem or as factual as an x-ray. It can reveal wonders, explain science, evoke a memory. It can look at the ordinary and see the extraordinary.

One of the things that photographs do best, however, is to reveal the moods and emotions of people. You will find that is the role at the heart of this exhibition. As you look at . . . and into . . . those pictures, I hope you will also find something else that photographs can be. They can be unforgettable.

Doris C. O'Neil
Director of Vintage Prints, Time Inc.

THE SEARCH FOR PEOPLE AS THEY REALLY ARE

One of the first stories I worked on as a brand new reporter for LIFE is represented by a picture in this exhibition, Andreas Feininger's photograph of the Brooklyn Bridge. This might seem a relatively simple assignment. It certainly seemed so to me. After all, the bridge wasn't going anywhere. It just stood there, arching across the East River as it had been doing for 65 years. It was only a few miles from LIFE's midtown office building, so Feininger and I could get to the bridge easily whenever we wanted to. Famous for its beauty and grandeur, it was bound to make wonderful pictures. Best of all, it was inanimate, so we would not have to worry about catching the right facial expression. I had already learned during my few months at LIFE that catching the exactly right facial expression was a constant challenge to photographers. This one would be a cinch.

Feininger and I set off with two heavy camera cases – large suitcases, really – containing several view cameras, a full assortment of lenses for each camera and tripods. We were looking for the right spot from which to take pictures, almost certainly a rooftop somewhere on the Brooklyn side. I suggested that since we were only hunting for a location, perhaps it wasn't necessary to lug the equipment around with us. No, Feininger explained. We might find just the right spot at just the right time of day with perfect light and perfect weather and perhaps the perfect boat moving down the river. If so, we must be ready. Besides, we must have a photographic record of how the bridge looked from each rooftop so that, if necessary, we could return on another day when the light might be better. Would I please make a note of each street address so that we could come back to each building? And would I please pick up one of the camera cases?

Most of the buildings we visited during the next two weeks had elevators, but not all. Even where there was an elevator to the top floor, we usually had to climb the final flight to the roof, often up a steep metal ladder, dragging the camera equipment behind us. Janitors had to be persuaded, frequently by a five-dollar bill, that we should be allowed on the roof. I stood on more rooftops in that time than in all the rest of my life. I also learned two things about LIFE photography: 1) the more famous or beautiful a person or an object is, the harder it is to take a fresh picture that the editors would want to publish, and 2) even a bridge has a facial expression that can be captured.

There are 199 other photographs in this exhibition, and there are surely 199 other stories about how each one was taken and under what circumstances. Sometimes it

really is a matter of catching the exactly right expression on the perfect occasion: Lisa Larsen's picture of a supremely coy Eisenhower not answering a question about running for President, or Alfred Eisenstaedt's companion picture of Senator Robert Taft enduring a rooster while running for President. These are public occasions that cannot be repeated. The photographer either sees the moment or he doesn't, he is either in focus or he isn't, and his eye is either trained or it isn't. It is not enough merely to be there with a camera in your hands. Photographers, even professional ones, probably miss a thousand of these moments every day.

Sometimes the picture is the result of infinite preparation, like Gjon Mili's photograph of Joe Walcott knocking down Joe Louis. Probably every ringside photographer at that fight got a picture of Louis on the canvas, but Mili had negotiated a different camera position and set up the lighting that would make it work. This may be commonplace today. In 1947 it was a breakthrough. Or Philippe Halsman's famous, and zany picture of Salvador Dali. First you have to get the cats and the buckets of water, and then you have to hurl them at each other repeatedly until you get what you want – if that's what you want.

Sometimes – often, in fact – the picture comes from having a sense of humor or beauty or elegance. So many pictures in this exhibition have one or more of those qualities that it would be unfair to single out examples. These are pictures in which the character and personality of the photographer are the principal ingredients. If a photographer has no sense of humor, he is unlikely to take many funny pictures, even by accident. If he has no sense of beauty or elegance, he better have some other quality to recommend him, because he will not take many beautiful or elegant pictures. Of course, the best photographers can bring to any situation, even to a news picture, these qualities that can turn a routine picture into a memorable one.

But for many pictures in this exhibition and in LIFE magazine, the most important weapon we had was the luxury of what I can only call "hanging around." This is especially true of the black-and-white picture essay, which may have been LIFE's finest contribution to photojournalism, after the celebration of photography itself. Pictures from many of these essays are in this exhibition, including three by Gene Smith: "Maude Gallen, Nurse Midwife," "Spanish Village" and my favorite, "Country Doctor."

Throughout this decade of 1946–1955, LIFE was particularly engaged in trying to hold up a mirror to real life. Yes, we ran many Hollywood and Broadway glamor stories, and we covered all the fads and foibles and fashions of the day, and did so with relish. We ran all the news pictures that were fit to print, and a good many that weren't. But if I could characterize the special quality of these years in LIFE, I would say that we did our best to reveal people as they are. We tried to show what life was truly like, and that required a lot of hanging around.

With rare exceptions, real people do not relax in the presence of a camera, especially if it is a LIFE camera. They are stiff, nervous, hoping to look their best. Their smiles are a little tight, their expressions a little false. They wear their best clothes, even to do the laundry. They are not themselves. A photographer must spend time with them, live with them, be there every day until they no longer notice him. They must grow accustomed to the click of the shutter, until finally they do not hear the click at all. That is when the good pictures begin to happen. But even then the photographer must still hang around, infinitely patient for the events and arguments and moments of anger and laughter and love that give ultimate life to a photograph.

You will see these here.

Ralph Graves
Former Managing Editor of LIFE

DOUBLE EXPOSURE

███████████

Sometimes a decision made for one reason may turn out to be the right one for an entirely different reason. The first photograph in this book by J.R. Eyerman showing a 3-D movie audience wearing spectacles is an eyestopper, an eminently good picture choice. It could also have been chosen as a symbol for a decade portrayed in a different dimension, a third dimension, if you like, one that is an image of reality.

Nearly 30 years after "The Second Decade," we are blessed with hindsight in our assessment of world history. We have also become less naive in looking at photographs and do not necessarily believe in them as the truth, nothing but the truth. We also know that the editors of LIFE had their own conceptions and prejudices in selecting what they considered newsworthy, valid, interesting or trend-setting for a given week.

Like Doris O'Neil, I became a privileged child of that second decade when I became a LIFE staff photographer, working alongside many of the photographers represented in this book. Some of them are my close friends and I have an insight into how we, the photographers of the period, worked; how we perceived our role as eyewitnesses; how we saw everyday life on LIFE magazine terms; how we often measured our own importance and that of our story by how many pages it received. The brilliance of the photographer's inventiveness, creative vision, composition and use of light – yes, a word we never applied to our work, *artistry* – sometimes led to an imaginative, personal view of reality.

Now, 30 years later, we are presenting work that was selected from a mind-boggling quantity of visual output, the best that the world's professionals and anybody with a camera ready at the right place at the right time offered for publication.

The years 1946–1955 were radically different from LIFE's formative first decade when photographers first learned what their photographs looked like laid out in lavishly large magazine spreads; how a picture story could be shown with a beginning, a flow and an end; how words and pictures together could take the viewer smack into the event, the story; how the magazine presentation made you feel you were there. In LIFE's first decade television did not yet exist.

Those first 10 years were heady, exciting, dangerous and heroic times for the world and for the medium. They included World War II, with its European and Pacific "theaters," which were covered by correspondents, true eyewitnesses with the camera braving all dangers to be there, to capture that fleeting moment, and to have it published

in LIFE where it was seen by millions and saved for future generations. The drama of World War II with its staggering costs and cast of millions was documented by the war correspondents and photographers. And in the process, they became famous.

Well, the second decade had to be different. Peace is less spectacular than war. It is much more difficult to capture an interior feeling with a still photograph than to create excitement with living theater, talkies on film, and finally television's docudramas.

The second decade of LIFE magazine brought about the development of the personal picture essay. The photographer evolved as a storyteller with the magazine providing 10 to 16 pages on which to develop a theme. It could be the story of an everyday type of person, such as "The Country Doctor," or the slightly fictionalized story of a young single woman living in the big City, "The Private Life of Gwyned Filling." The photographer was credited as an author and had many author's prerogatives. This gave the photographers recognition and was a prelude to the story-telling television format.

The pioneers of LIFE's first period developed and demonstrated the attraction of Robert Capa's wartime maxim: "If your pictures are not good enough, you are not close enough." To be light on your feet, move into the scene, to be on even level with your subjects (or even ahead of them) was not a guarantee of a good photograph, but it was a prerequisite.

What will you find within these pages? The birth pains and death struggles of Israel, Berlin and Korea divided, the end of colonialism in Indochina and Gandhi's India, the establishment of the United Nations. There are memorable excerpts from the photographic essays by the late and now legendary W. Eugene Smith, and the still producing multi-talented Gordon Parks; a portrait gallery taking us back 30 years from the world of theater and the arts: Elizabeth Taylor, Audrey Hepburn, Grace Kelly, Gina Lollobrigida, Marlon Brando, a bouncing Ray Bolger, and the reigning queen and king of the theater, Vivien Leigh and Laurence Olivier, all looking so young and beautiful. And there are the artists Pablo Picasso, Marcel Duchamp, Henri Matisse, Jackson Pollock, Salvador Dali, Andrew Wyeth and Grandma Moses. There is plenty of music with Leonard Bernstein, Jimmy Durante and Aaron Copland; theater with Noel Coward, Tennessee Williams; and, oh, the legs of Marlene Dietrich! And Americana, politics and politicians galore, the well remembered press shot of President Truman at

the piano with James Petrillo and his trumpet; presidential hapless Robert Taft holding a gift rooster; Adlai Stevenson, who would rather smell flowers like Ferdinand the bull than run for the presidency; General Eisenhower displaying the smile that won him a grateful America's heart and vote; a very young Massachusetts senator's elegant wedding reception; church suppers; Brooklyn Dodger baseball fans; the Joe Walcott knockdown of Joe Louis; fraternity brothers singing the *Sweetheart of Sigma Chi*; Fourth of July lovers on a California beach; a teenager getting a crew-cut.

In closing this foreword and reminiscence I would like to pay tribute to a number of those photographers who are now gone but who will be remembered by their photographic witness in the Life Picture Collection. The exhibition of this work was first held at the International Center of Photography where we are seeking to give recognition to work that shows the wondrous quality of everyday life perceived with sensitivity, as well as those "things to be corrected, and things to be appreciated" as Lewis Hine described his work. And may I add: preserved and remembered.

Cornell Capa
Executive Director
International Center of Photography

LIFE : THE SECOND DECADE

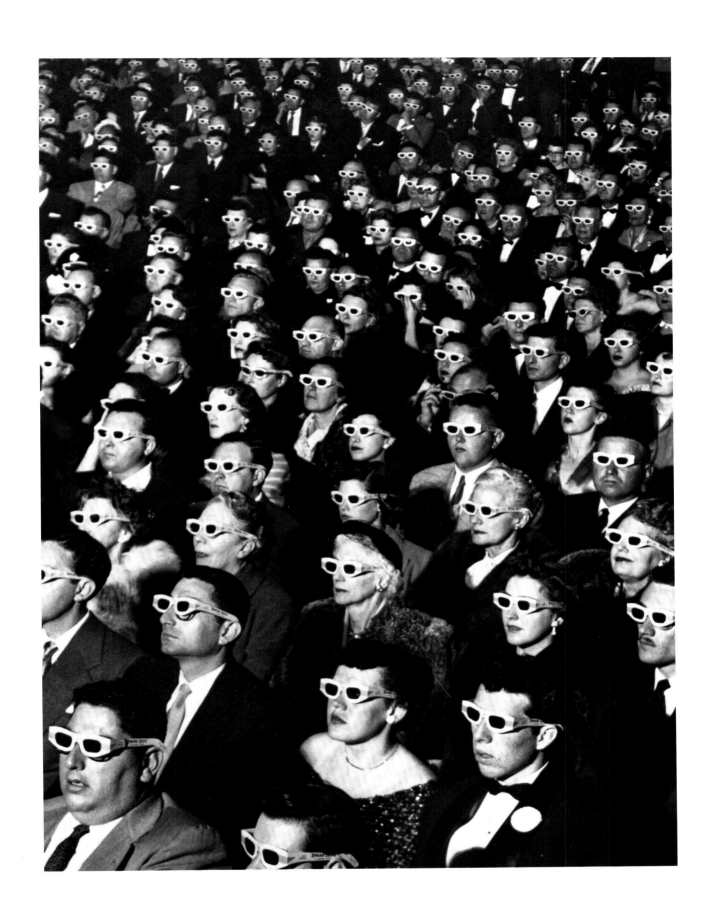

J.R. Eyerman 1952
Audience watches premiere of *Bwana Devil*
wearing Polaroid spectacles to enjoy the
three-dimensional sequences.
LIFE December 15, 1952

1

Nina Leen 1946
Four generations of an Ozark family with a fifth
generation present in the portraits on the wall.
LIFE July 26, 1948

2

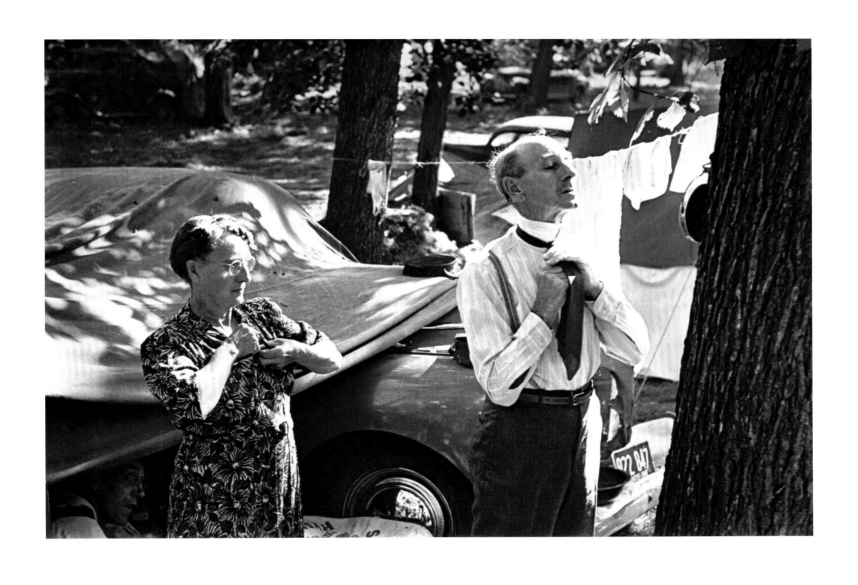

Leonard McCombe 1946
Camping in Iowa.

3

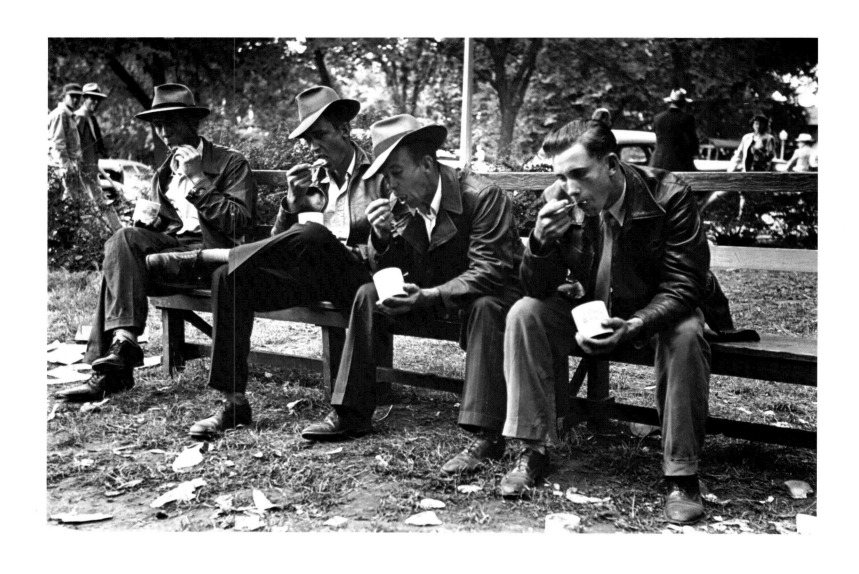

Leonard McCombe 1946
Men enjoying ice cream at an Iowa fair.
LIFE August 17, 1953

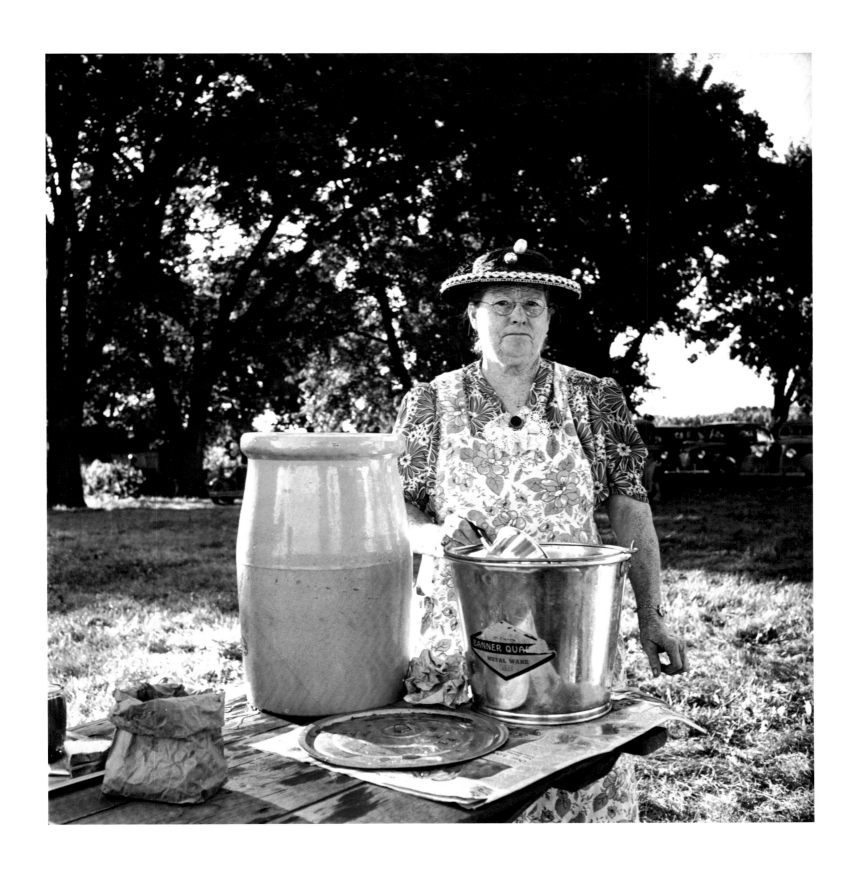

Bob Landry 1946
Iowa woman presides at a
Presbyterian church supper.
LIFE September 30, 1946

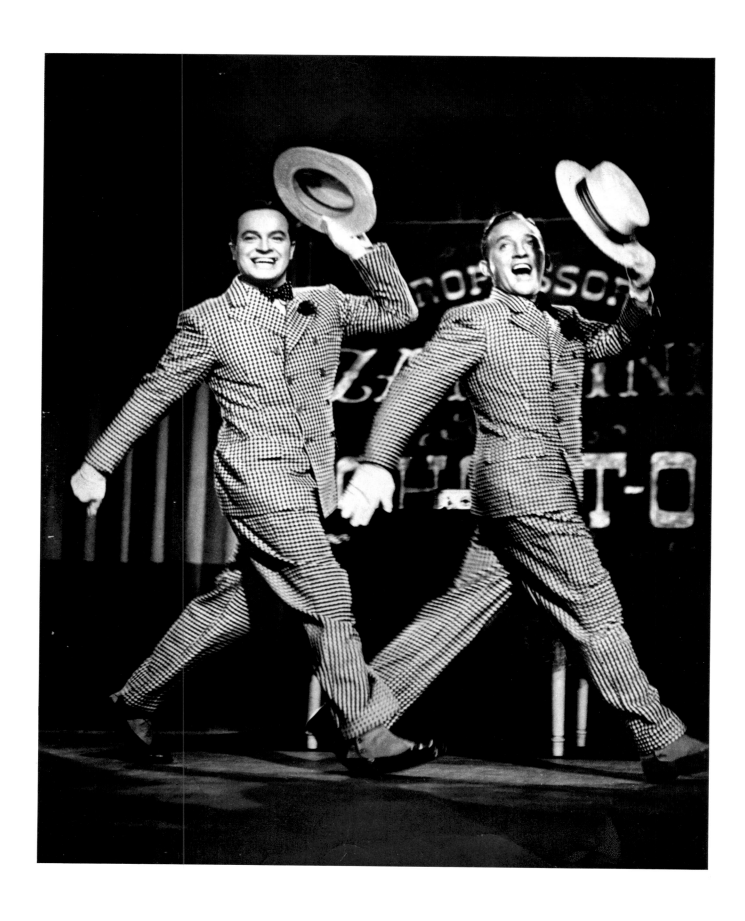

Jack Koffman 1946
Bob Hope and Bing Crosby in a dance routine
from their movie, *Road to Utopia*.
LIFE February 4, 1946 Cover

6

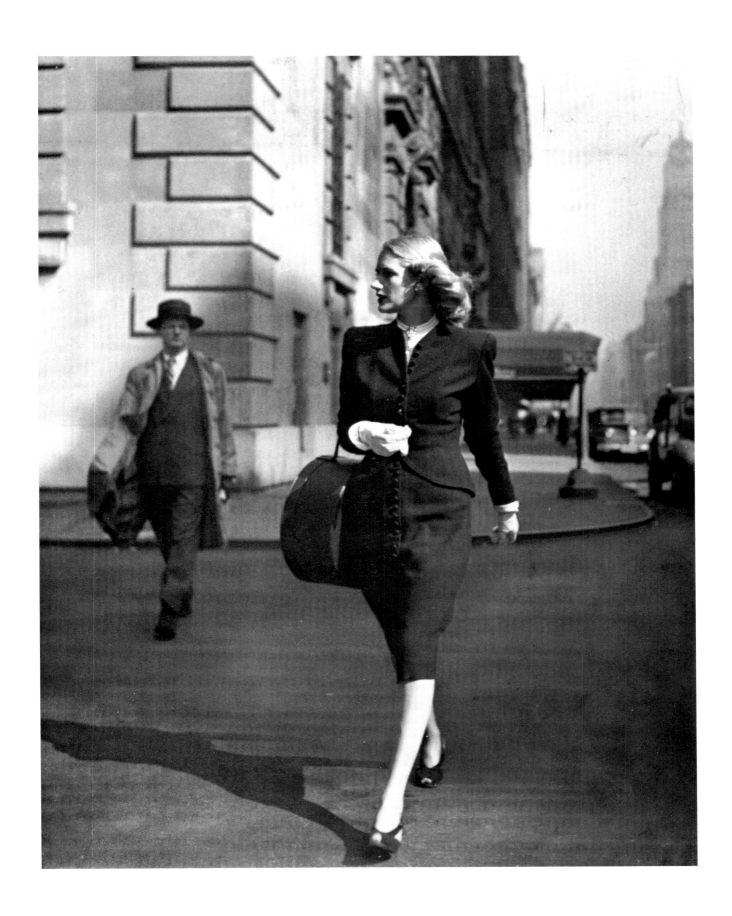

Ann Rosener 1946
Carrying her hatbox, the symbol of the model's trade, Lily Carlson walks down Park Avenue on her way to work.
LIFE March 25, 1946

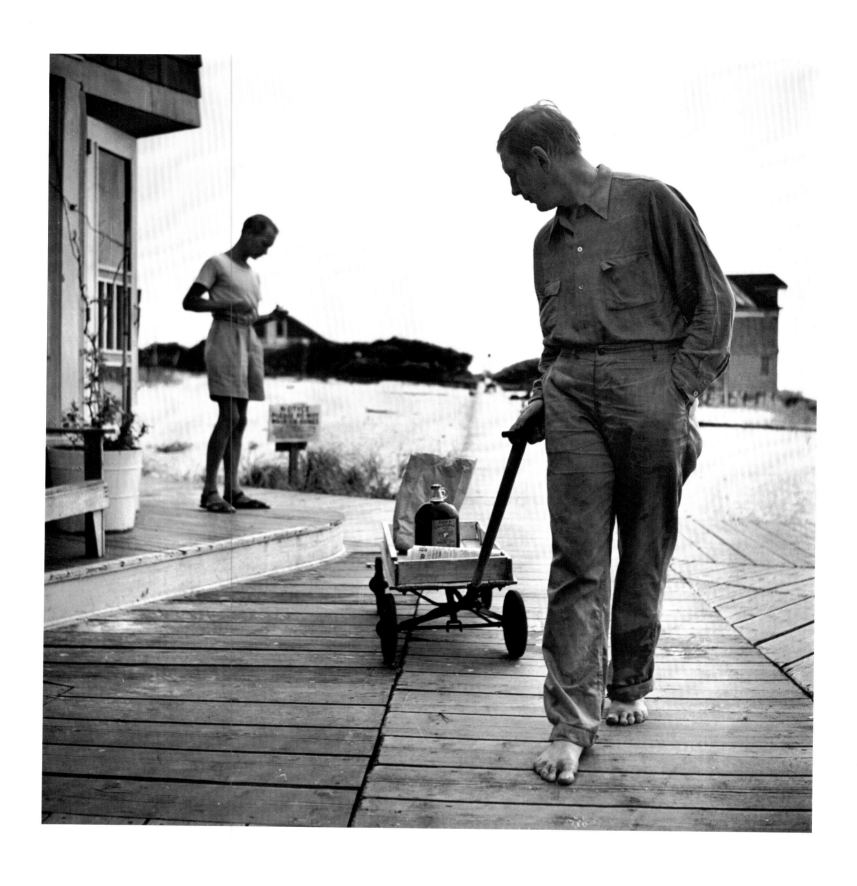

Jerry Cooke 1946
Poet W.H. Auden at Fire Island, New York.

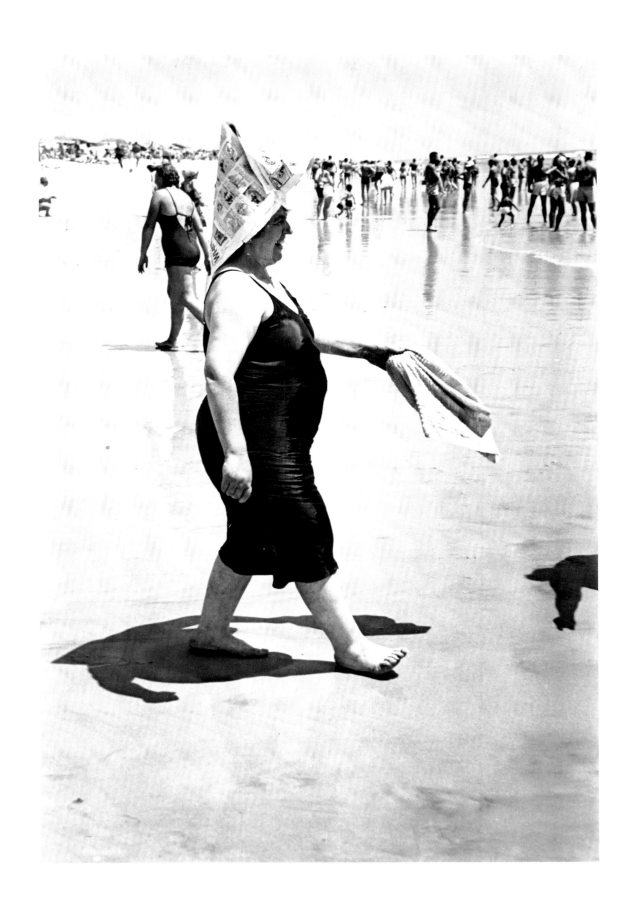

Leonard McCombe 1946
An August day at Jones Beach, New York.
LIFE August 12, 1946

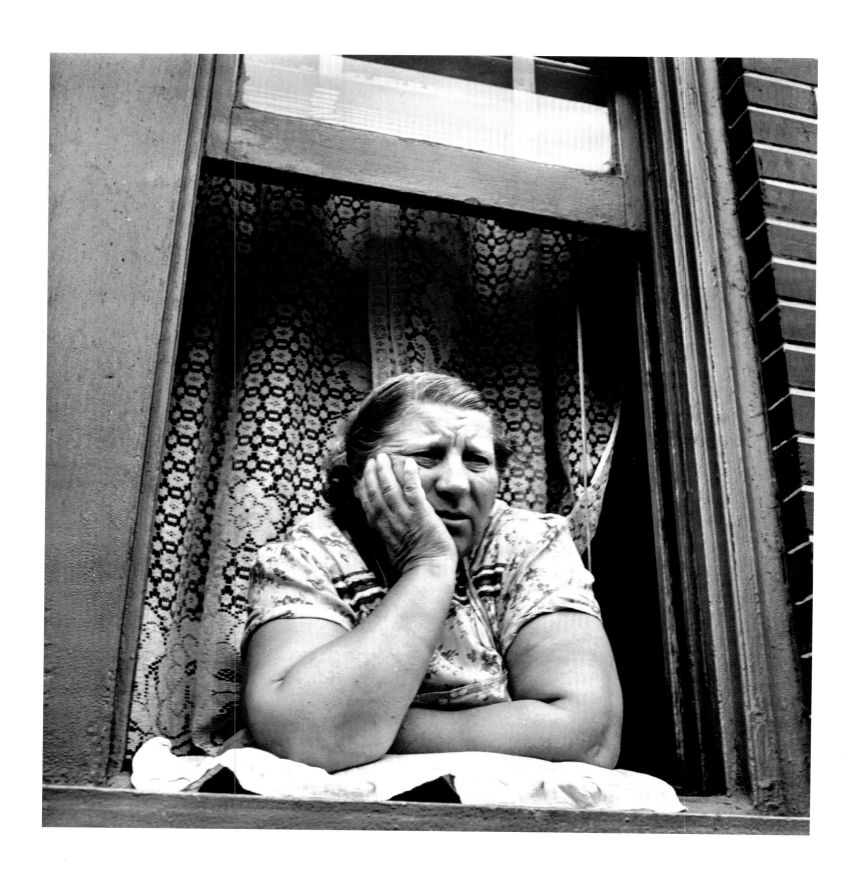

Edward Clark 1946
Woman watches street scene from her Brooklyn
window.

10

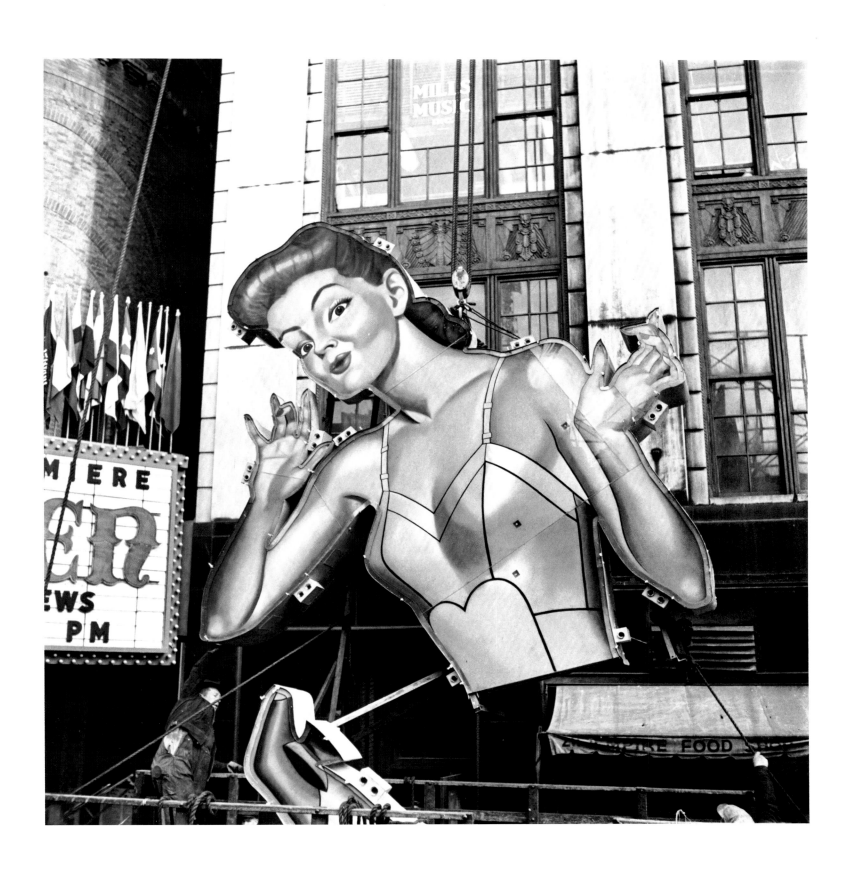

Kay Chester 1946
Sign advertising lingerie is hauled into place,
New York City.

11

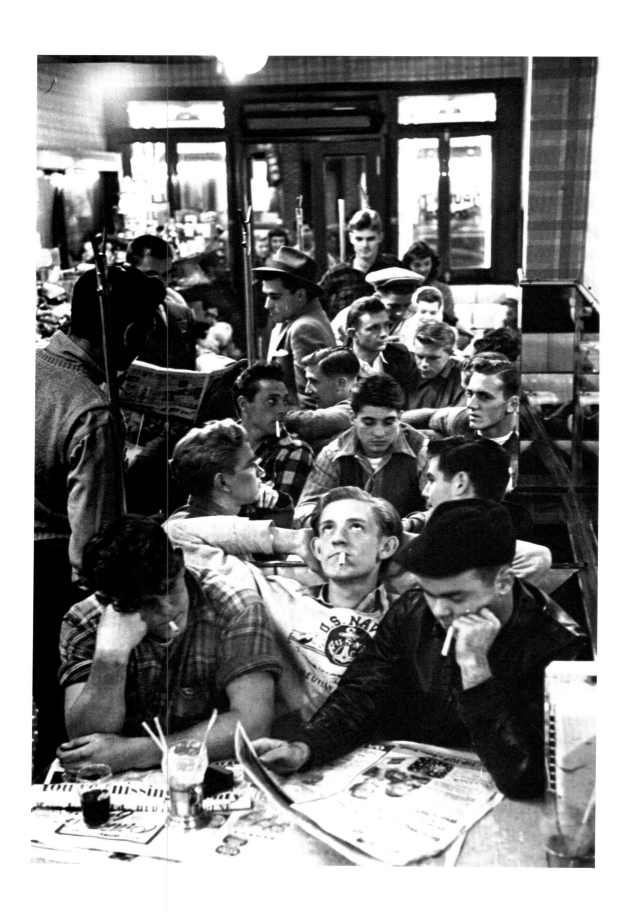

Leonard McCombe 1946
Former servicemen, living on unemployment
pay of $20 a week for 52 weeks, gather in a
Long Island, New York drugstore.
LIFE November 25, 1946

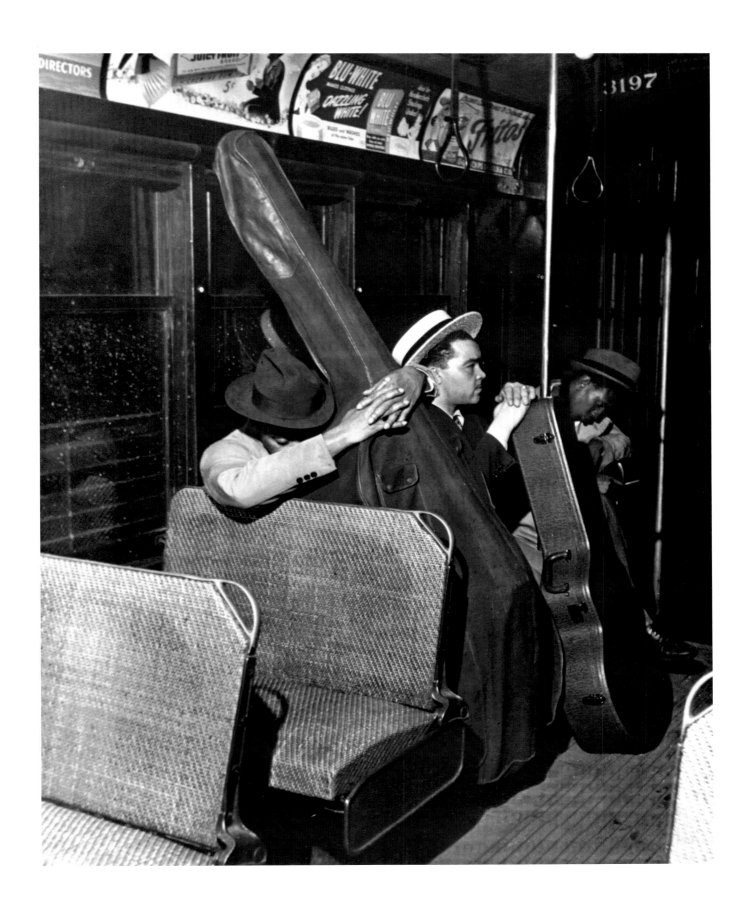

Roger Coster 1947
Nightclub musicians take a streetcar home at
4:30 A.M., Chicago, Illinois.

13

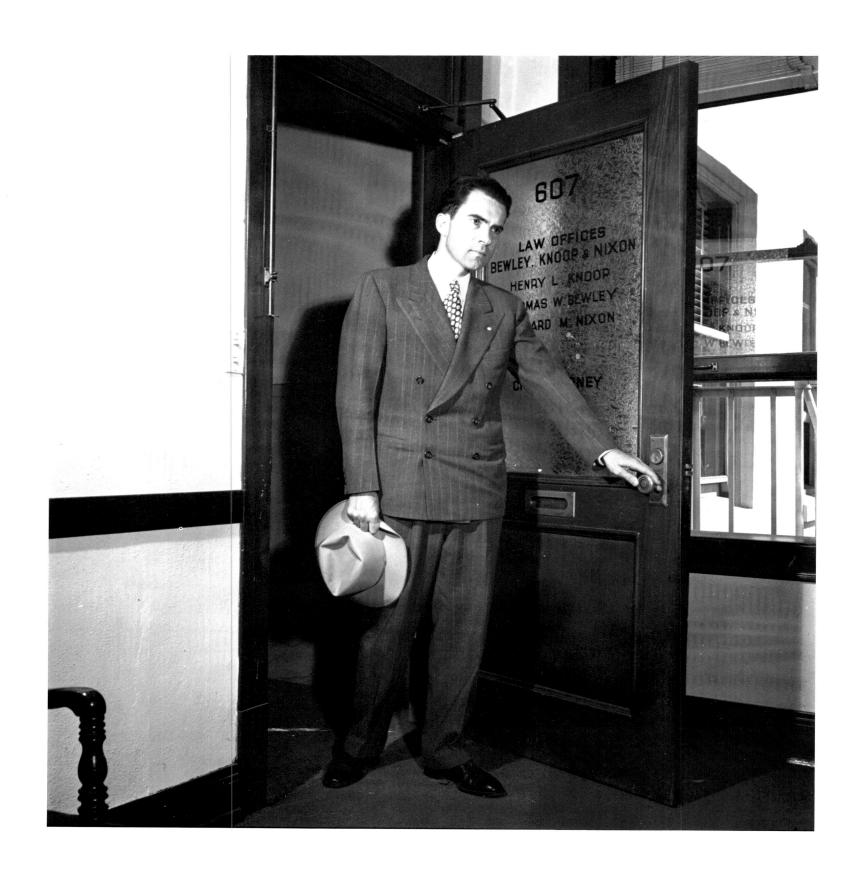

George Lacks 1946
After World War II, Richard M. Nixon returns
to his law office in Whittier, California to resume
his career.
LIFE December 14, 1953

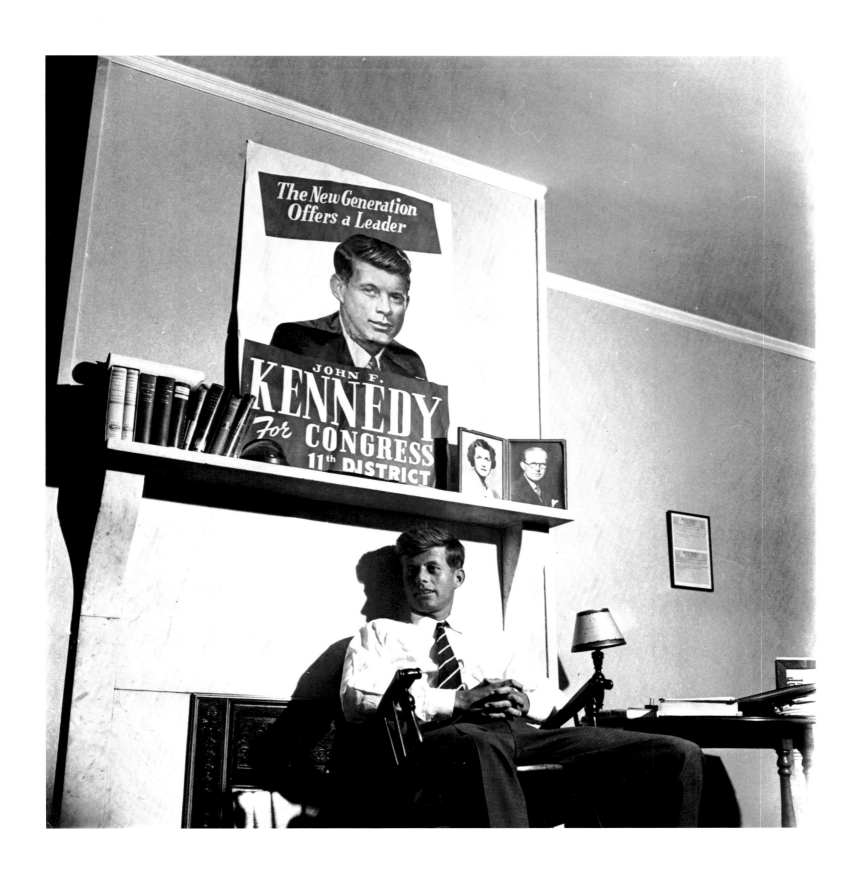

Yale Joel 1946
John F. Kennedy, candidate for Congress at 29, is
photographed in his room at Boston's Bellevue
Hotel with pictures of his parents on the mantel.

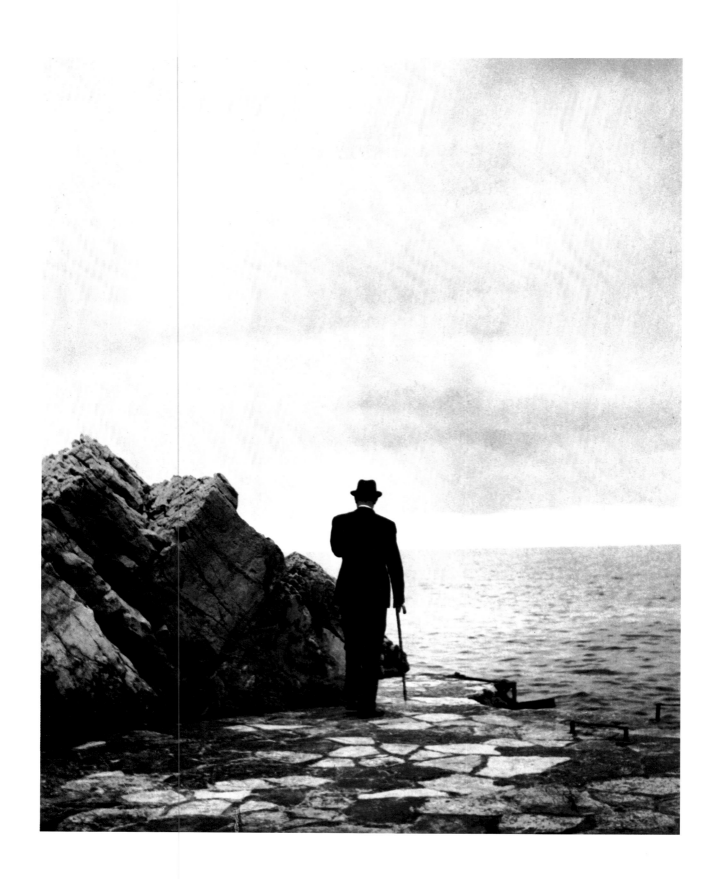

Nick De Morgoli 1946
Charles de Gaulle, who had recently resigned as
Provisional President of France, stares out over
the Mediterranean at Antibes as he begins a
12-year withdrawal from political life.
LIFE February 18, 1946

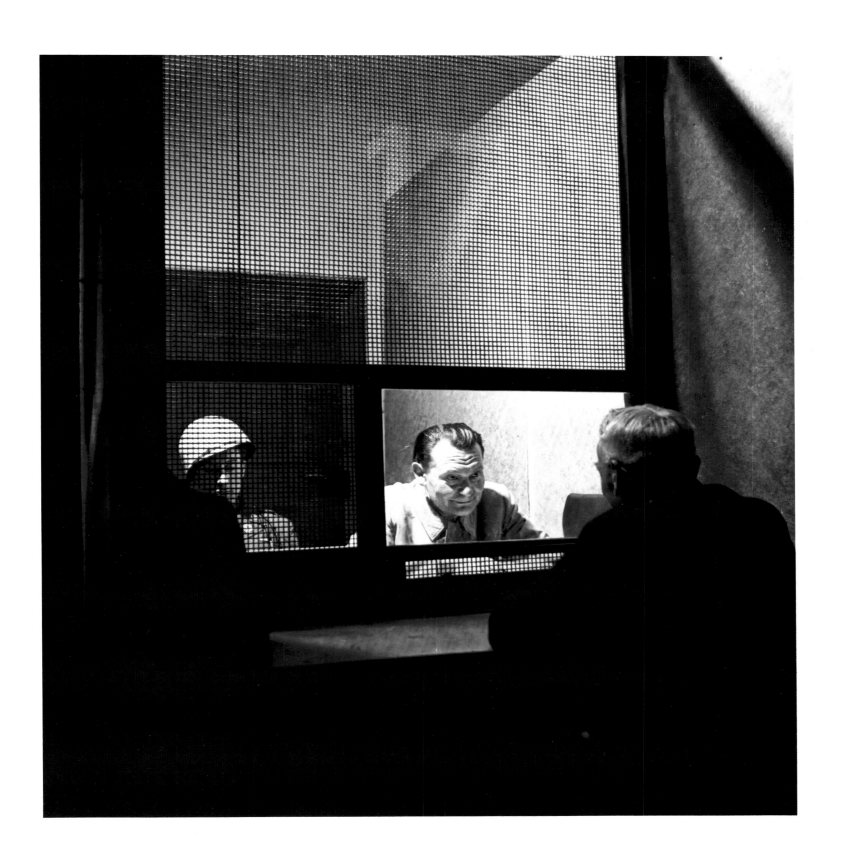

Ralph Morse 1946
In the defense counsel room at Nuremberg,
Hermann Goering talks with his lawyer while a
U.S. MP stands guard.
LIFE April 1, 1946

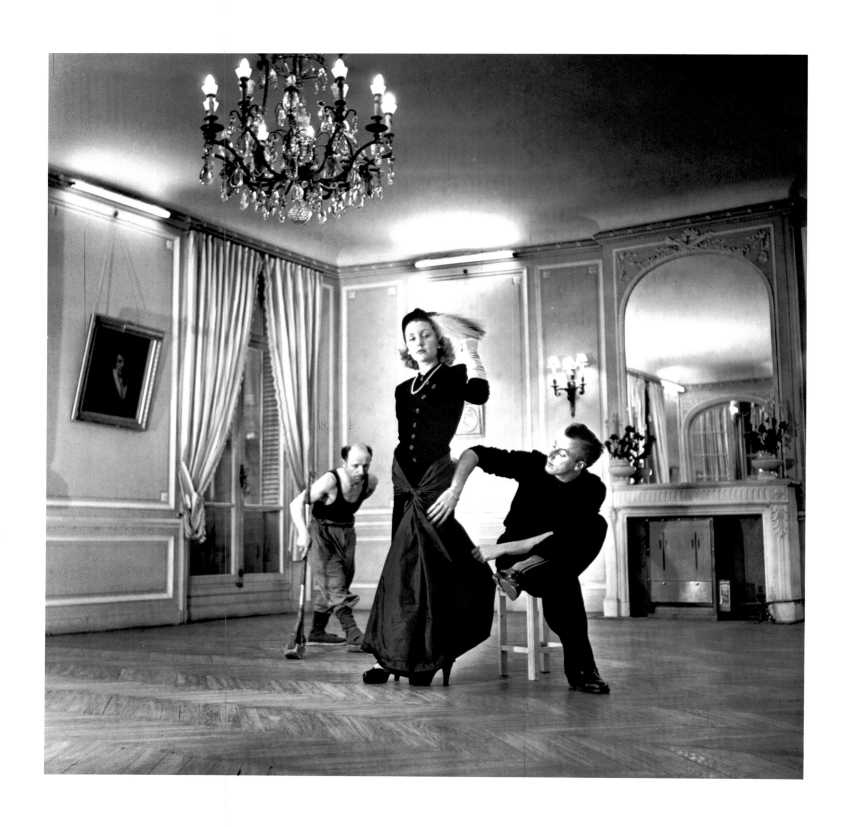

Nina Leen 1946
While a floor polisher works busily nearby,
couturier Jacques Fath adjusts a gown on his
wife before a Paris showing.
LIFE April 1, 1946

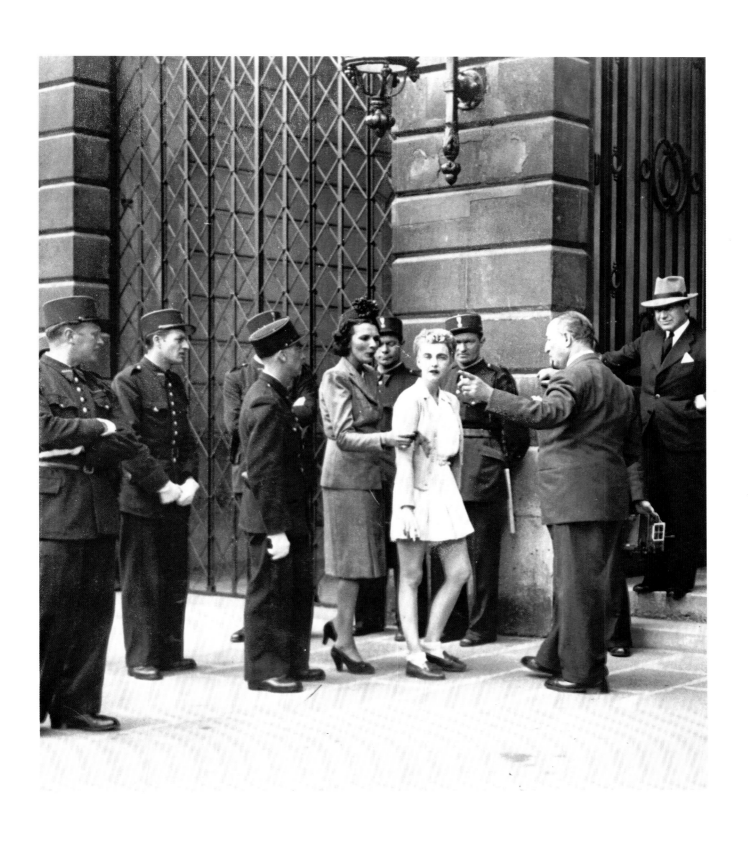

Angelo Maso 1946
Barbara Hutton being barred from the front
door of the Hotel Ritz, Paris, because she is
wearing culottes.
LIFE May 27, 1946

19

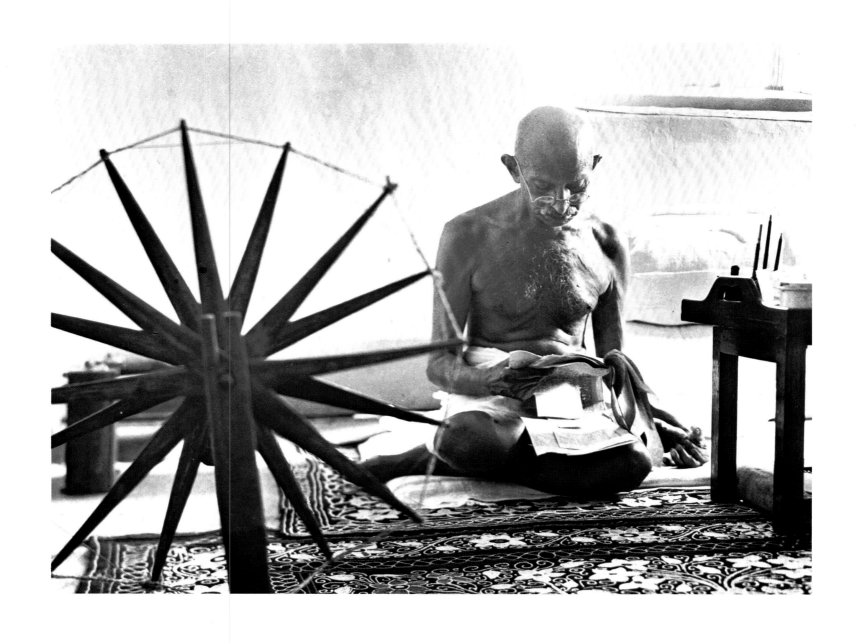

Margaret Bourke-White 1946
Mahatma Gandhi beside his spinning wheel,
symbol of India's struggle for independence.
LIFE July 15, 1946

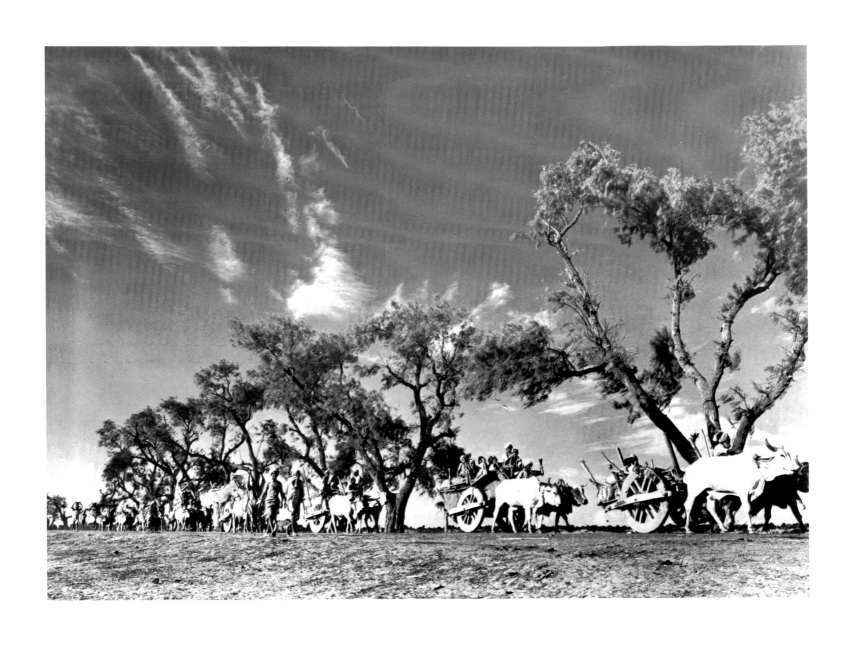

Margaret Bourke-White 1947
Procession of Sikh refugees stretches across the
landscape as they migrate to the Hindu section
of the Punjab during the partition of India.
LIFE November 3, 1947

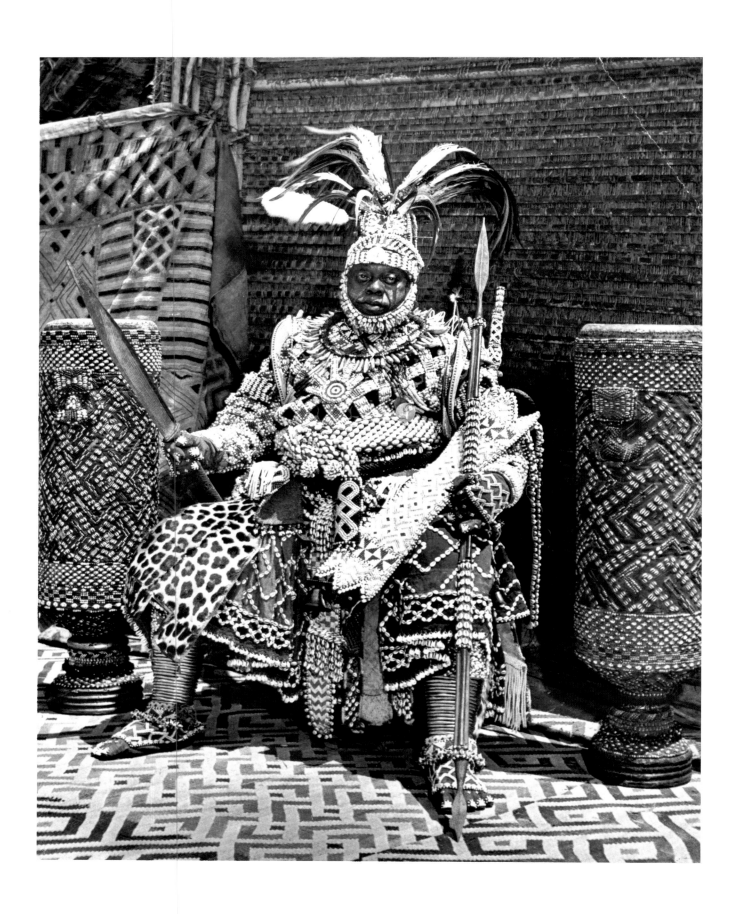

Eliot Elisofon 1947
King of Bakuba tribe, Kasae Province,
Belgian Congo, at the time of his coronation.
LIFE March 3, 1947

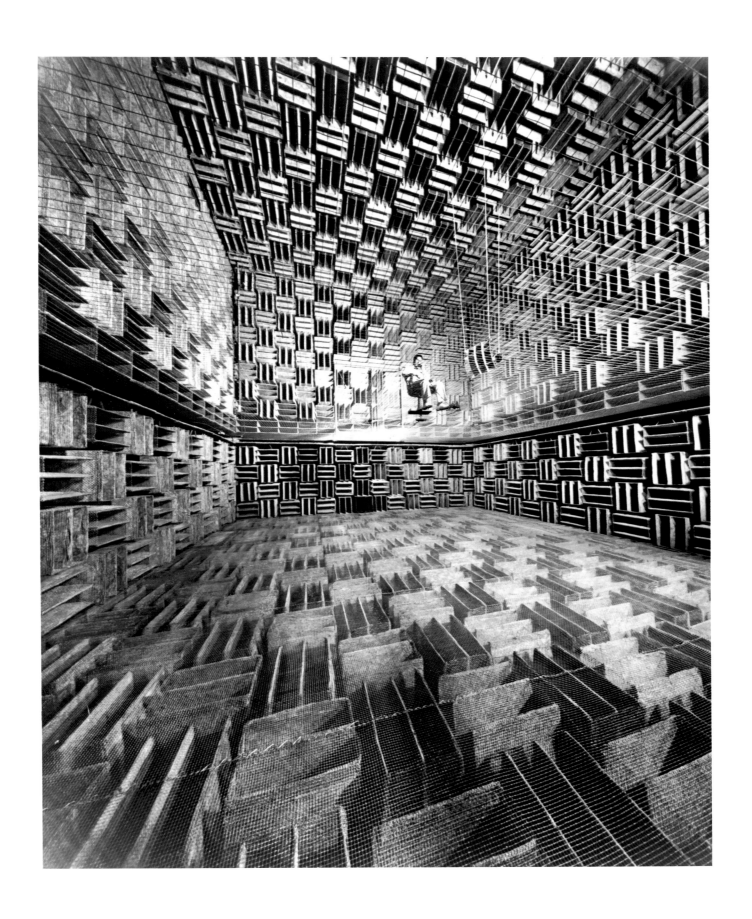

Eric Schaal 1947
Bell Telephone engineer conducts experiment in
acoustical research room designed to eliminate
99 per cent of all outside sound.
LIFE September 8, 1947

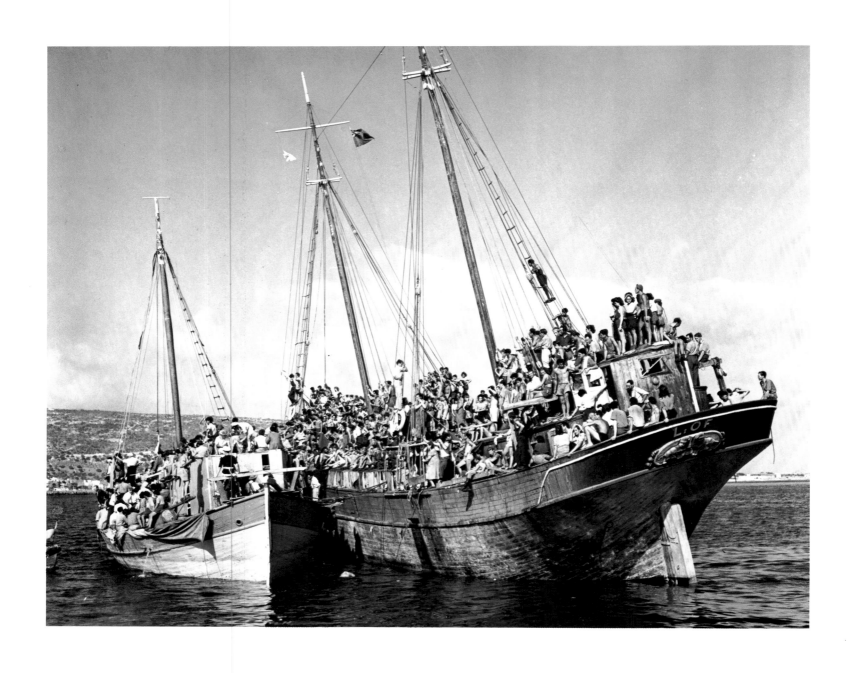

David Douglas Duncan 1946
Illegal Jewish refugees, prevented by British
from landing, are held in Haifa harbor before
being shipped to internment in Cyprus.
LIFE September 2, 1946

24

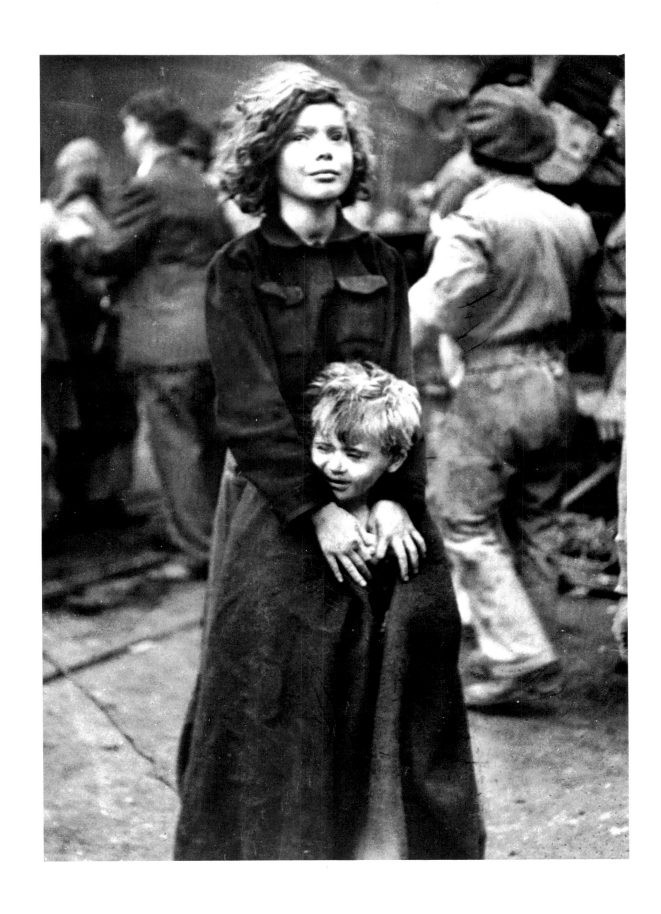

Cornelius Ryan 1946
Separated from their parents, a sister and
brother await deportation from Palestine as
illegal Jewish immigrants.
LIFE December 30, 1946

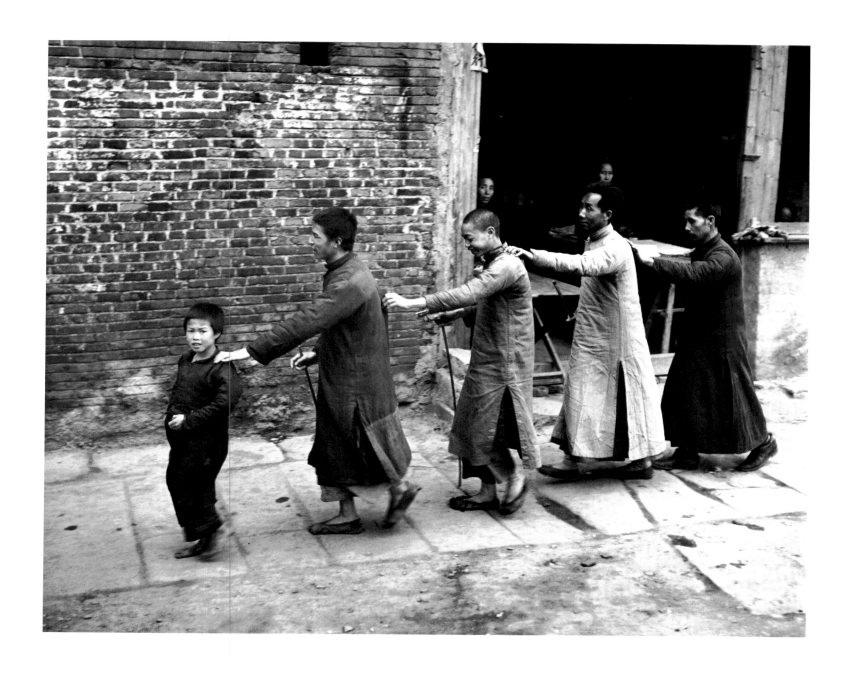

George Silk 1946
A small boy leads the blind through streets of
Hengyang during famine in China.

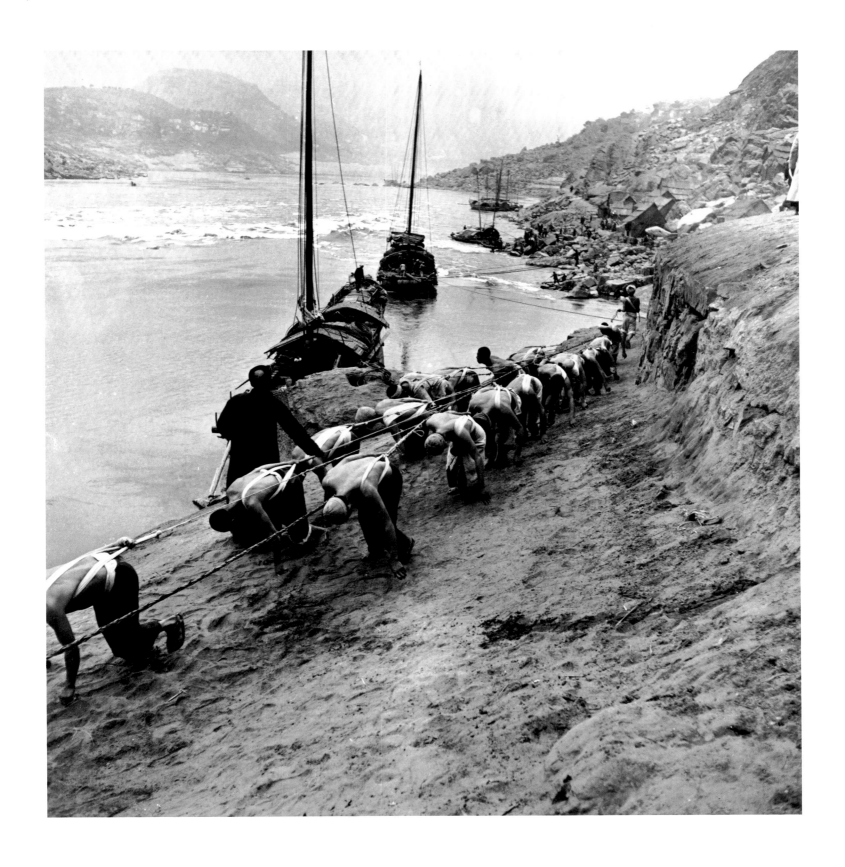

Dmitri Kessel 1946
Harnessed and bowed, Chinese trackers plod
along the riverbank, towing a junk slowly up the
Yangtze.
LIFE June 11, 1956

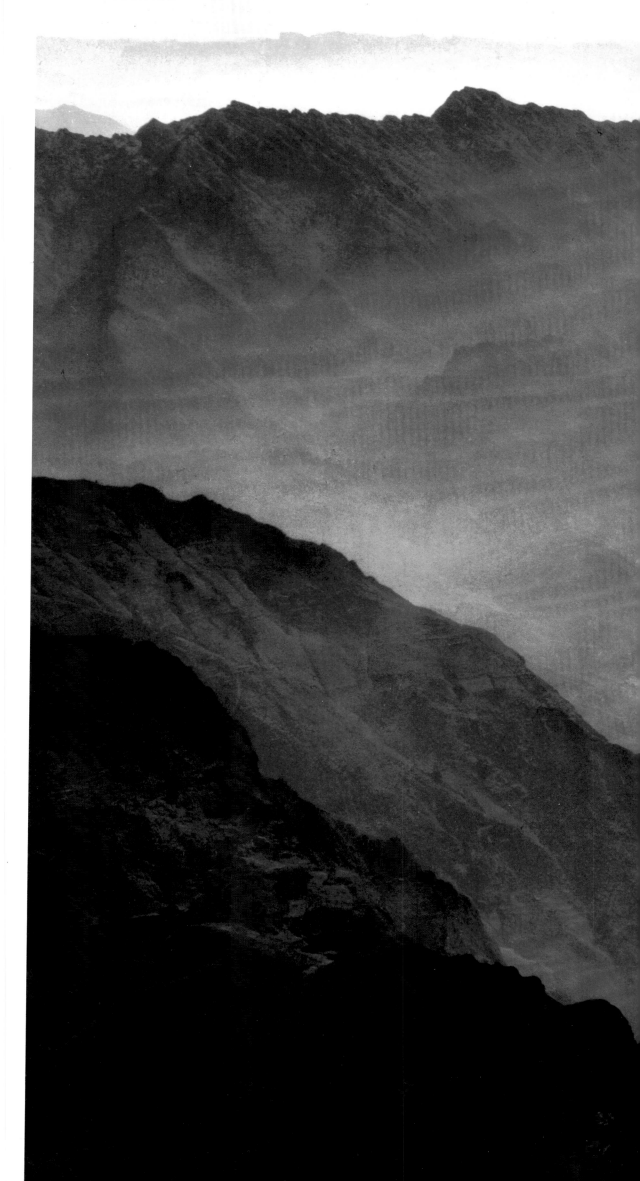

Dmitri Kessel 1946
Yangtze River gorge.
Szechwan.
Western China.
LIFE April 4, 1955

28

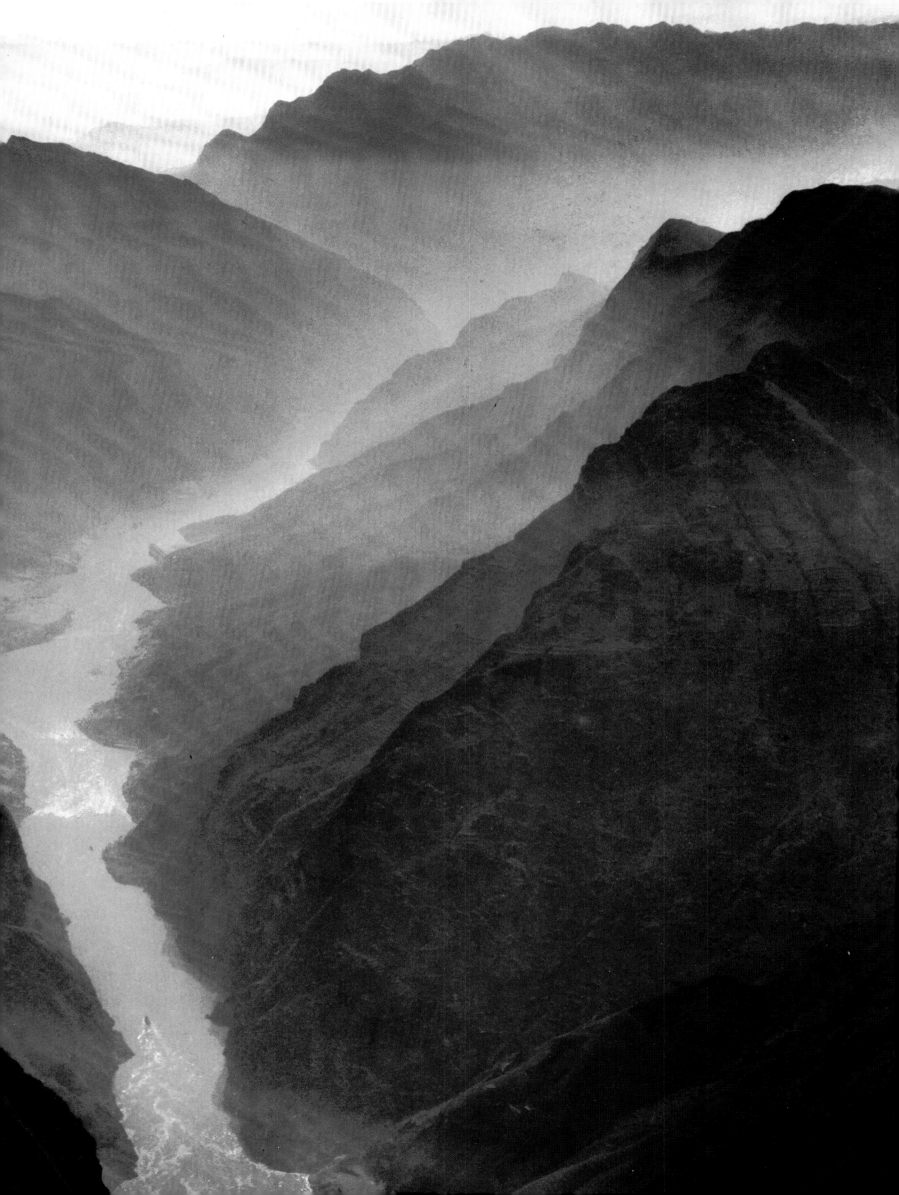

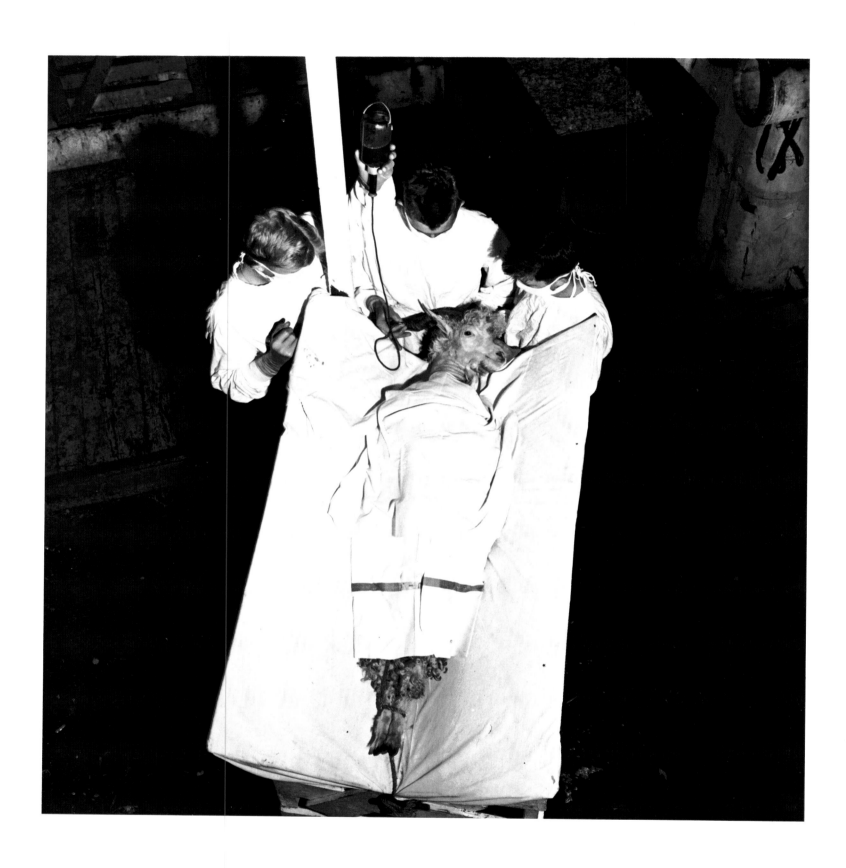

George Skadding 1946
A goat, exposed to two atomic bomb tests at
Bikini, receives blood transfusion on his arrival
at Naval Medical Research Institute, Bethesda,
Maryland.
LIFE October 7, 1946

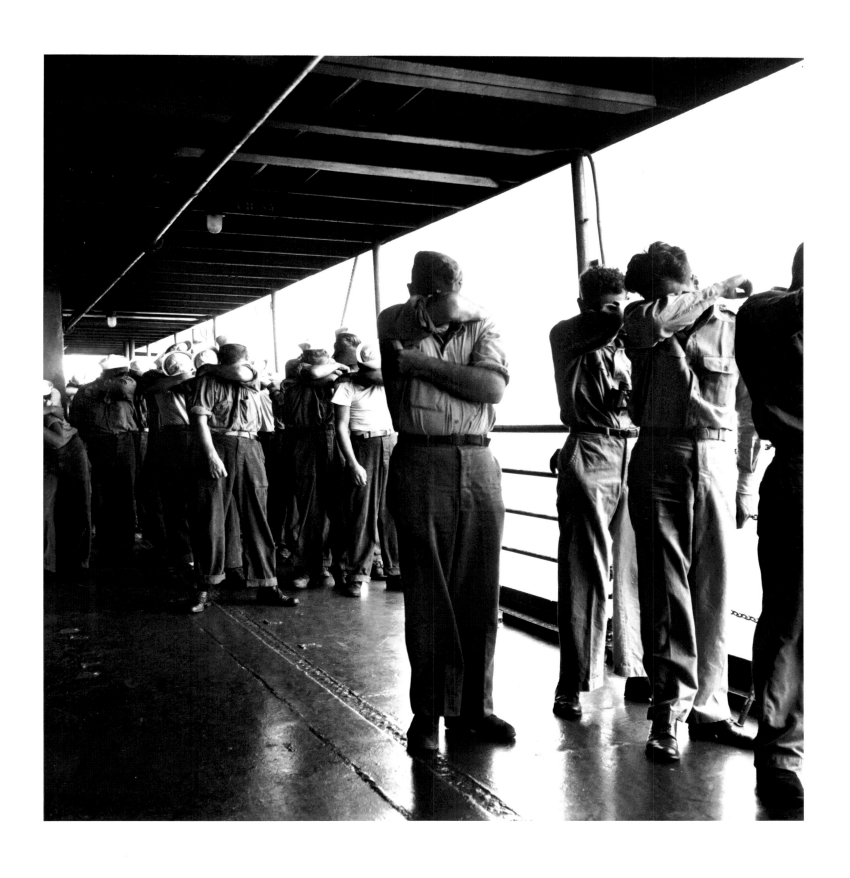

Fritz Goro 1947
Sailors shield their eyes during atomic bomb
test, Bikini.

30

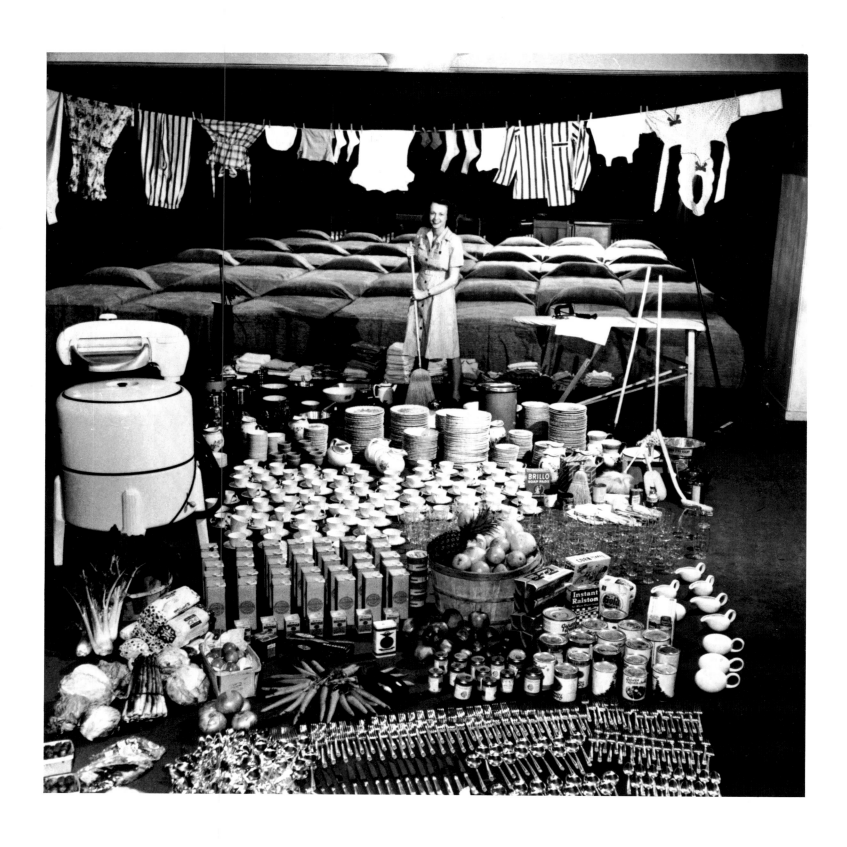

Nina Leen 1947
Marjorie McWeeney of Rye, New York, amidst a
typical week's load of housework and supplies.
LIFE June 16, 1947

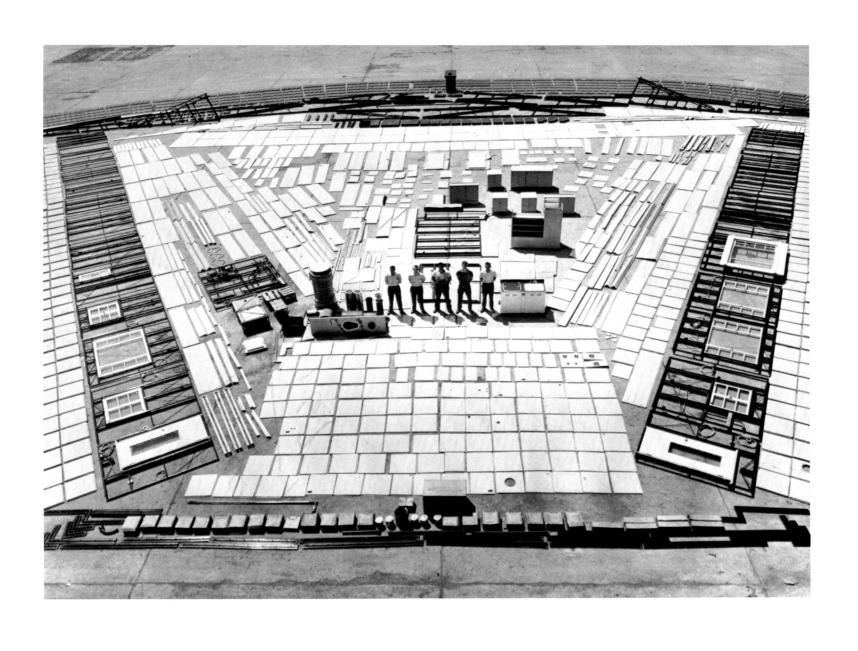

Components of a Lustron prefabricated house.

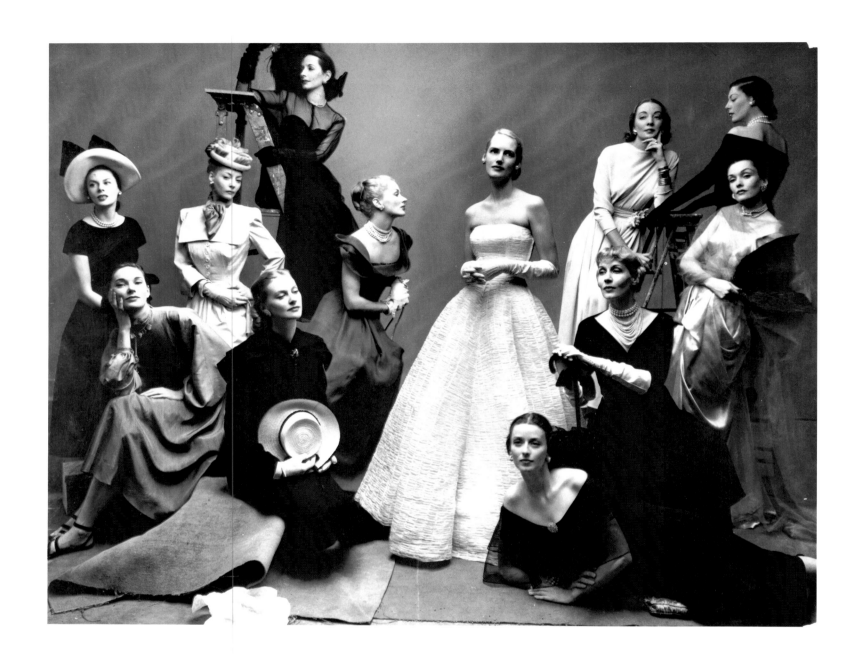

Irving Penn
Courtesy VOGUE ©1947 (renewed 1975) by
Condé Nast Publications, Inc.
Top U.S. fashion models, left to right: Meg
Mundy, Marilyn Ambrose, Helen Bennett, Dana
Jenney (holding white hat), Betty McLauchlen,
Lisa Fonssagrives, Lily Carlson, Dorian Leigh,
Andrea Johnson, Elizabeth Gibbons, Kay
Hernan (white gown) and Muriel Maxwell.
LIFE May 12, 1947

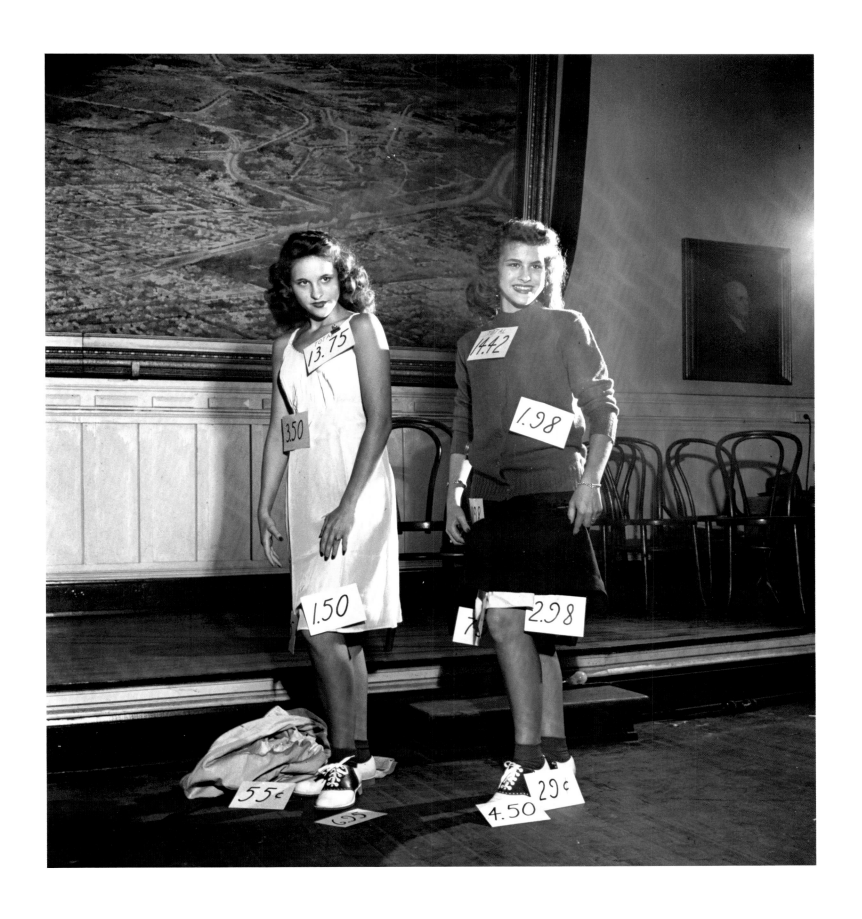

Robert Wheeler 1947
Twins model what $14 buys in 1947, left,
and what it used to buy in 1939, right.
LIFE November 10, 1947

34

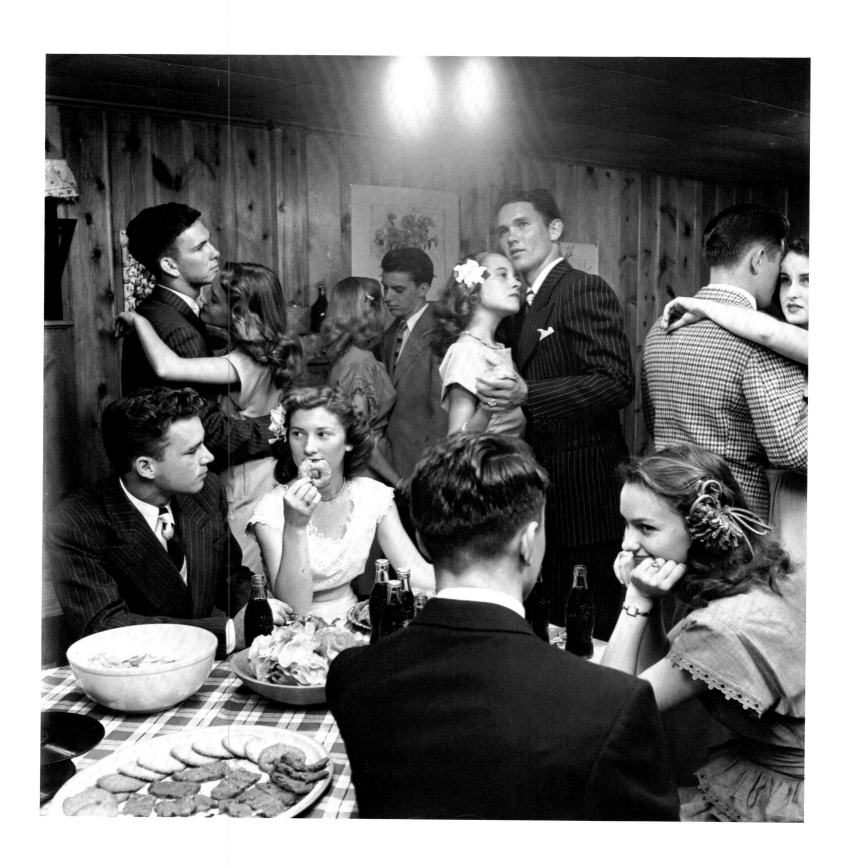

Nina Leen 1947
Teenagers in Tulsa, Oklahoma munch
doughnuts and sip Cokes whenever they are not
dancing with serious faces to sentimental music.
LIFE August 4, 1947

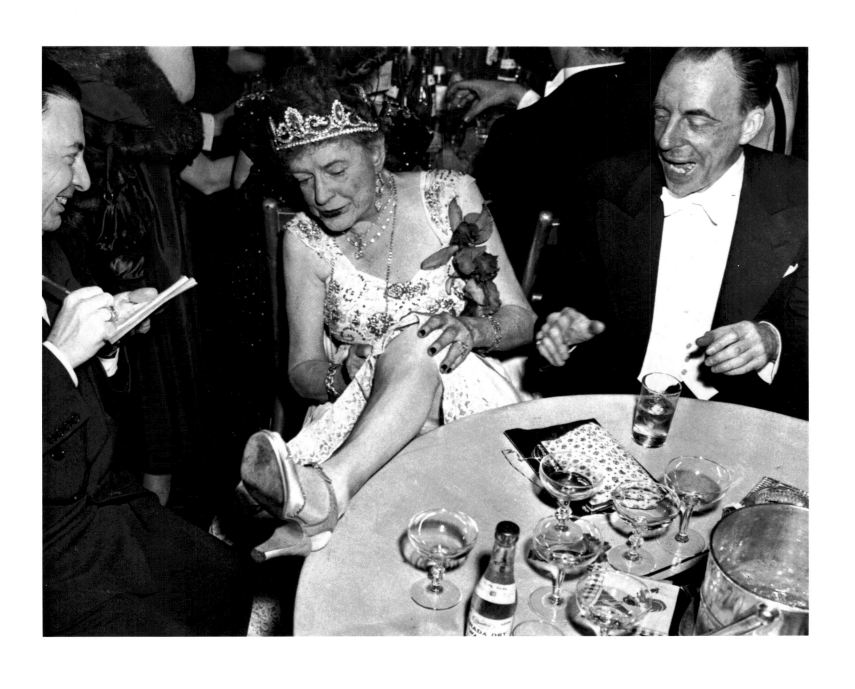

Walter Kelleher 1947
Mrs. Frank Henderson invites comparison of her
legs with those of Marlene Dietrich, on opening
night at New York's Metropolitan Opera.
LIFE November 24, 1947

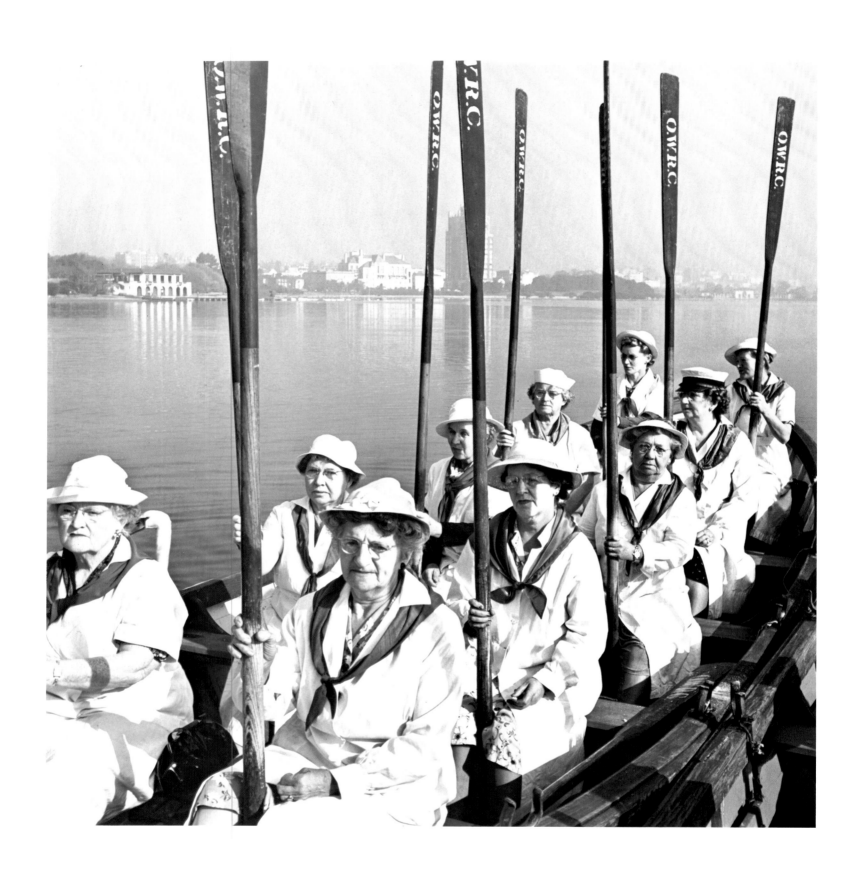

Charles Steinheimer 1947
The Oakland Women's Rowing Club of Oakland.
California.
LIFE February 9, 1948

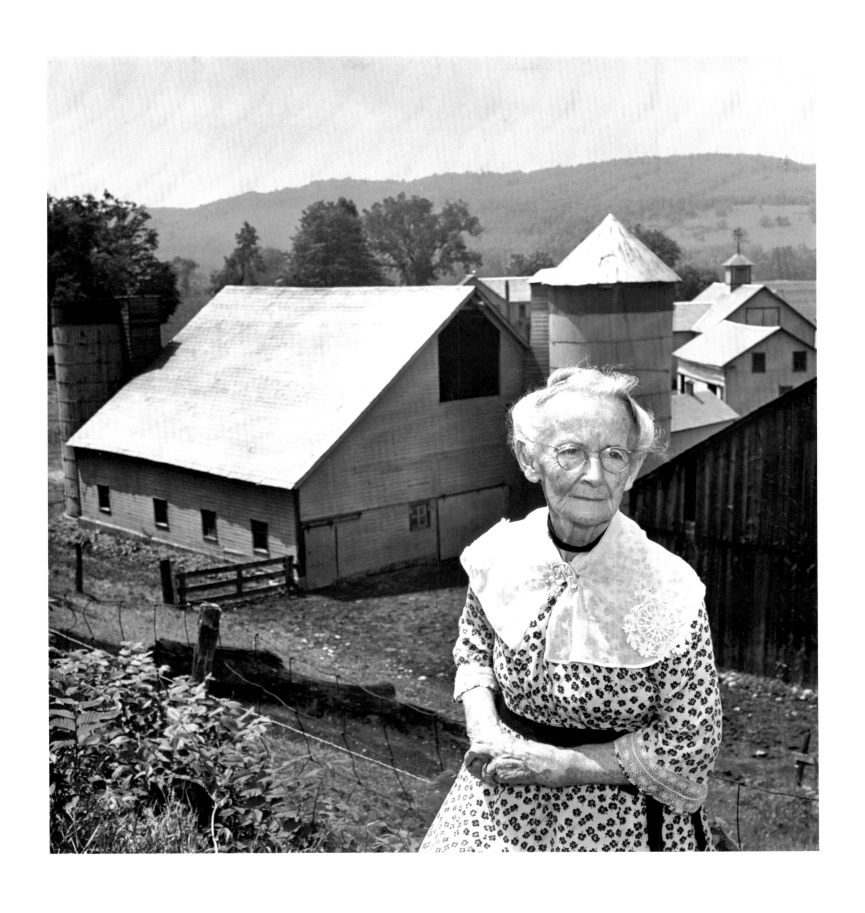

W. Eugene Smith 1947
Grandma Moses at Eagle Bridge, New York.

38

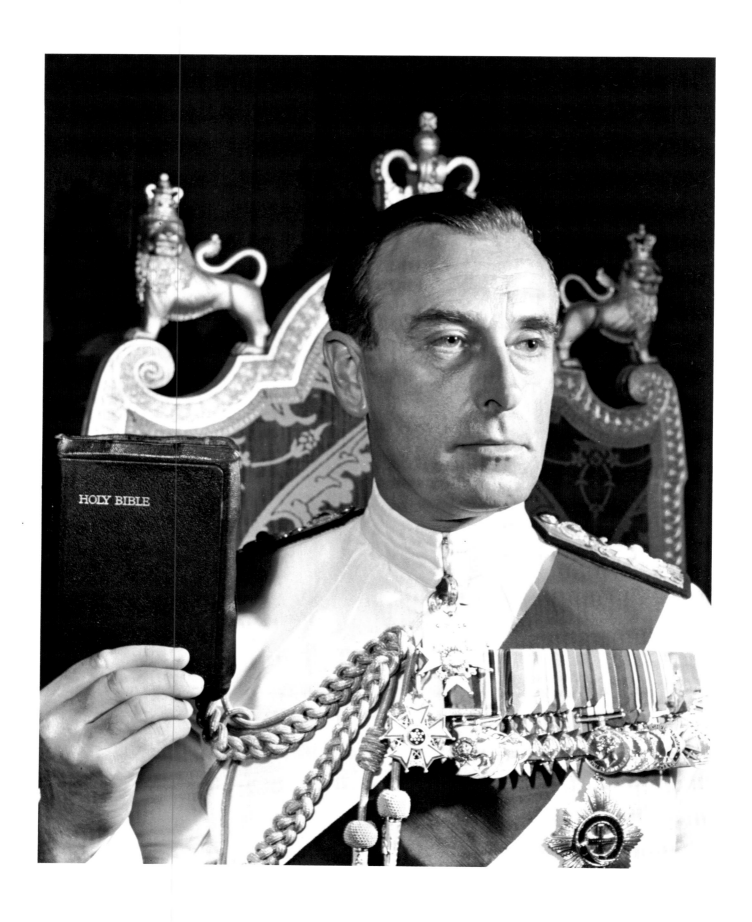

David Douglas Duncan 1947
Lord Louis Mountbatten takes the oath of office
as the last British viceroy of India.
LIFE August 8, 1947

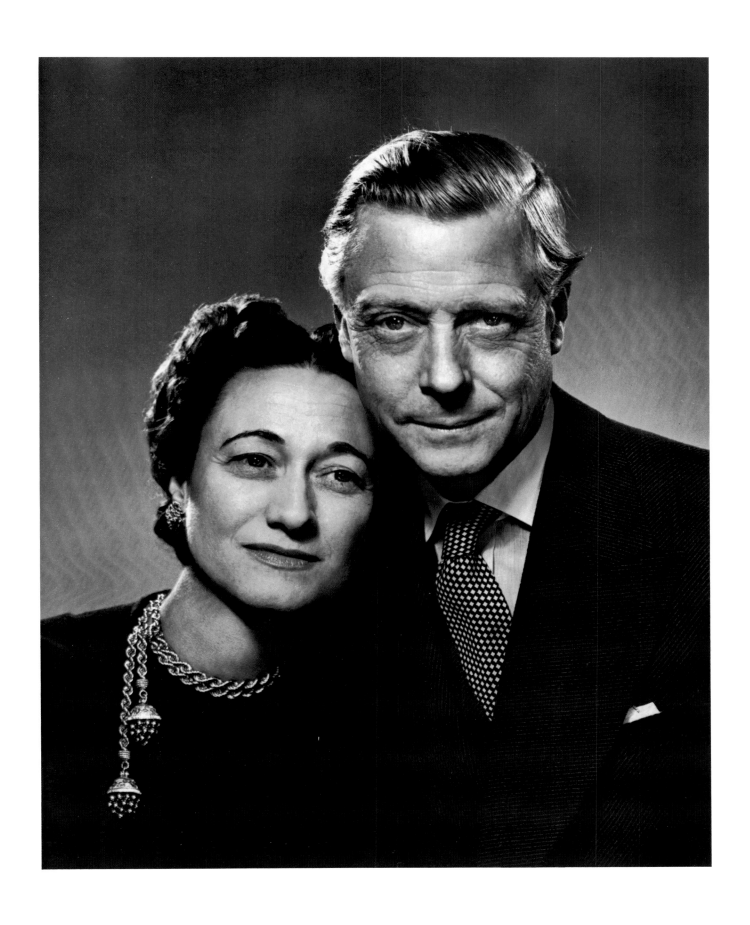

Philippe Halsman 1947
Portrait of the Duke and Duchess of Windsor.
LIFE May 22, 1950 Cover

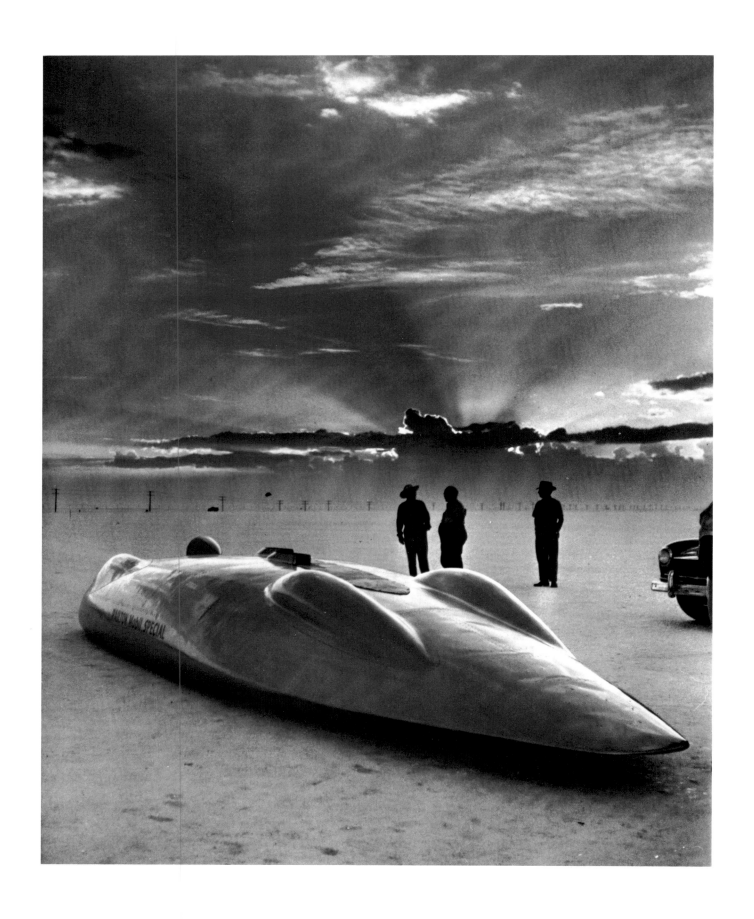

Jon Brenneis 1947
John Cobb's Railton Special racing car on
straightaway at Wendover, Utah.
LIFE September 1, 1947

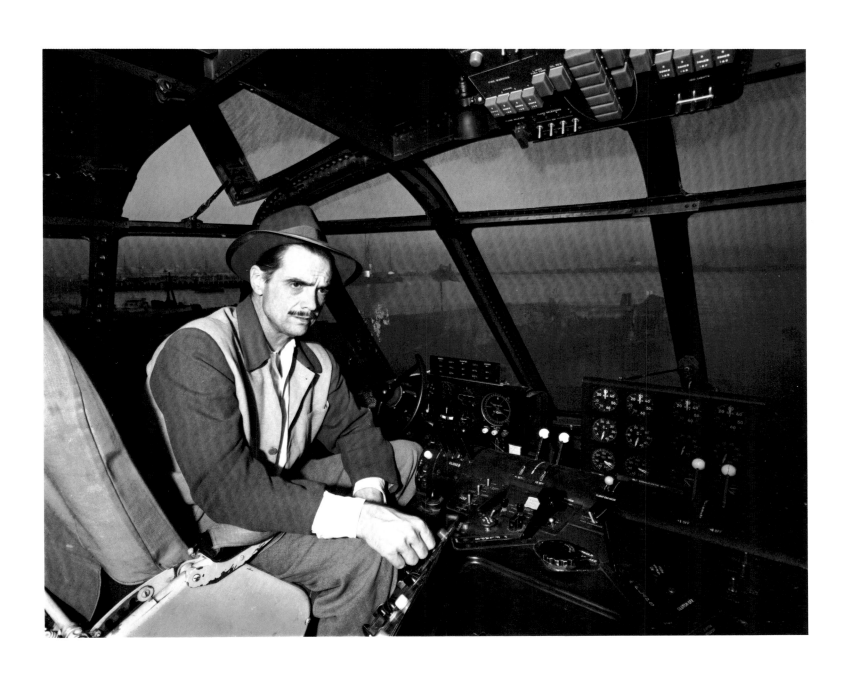

J.R. Eyerman 1947
Howard Hughes sits at the controls of his
200-ton flying boat, nicknamed *Spruce Goose*,
in Los Angeles harbor.
LIFE February 25, 1972

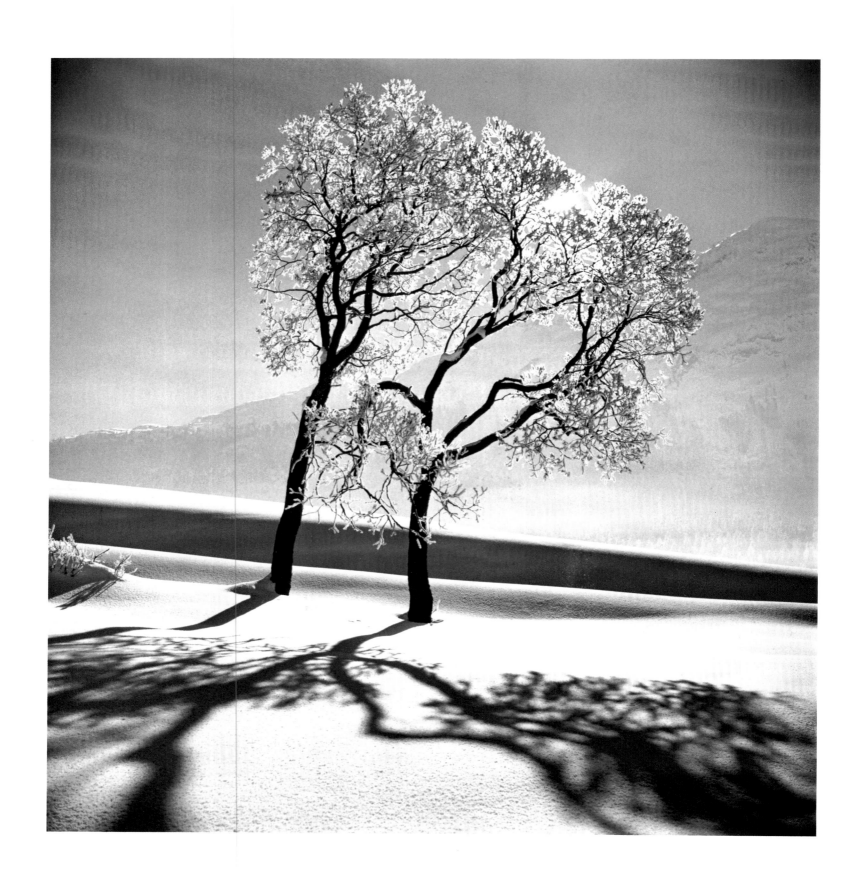

Alfred Eisenstaedt 1947
Trees in snow, St. Moritz, Switzerland.

43

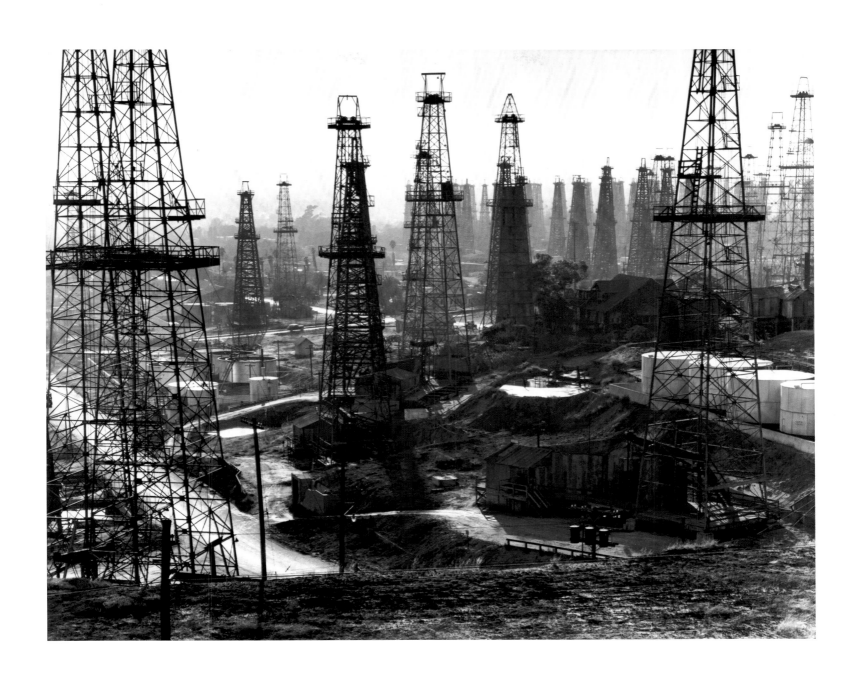

Andreas Feininger 1947
Forest of oil rigs on Signal Hill,
near Long Beach, California.
LIFE July 5, 1948

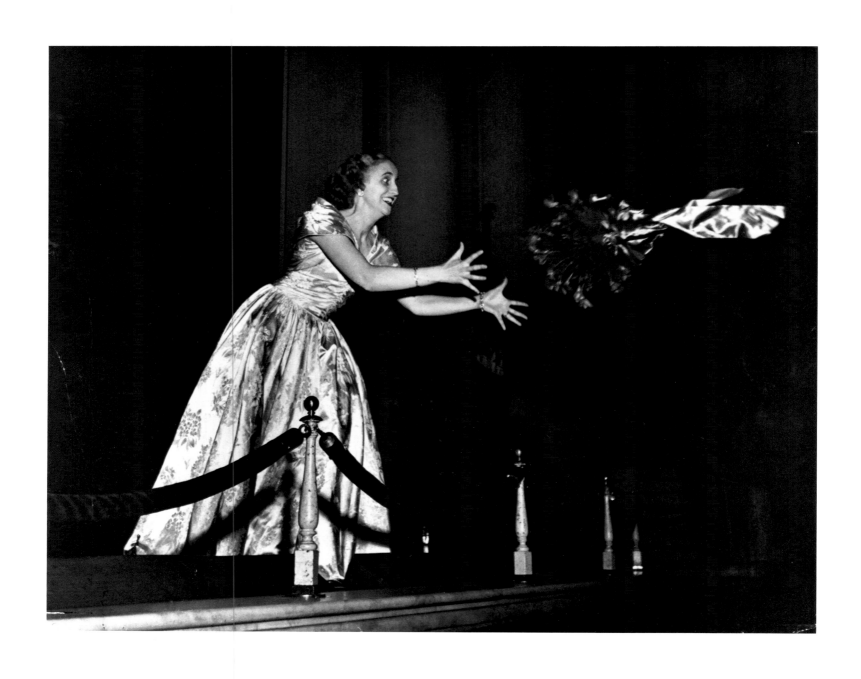

Thomas McAvoy 1947
Margaret Truman receiving a bouquet at the
conclusion of her concert in Washington's
Constitution Hall.

45

W. Eugene Smith 1947
Child enraptured at Mountain Music Festival,
Asheville, North Carolina.
LIFE October 20, 1947 Cover

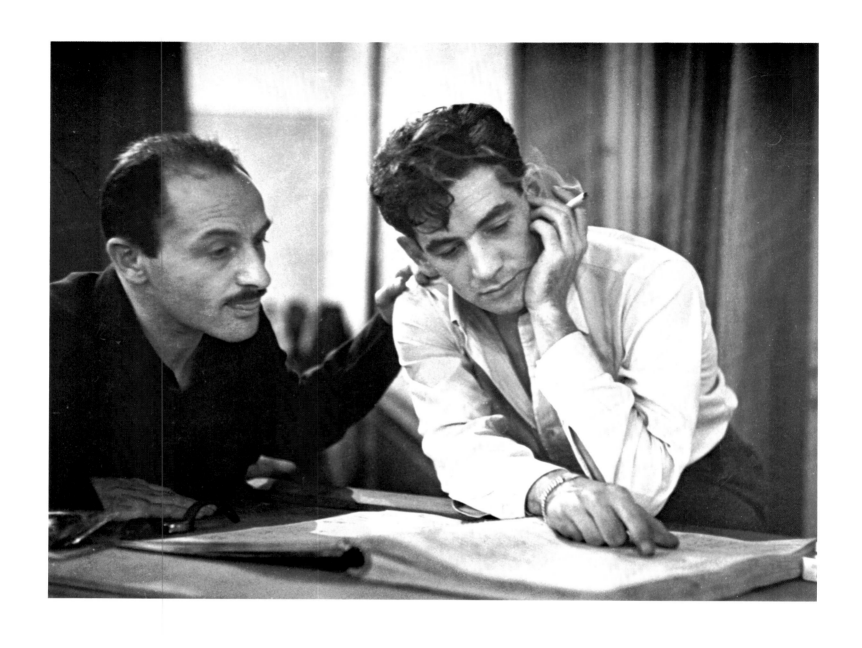

W. Eugene Smith 1947
Marc Blitzstein, left, and Leonard Bernstein
study score of a Blitzstein work during recording
session.

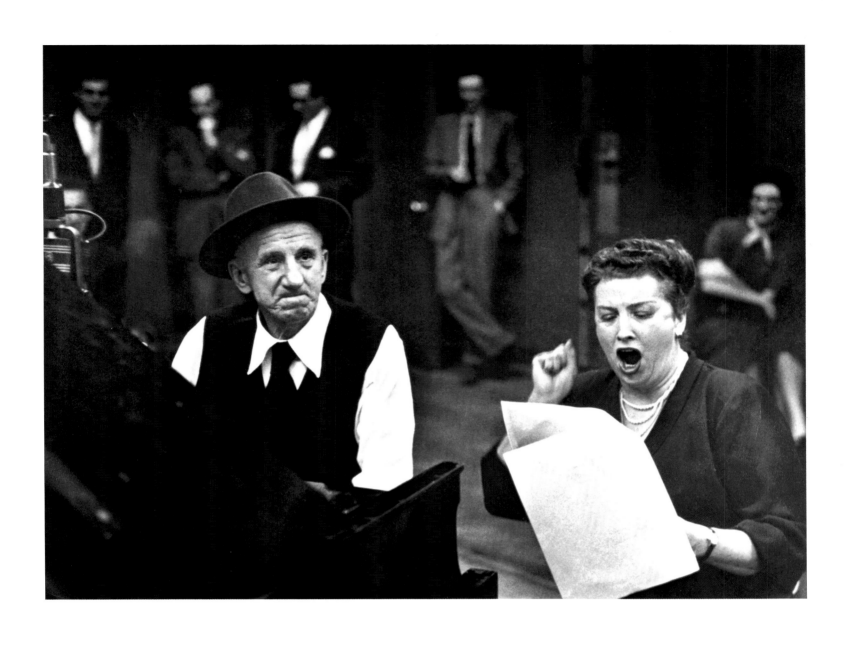

W. Eugene Smith 1947
Jimmy Durante and Helen Traubel join in
recording, "A Real Piano Player."
LIFE March 26, 1951

48

Paul Pietzsch 1947
Playwright Carson McCullers at age 30.

49

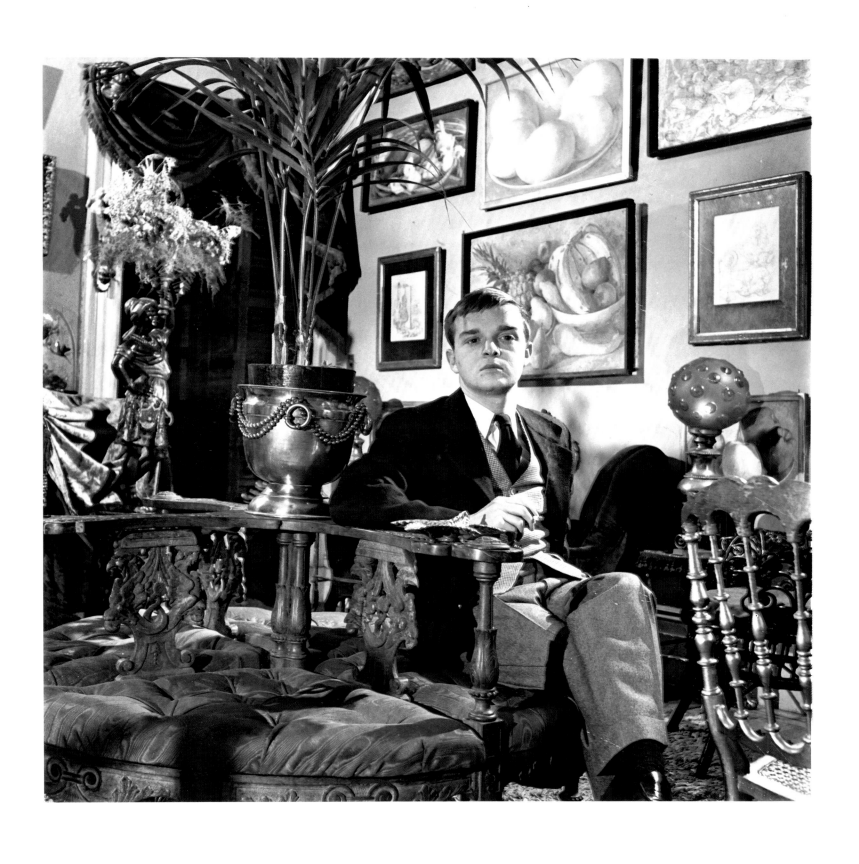

Jerry Cooke 1947
New Orleans-born Truman Capote at age 22.
LIFE June 2, 1947

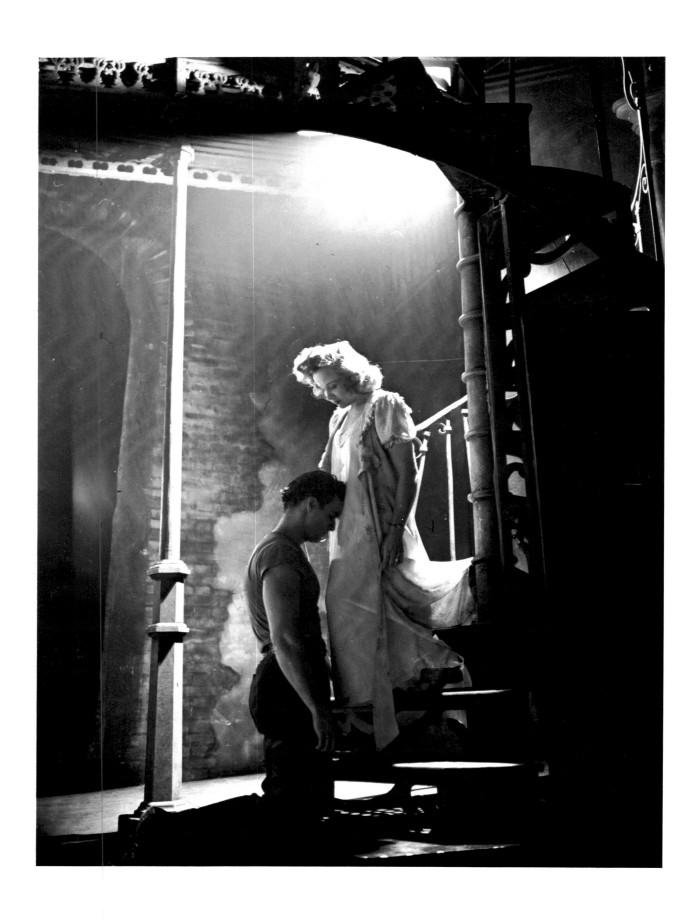

Eliot Elisofon 1947
Marlon Brando and Kim Hunter in Tennessee
Williams' *A Streetcar Named Desire*.
LIFE December 15, 1947

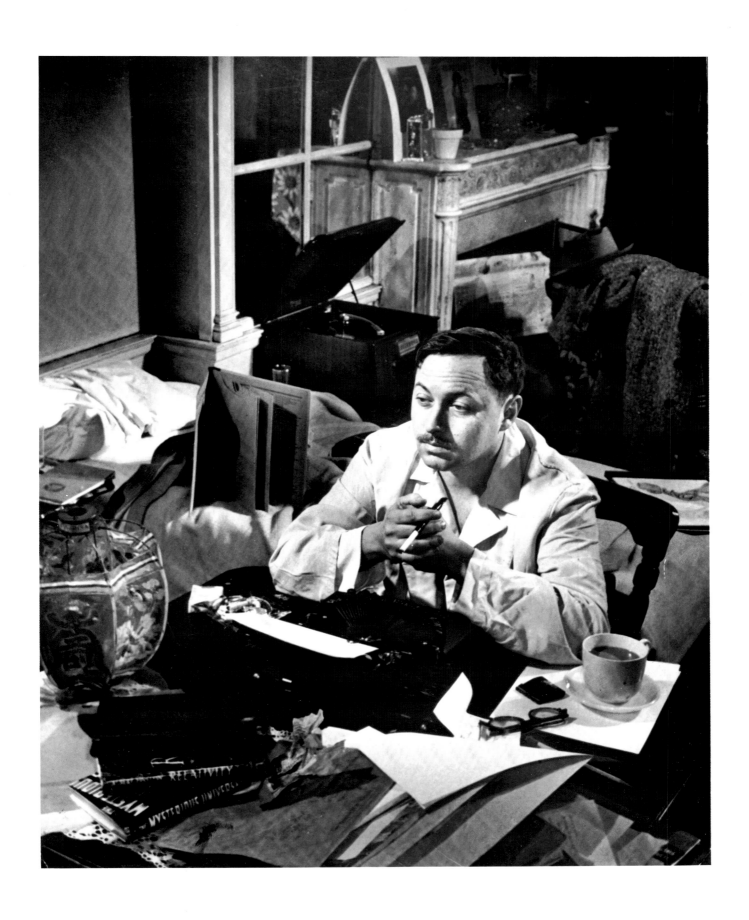

W. Eugene Smith 1948
Tennessee Williams at work on a new play,
New York City.
LIFE February 16, 1948

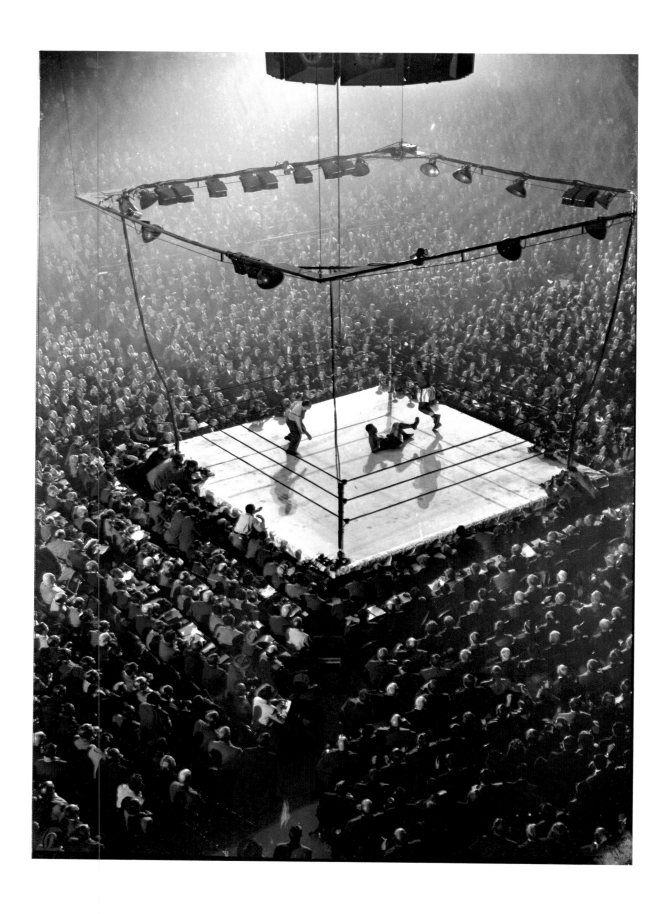

Gjon Mili 1947
Joe Walcott knocks Joe Louis to the canvas
in a championship match that Louis came
back to win.
LIFE December 15, 1947

53

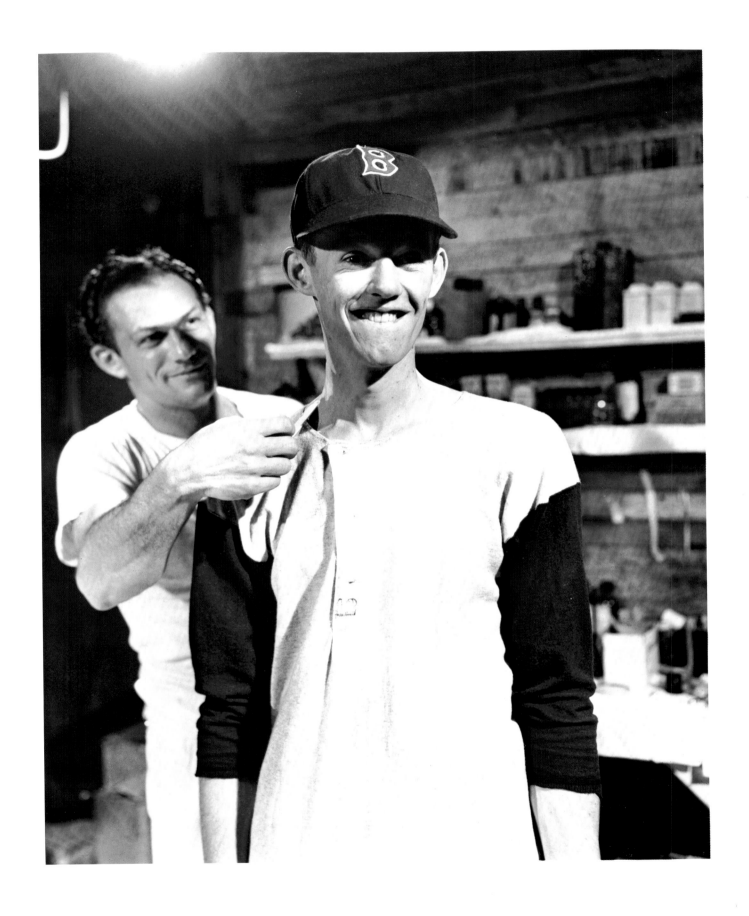

Joe Scherschel and Frank Scherschel 1948
A 19-year-old rookie, Morrie McDermott,
joins the Boston Red Sox.
LIFE March 22, 1948

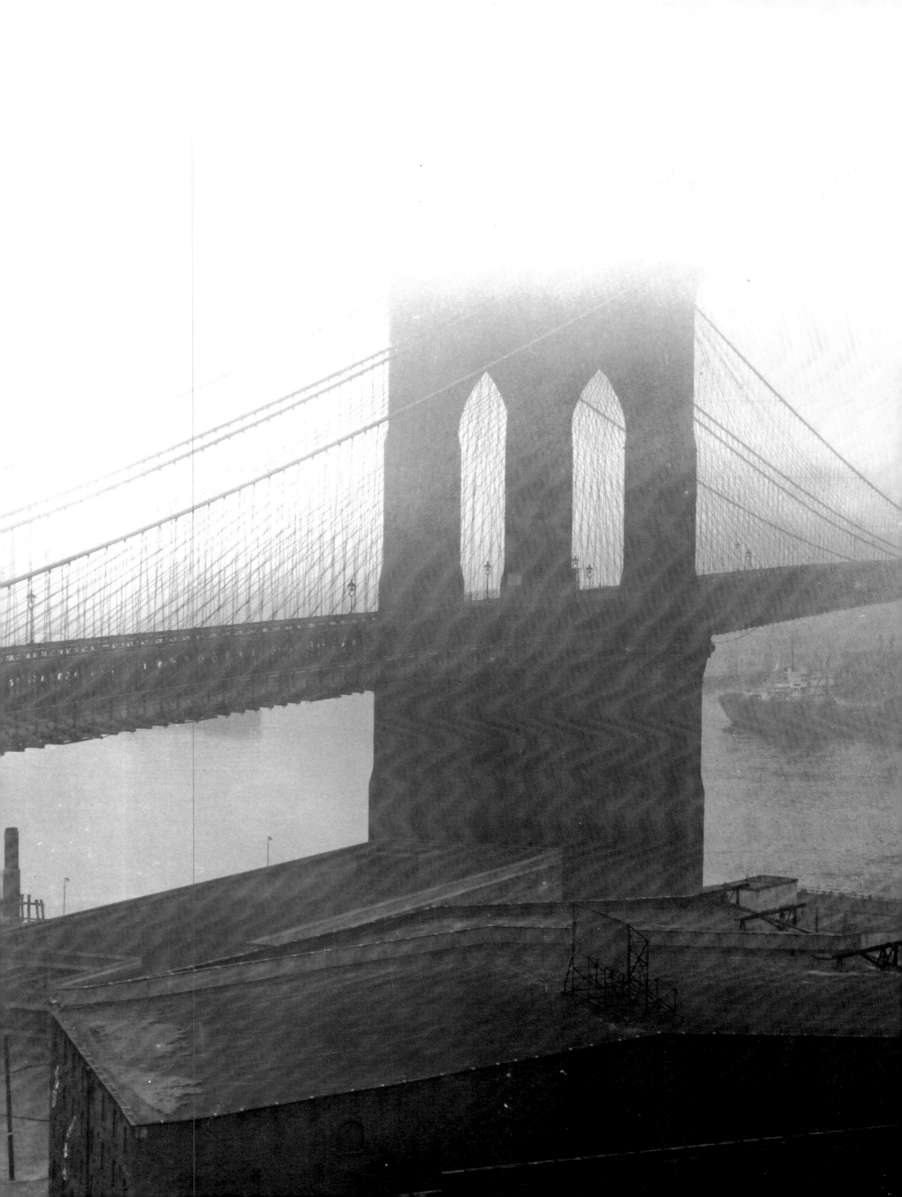

Andreas Feininger 1948
Brooklyn Bridge in fog.

55

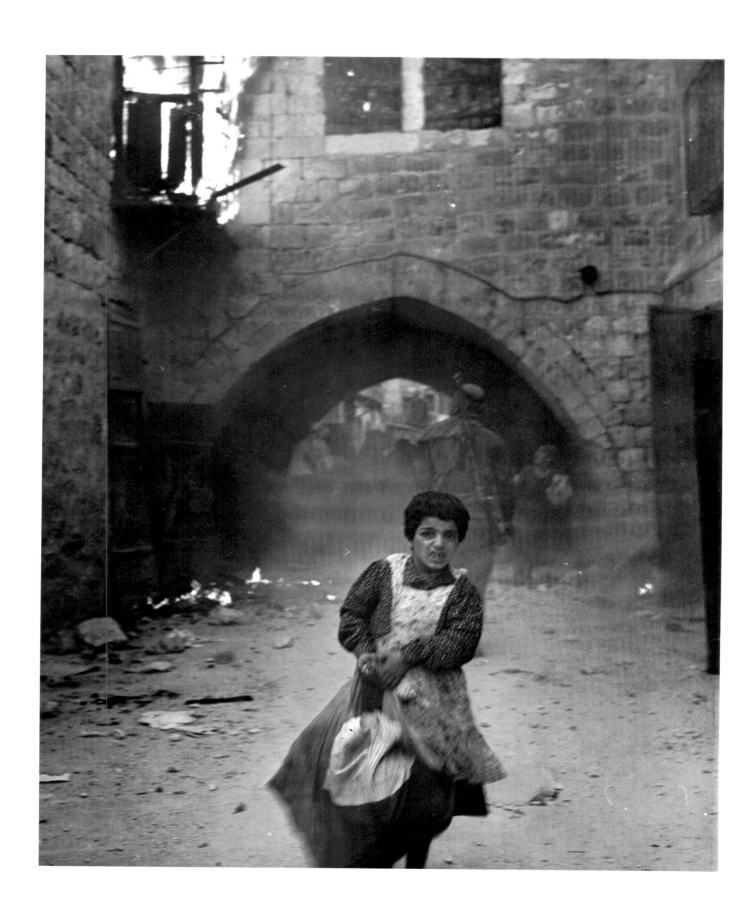

John Phillips 1948
Within hours of the establishment of Israel,
Jordan's Arab Legion engaged in house-to-house
fighting for possession of the Old City of
Jerusalem. In the confusion, a terrified child
flees down a burning street.
LIFE June 28, 1948

56

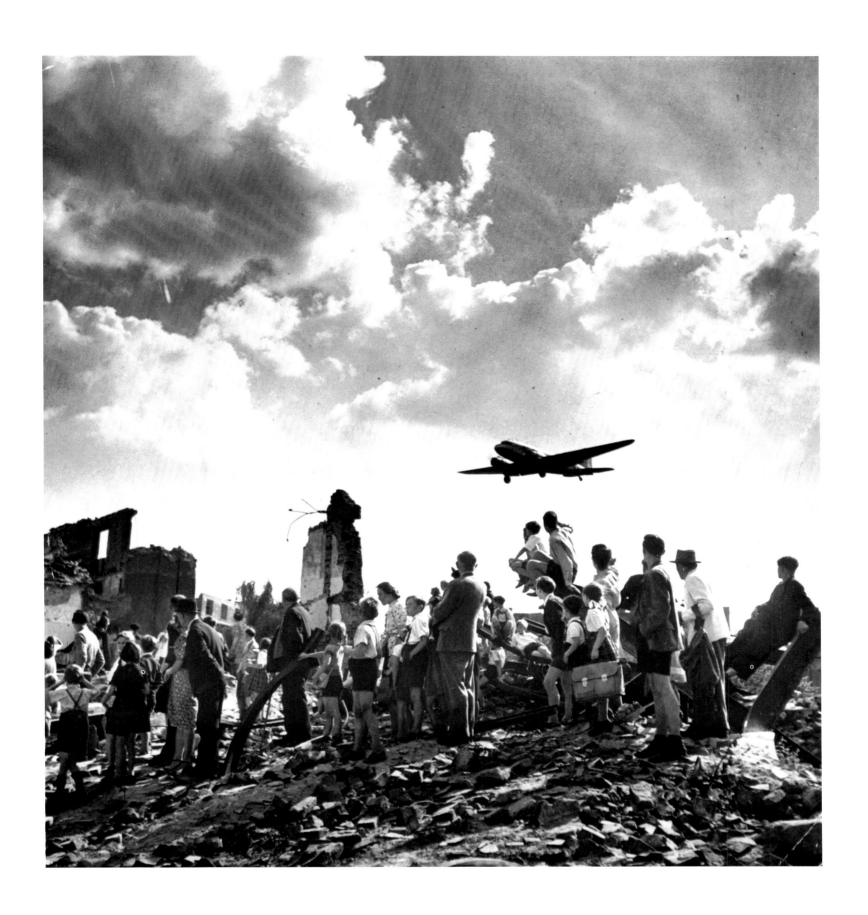

Walter Sanders 1948
During the Berlin airlift, residents of that
blockaded city watch from ruins at edge of
Tempelhof Airfield as a C-47 brings them food.
LIFE July 19, 1948

57

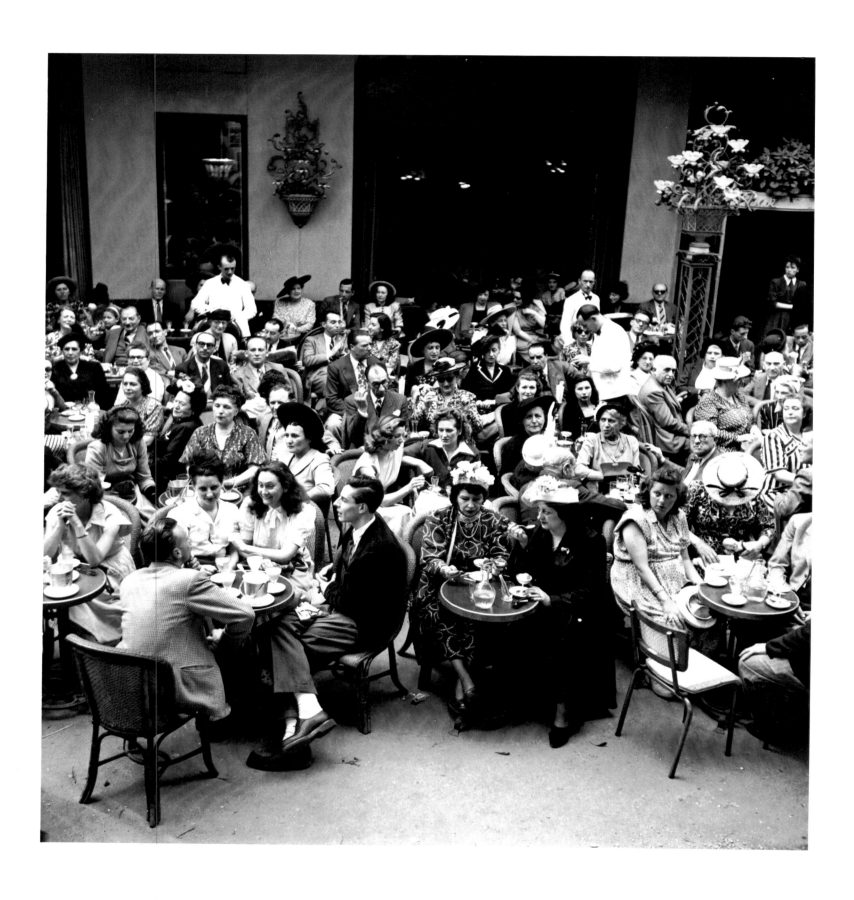

Yale Joel 1948
Patrons of a sidewalk café at corner of Rond
Point des Champs Elysées and Avenue Matignon
as café life begins to return to Paris.

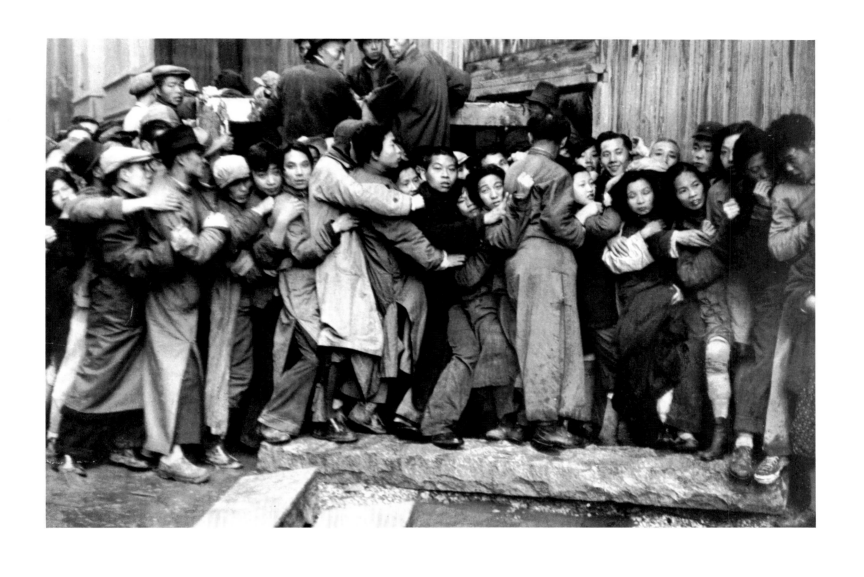

Henri Cartier-Bresson 1948
Shanghai citizens struggle to enter a government
bank to exchange their paper money for gold
before the arrival of the approaching Red
Chinese Army.
LIFE January 17, 1949

59

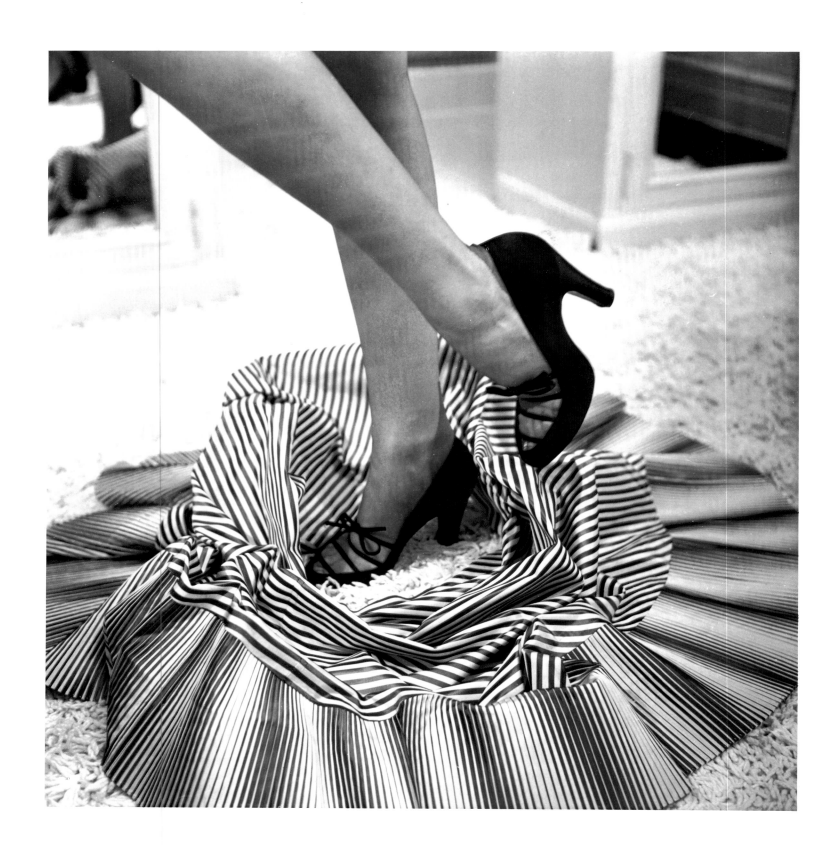

Nina Leen 1948
From a fashion essay on shoes and stockings.
LIFE April 26, 1948

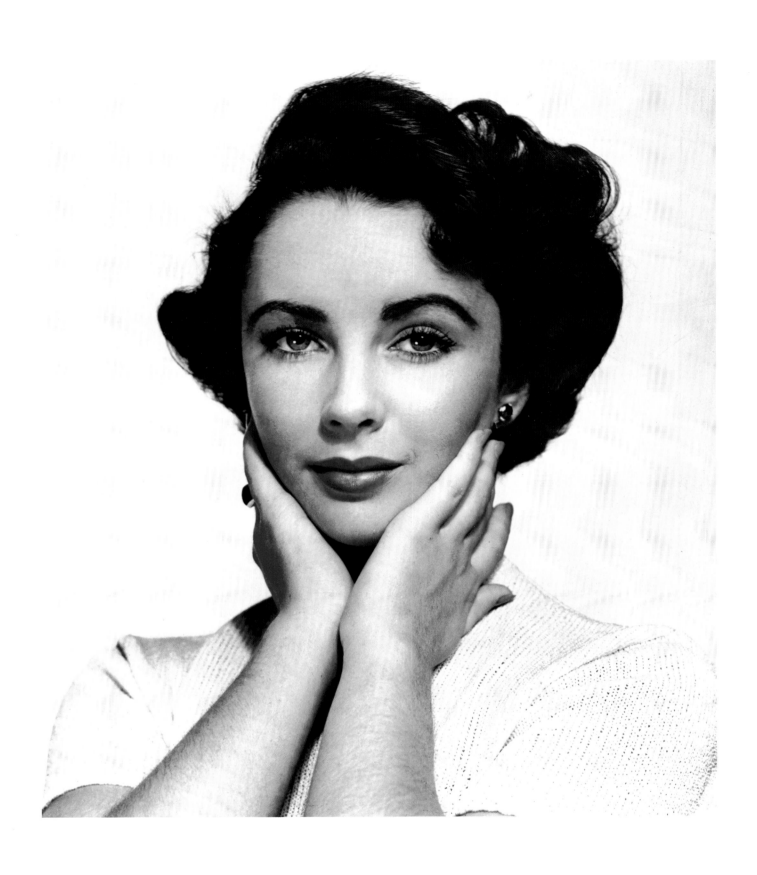

Philippe Halsman 1948
Elizabeth Taylor at age 16.

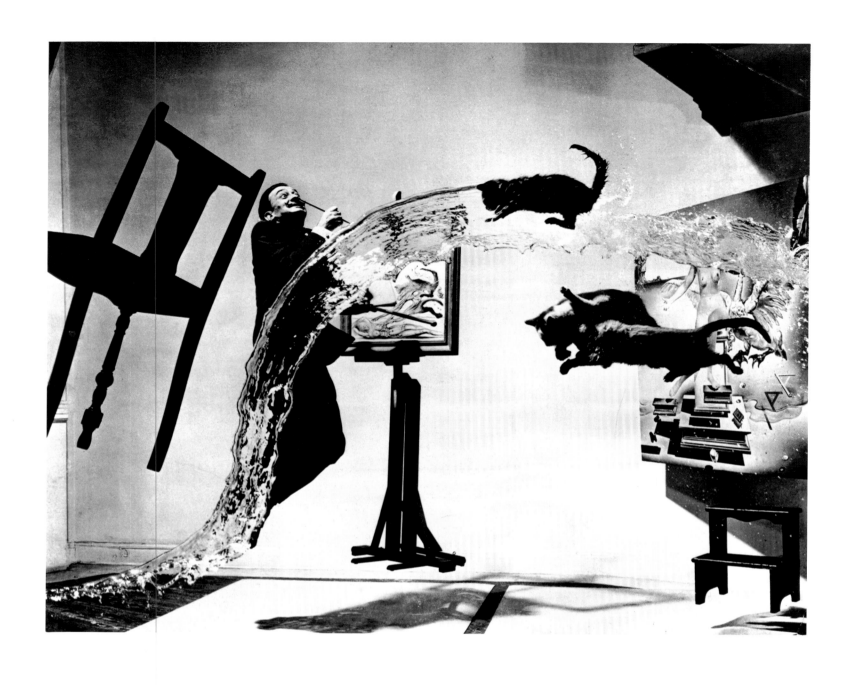

Philippe Halsman 1948
Salvador Dali joins with cats, water and other
objects in flying through the air to create a
photograph that suggests his own surrealistic
paintings.
LIFE August 9, 1948

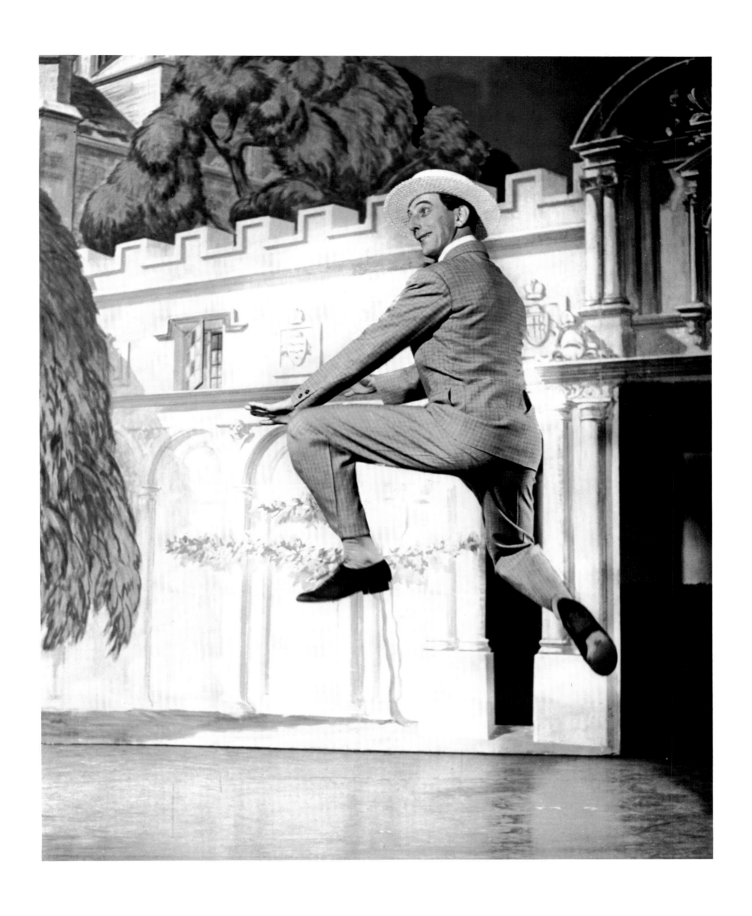

Philippe Halsman 1948
Ray Bolger singing and dancing "Once in Love
with Amy" in *Where's Charley?*

W. Eugene Smith 1948
Dr. Ernest Ceriani of Kremmling,
Colorado, walks through his patient's
dooryard. This photograph, and the
four following photographs, are from
the essay, "Country Doctor."
LIFE September 20, 1948

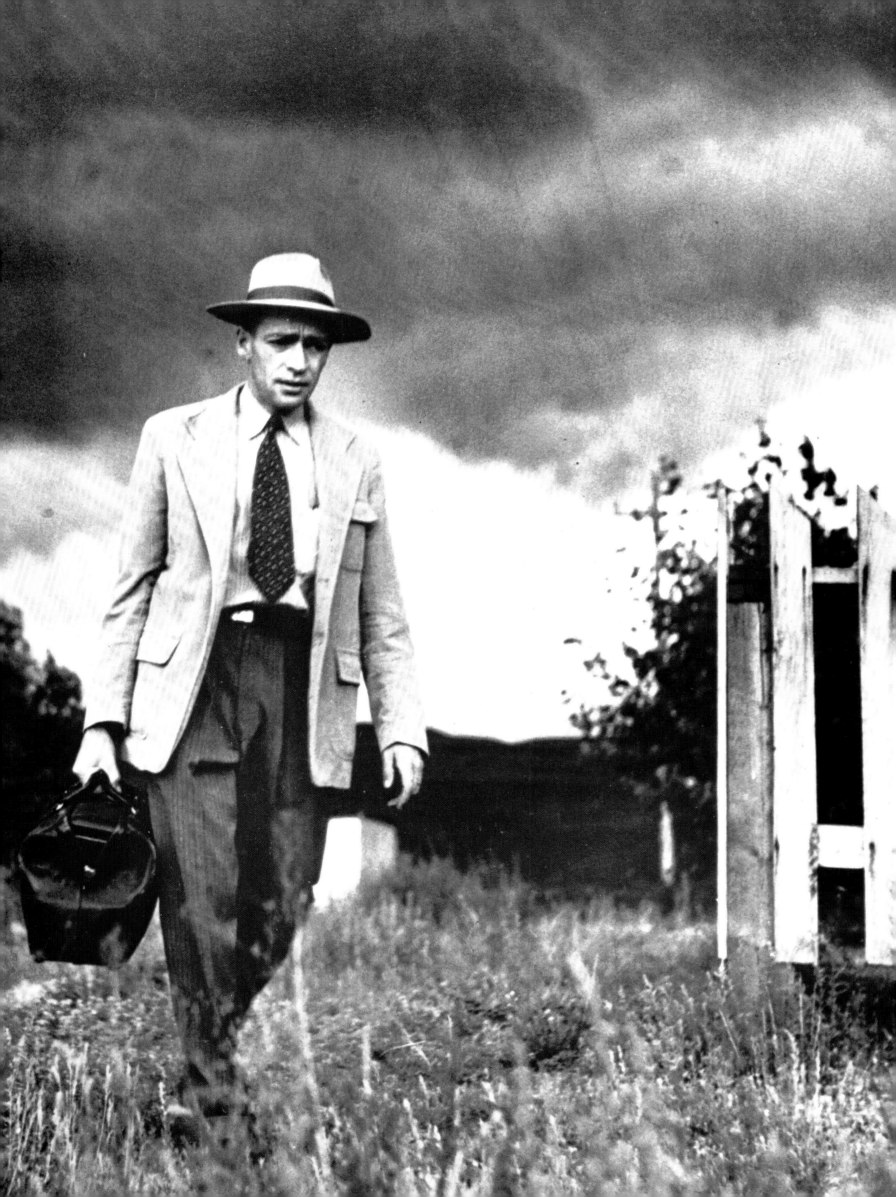

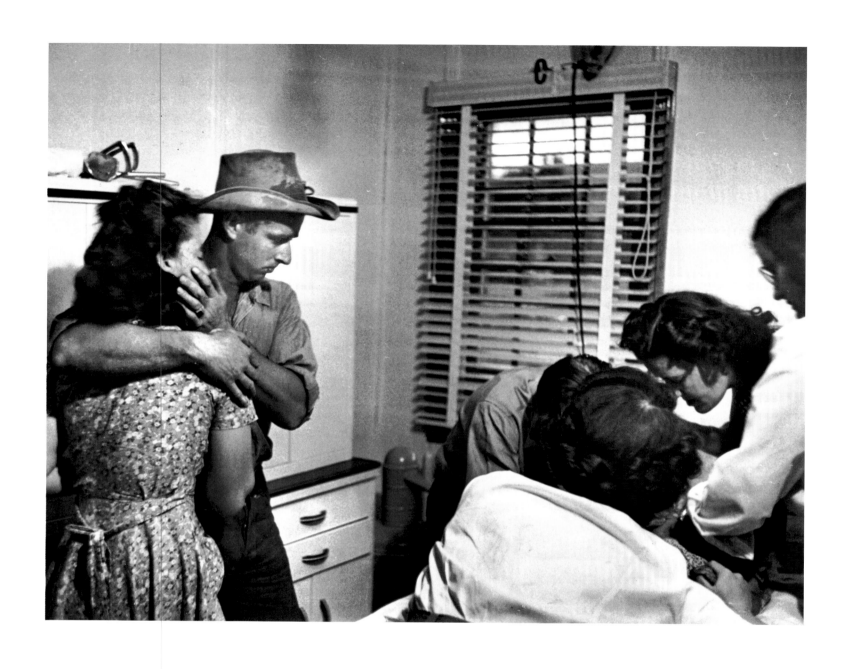

W. Eugene Smith 1948
Dr. Ceriani and nurses examine small girl who
was kicked in the head by a horse, as her parents
watch in anguish.
LIFE September 20, 1948

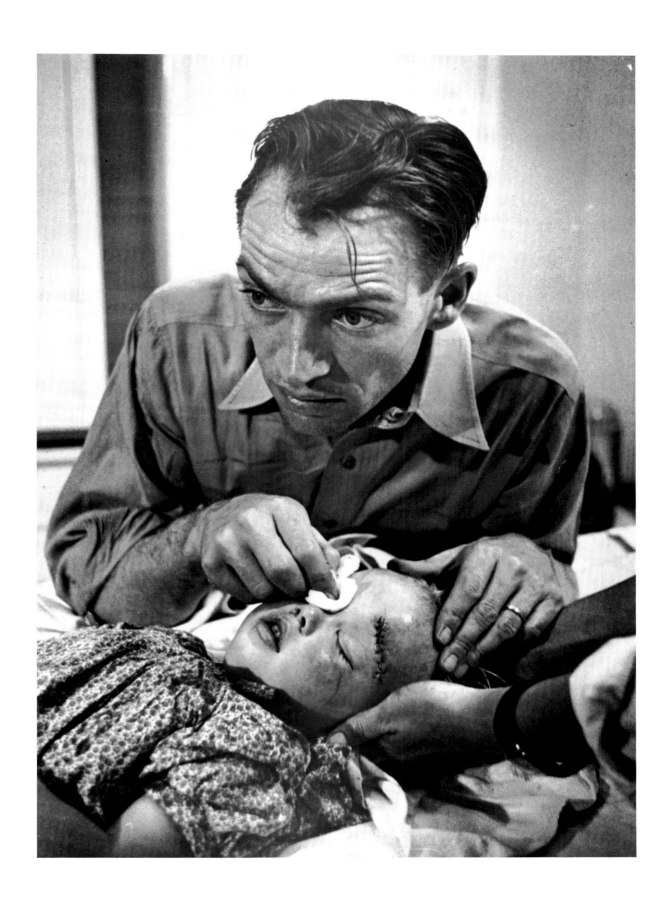

W. Eugene Smith 1948
Dr. Ceriani realizes the child's eye cannot be
saved.
LIFE September 20, 1948

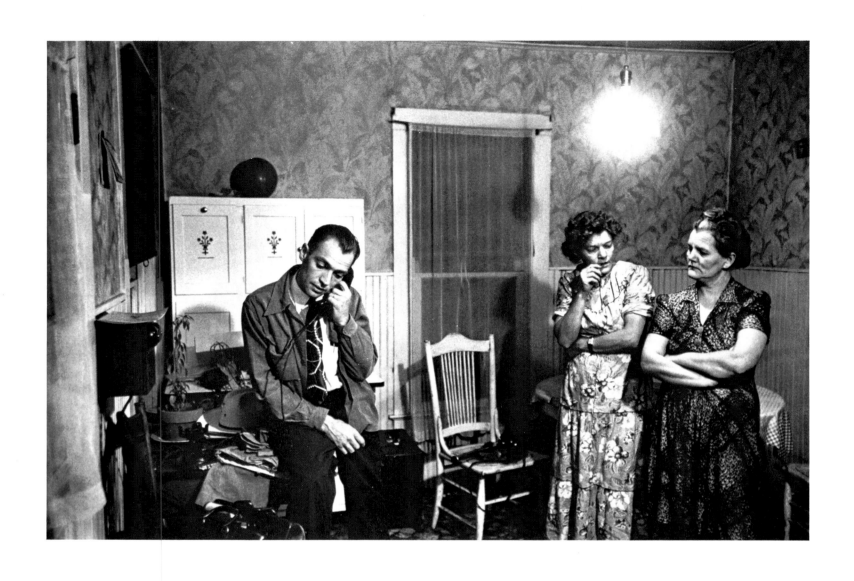

W. Eugene Smith 1948
Dr. Ceriani telephones the priest to tell him that
his patient will not live through the night.
LIFE September 20, 1948

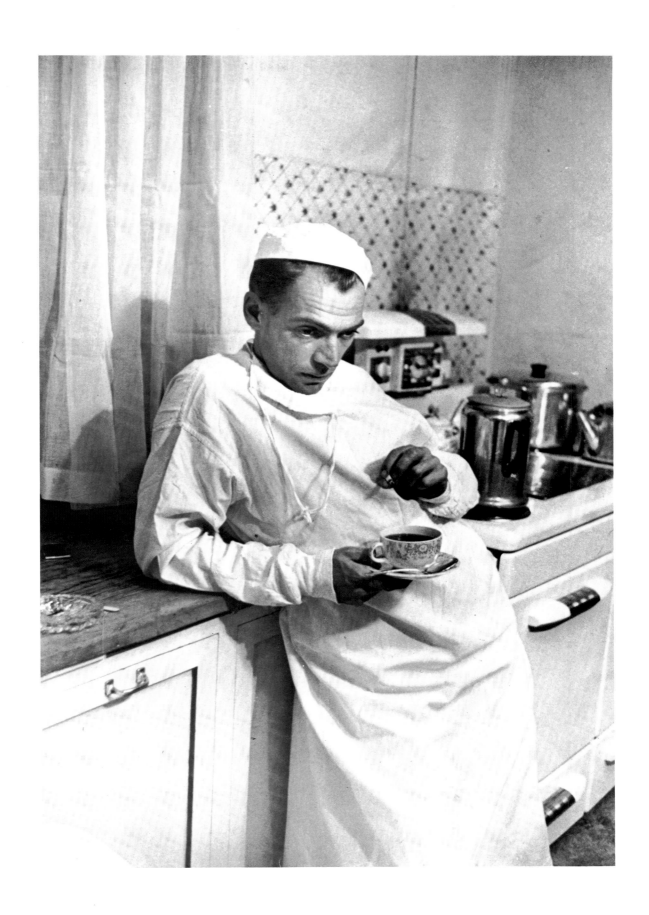

W. Eugene Smith 1948
Coffee in the hospital kitchen at 2:00 A.M. ends
one work day for Dr. Ceriani, with a new one to
begin in a few hours.
LIFE September 20, 1948

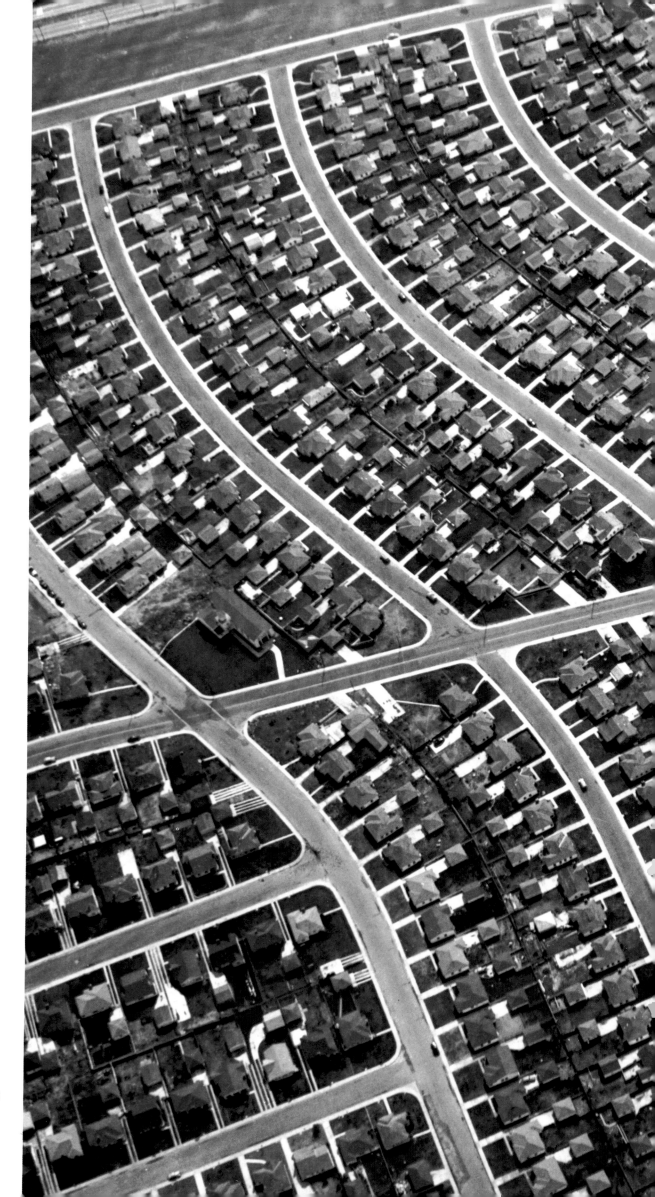

Loomis Dean 1949
Suburban housing,
California.
LIFE July 11, 1949

69

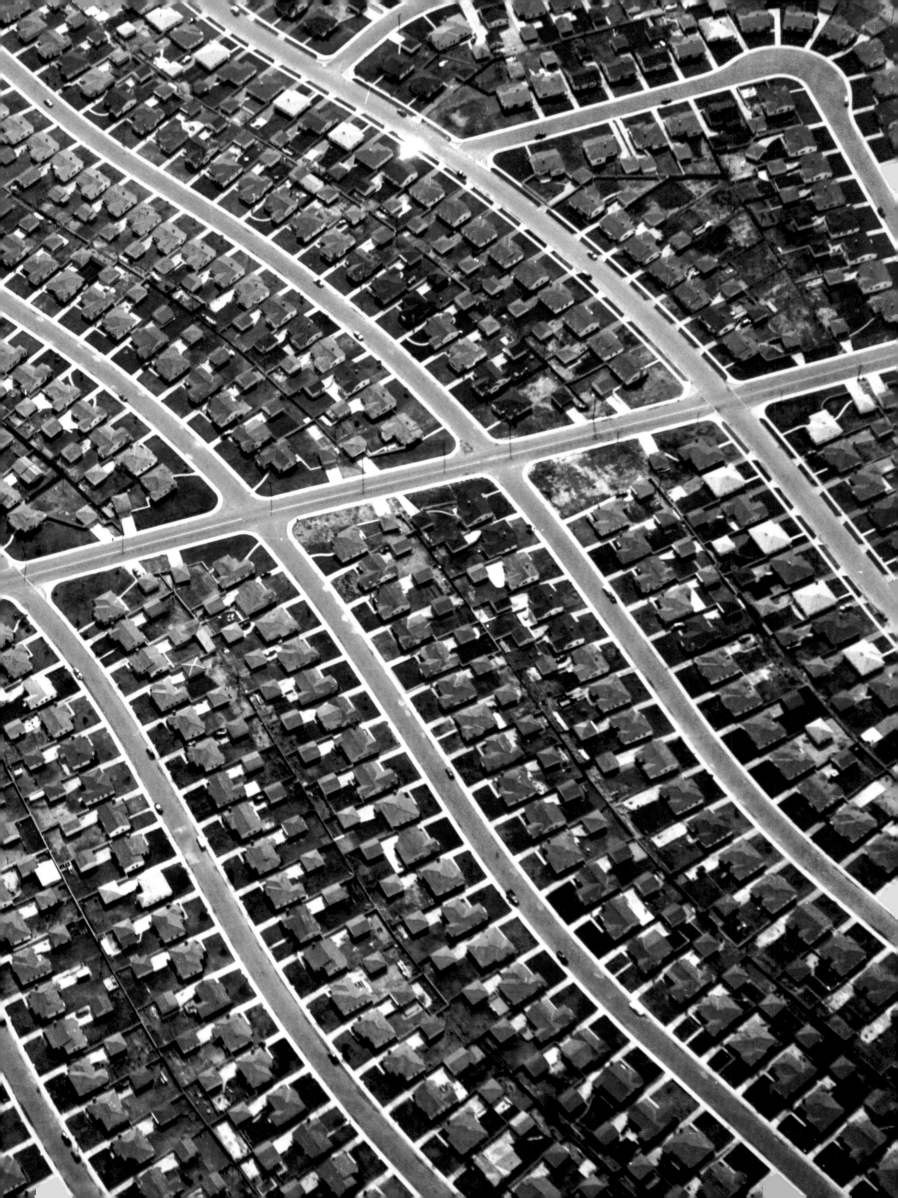

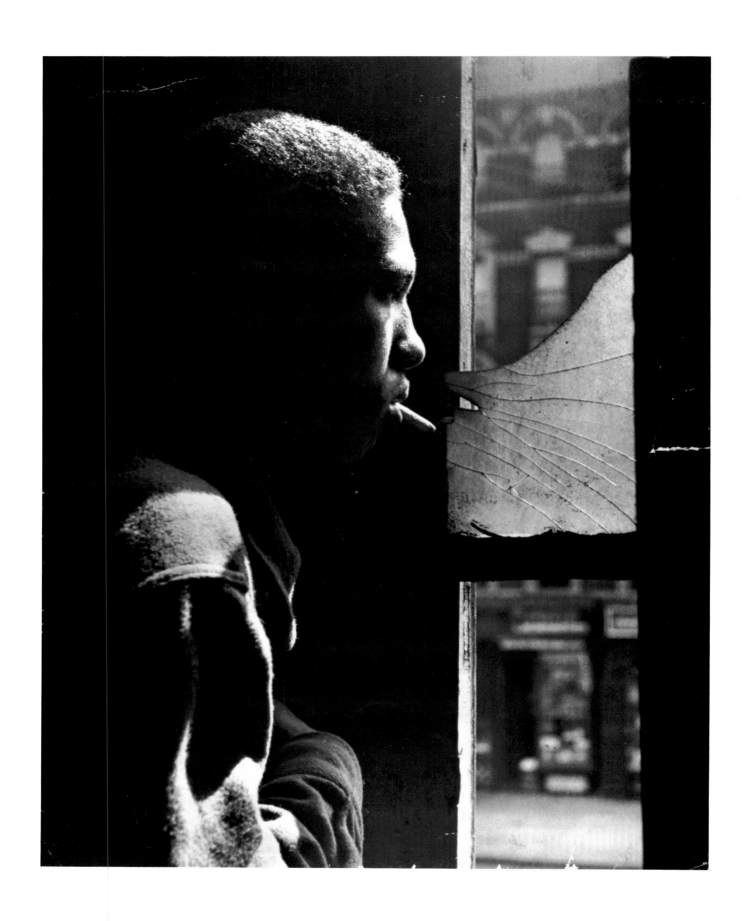

Gordon Parks 1948
Harlem gang leader hides from a rival street
gang in an abandoned building.
LIFE November 1, 1948

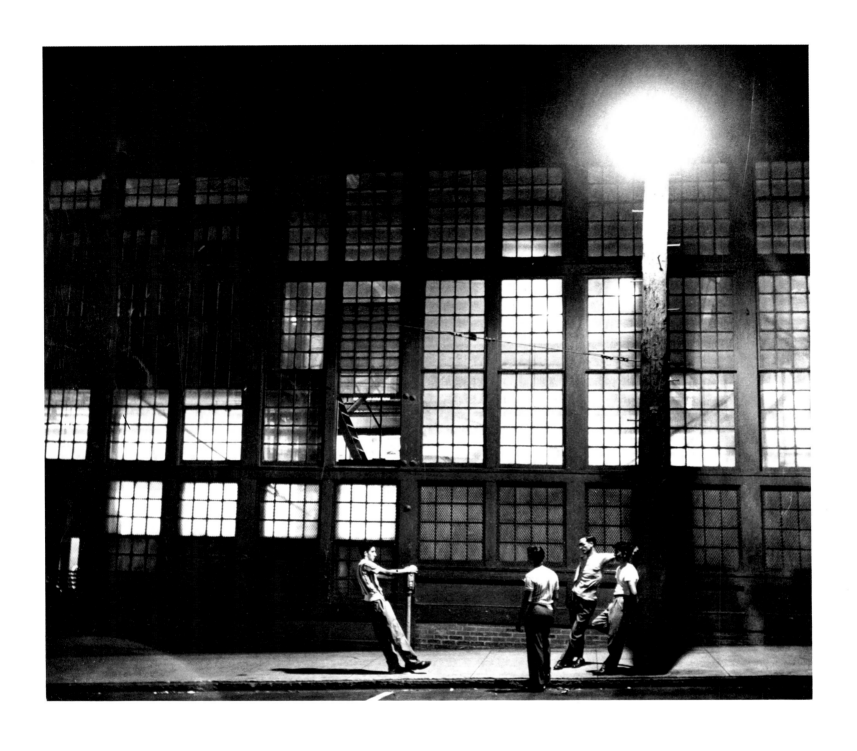

Gordon Parks 1949
Teenagers while away a summer night, Ansonia,
Connecticut.

71

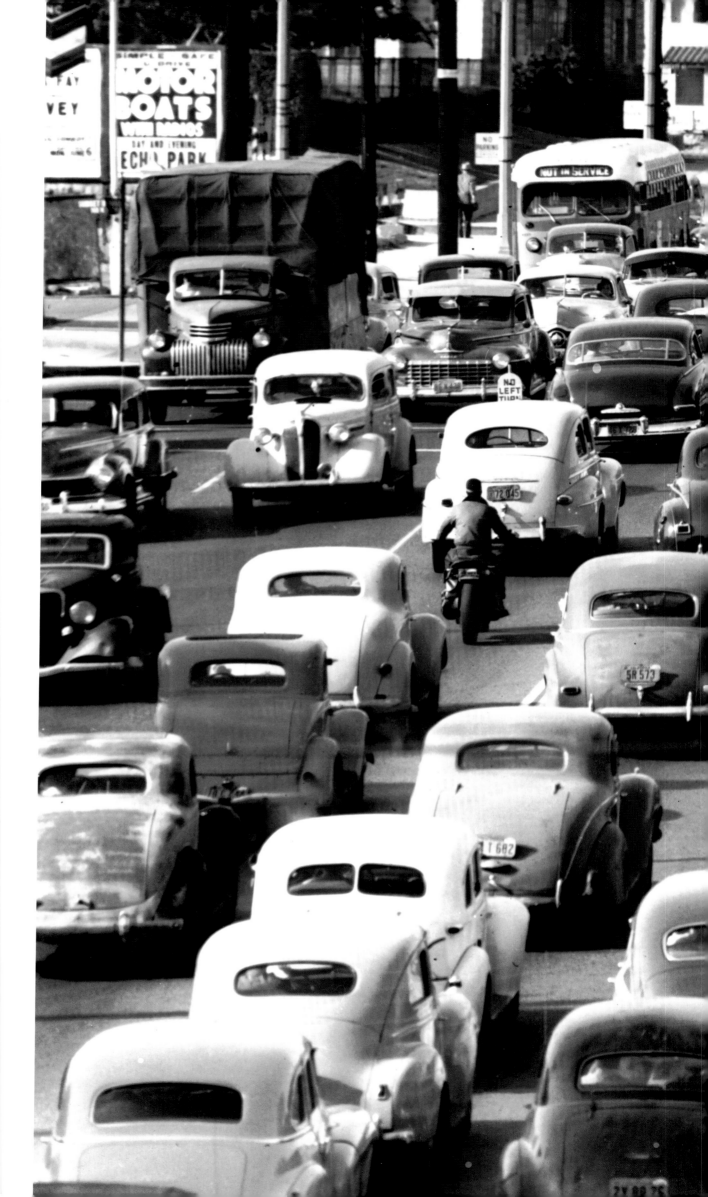

Loomis Dean 1949
Los Angeles traffic,
looking south on
Olive Street.

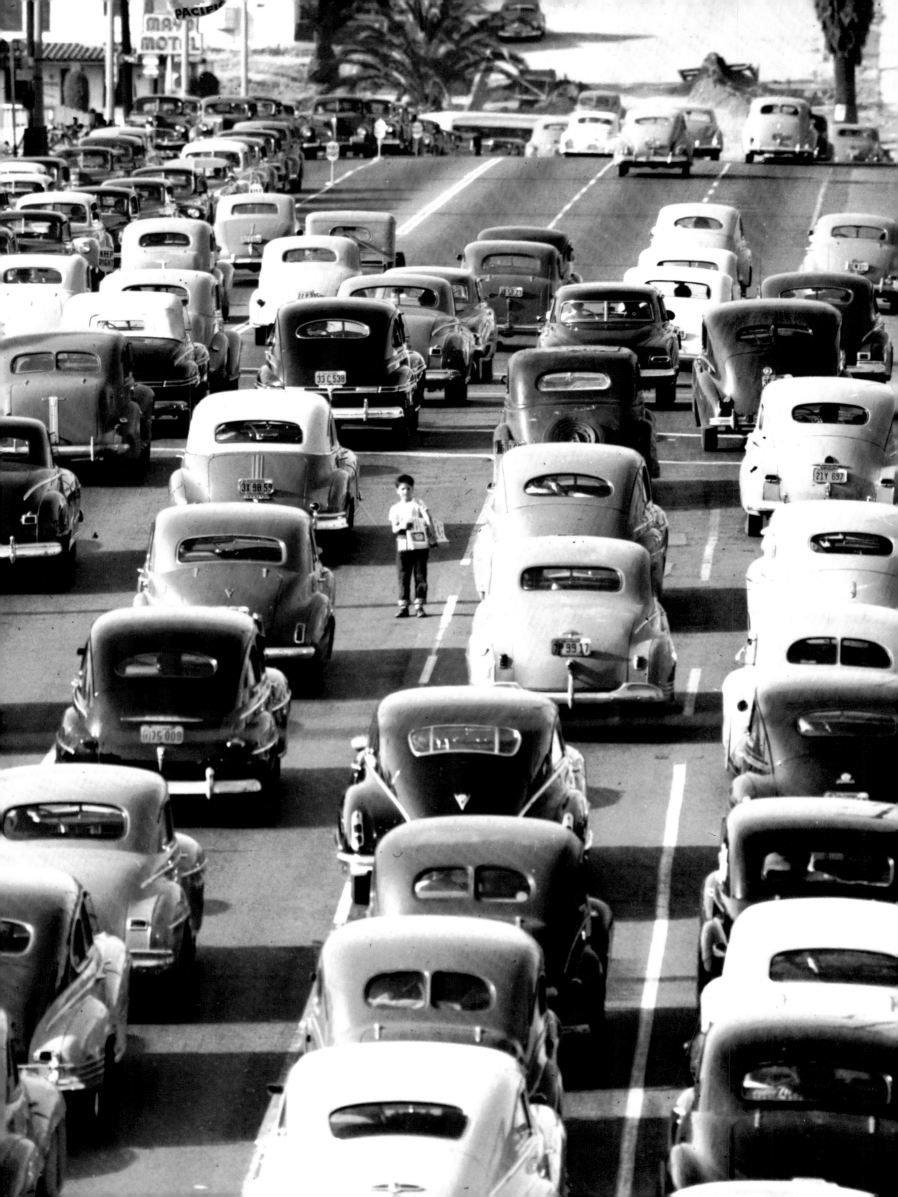

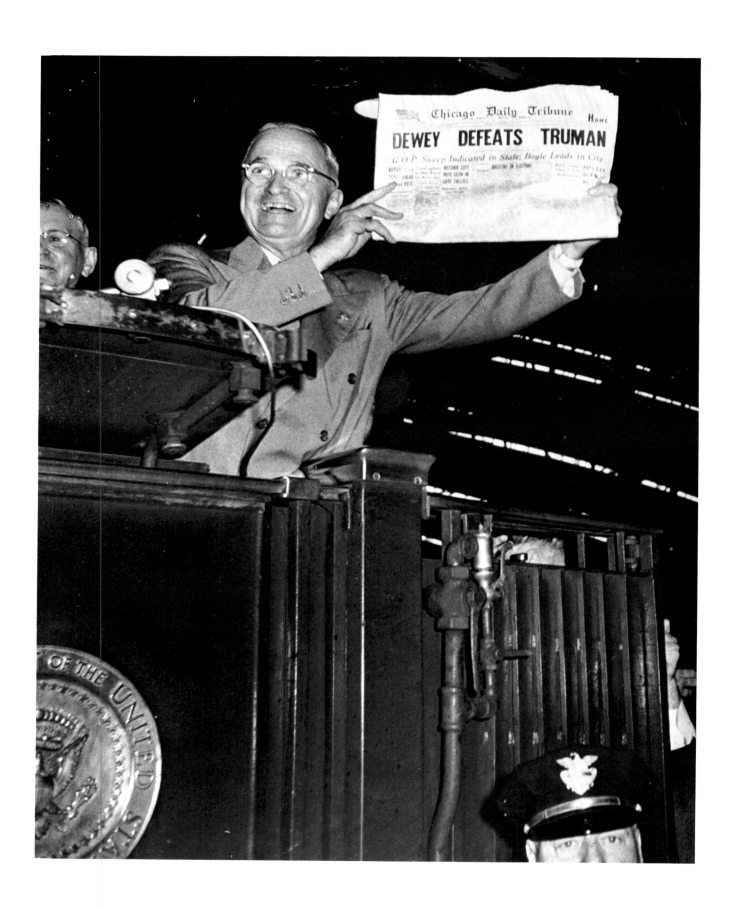

W. Eugene Smith 1948
President Harry S. Truman gleefully displays a
copy of the *Chicago Daily Tribune* that, in its
early editions, carried a highly inaccurate
headline.
LIFE November 15, 1948

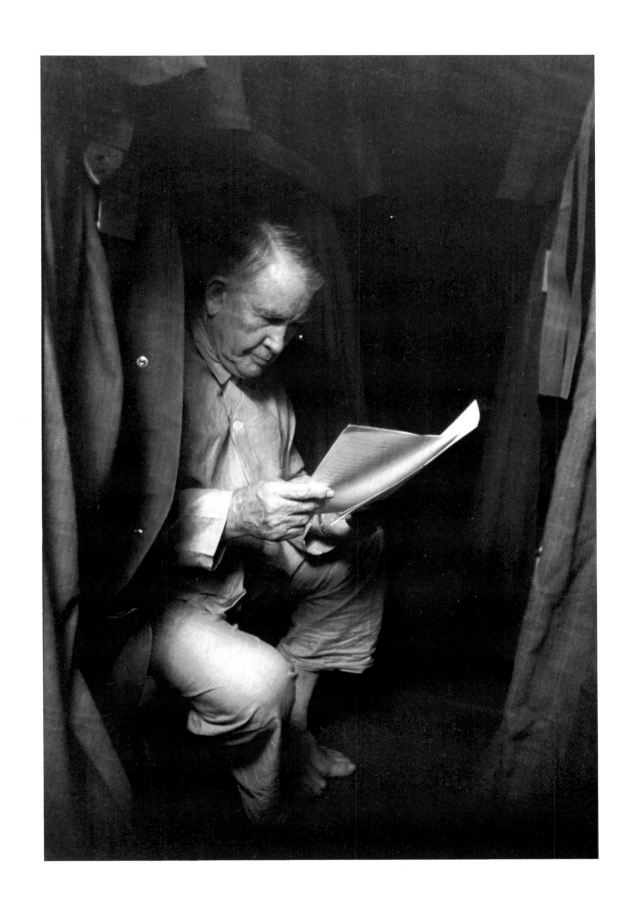

Lisa Larsen 1950
Vice President Alben Barkley studies his speech
in lower berth of his train while on a whistle-stop
campaign to support candidates of the
Democratic party.
LIFE October 23, 1950

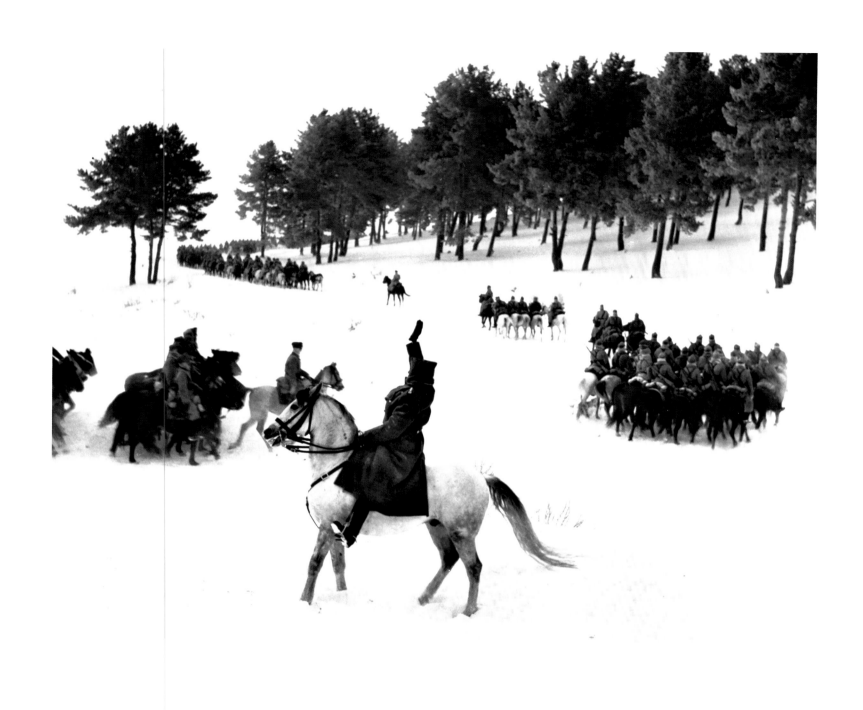

David Douglas Duncan 1949
Turkish cavalry performing winter maneuvers
on Russo-Turkish frontier.
LIFE January 31, 1949

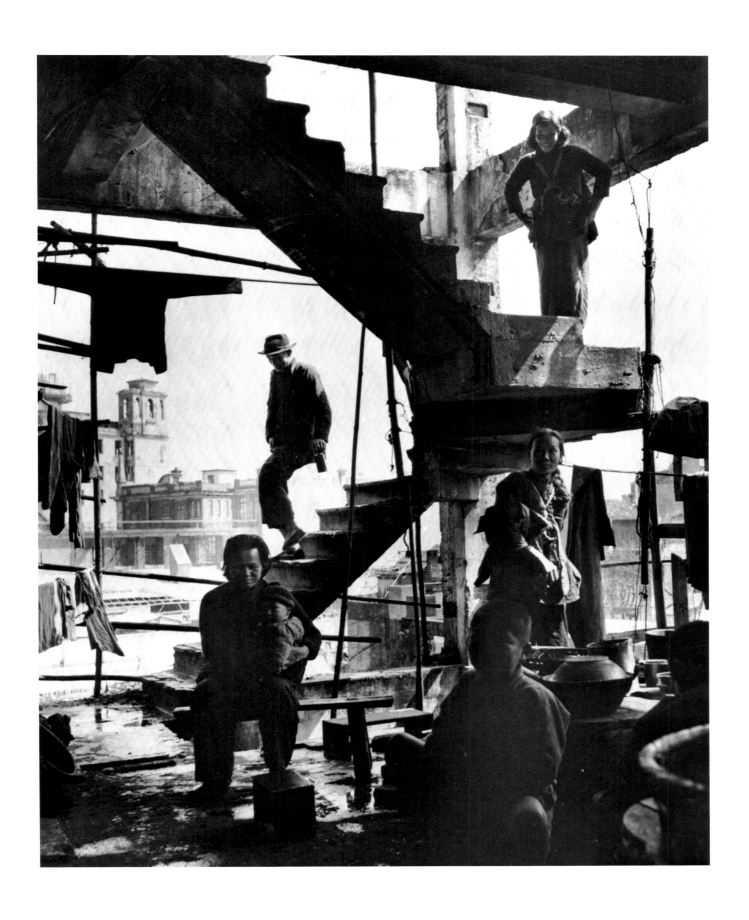

Carl Mydans 1949
Chinese Civil War refugees in building gutted
during the Sino-Japanese War.

76

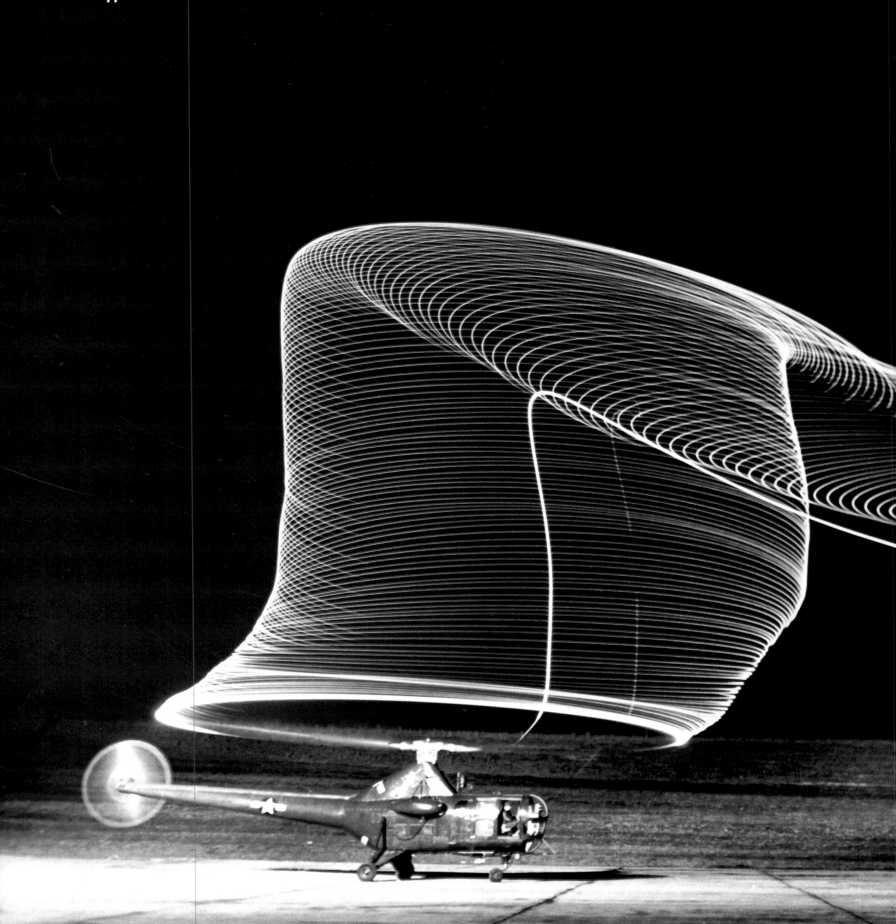

Andreas Feininger 1949
Pattern made at night by a helicopter with
lights on the tips of its rotor blades. With its
shutter open, the camera recorded the blades as
the helicopter rose, slipped forward, then rose
again. The heavy white line is a running light.
White spot near top is the moon.
LIFE February 28, 1949

77

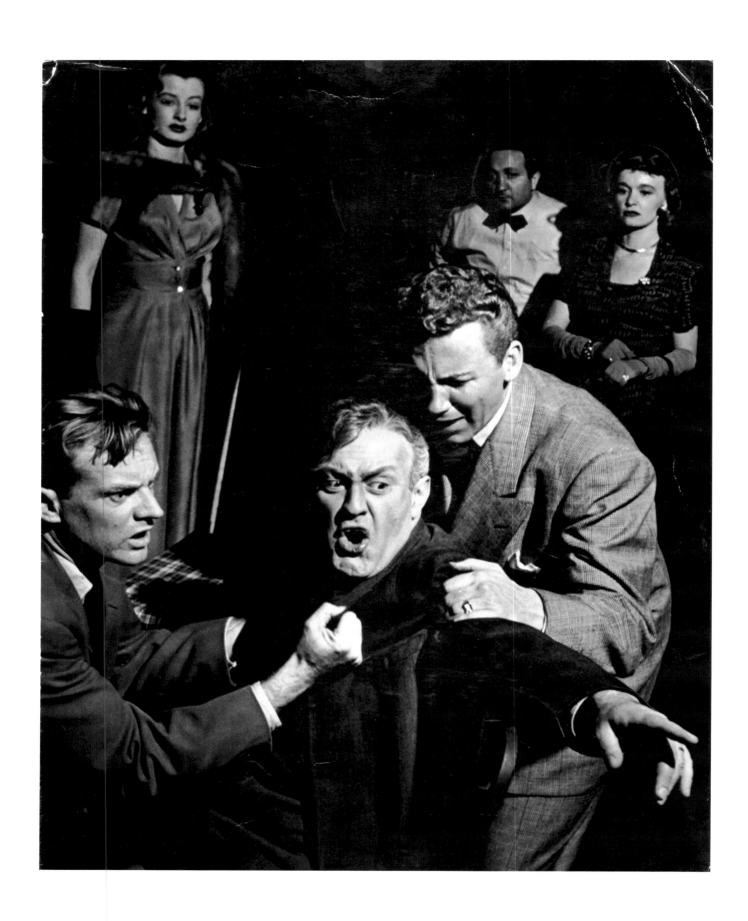

W. Eugene Smith 1949
A violent Willy Loman (Lee J. Cobb) is
restrained by his sons, Biff (Arthur Kennedy)
and Hap (Cameron Mitchell) in Arthur Miller's
Death of a Salesman.
LIFE February 21, 1949

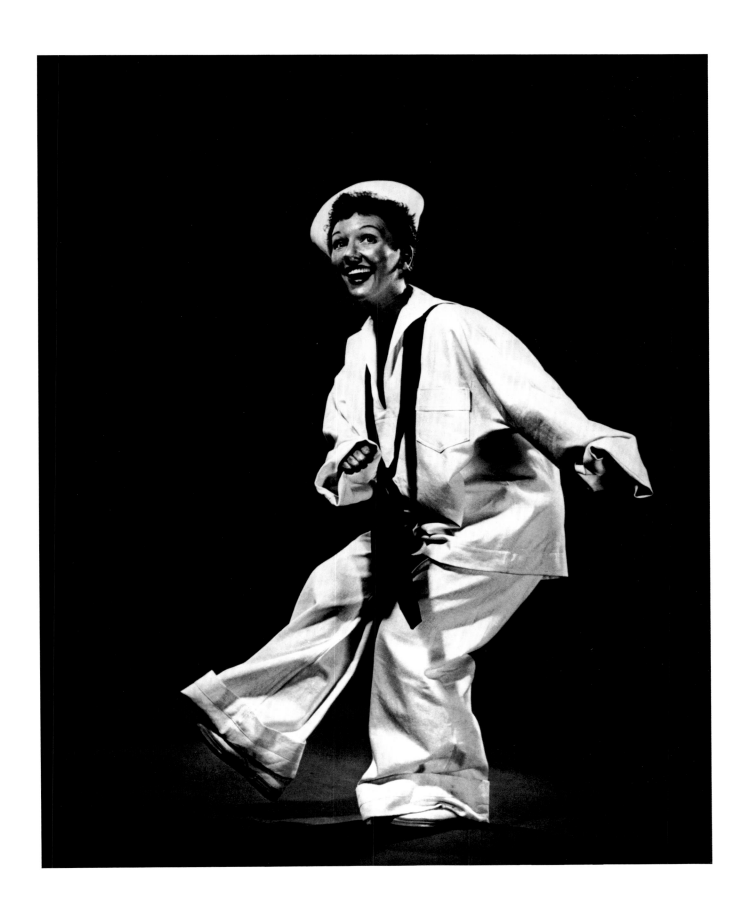

Philippe Halsman 1949
Mary Martin in *South Pacific*, singing
"Honey Bun."
LIFE April 18, 1949 Cover

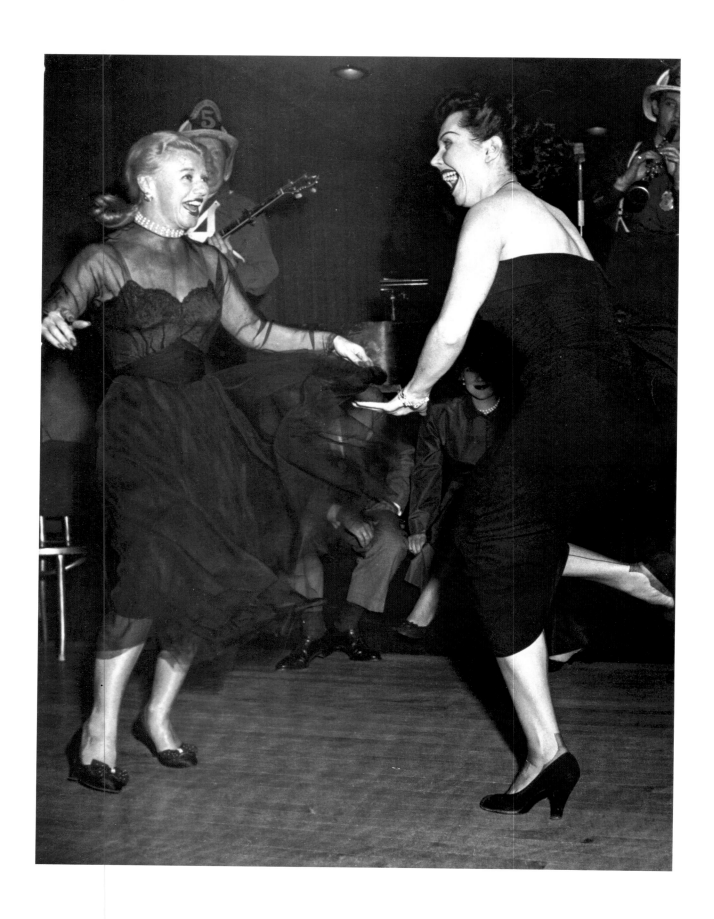

Ralph Crane 1950
Ginger Rogers and Ann Miller do the Charleston
in a Hollywood nightclub.
LIFE April 3, 1950

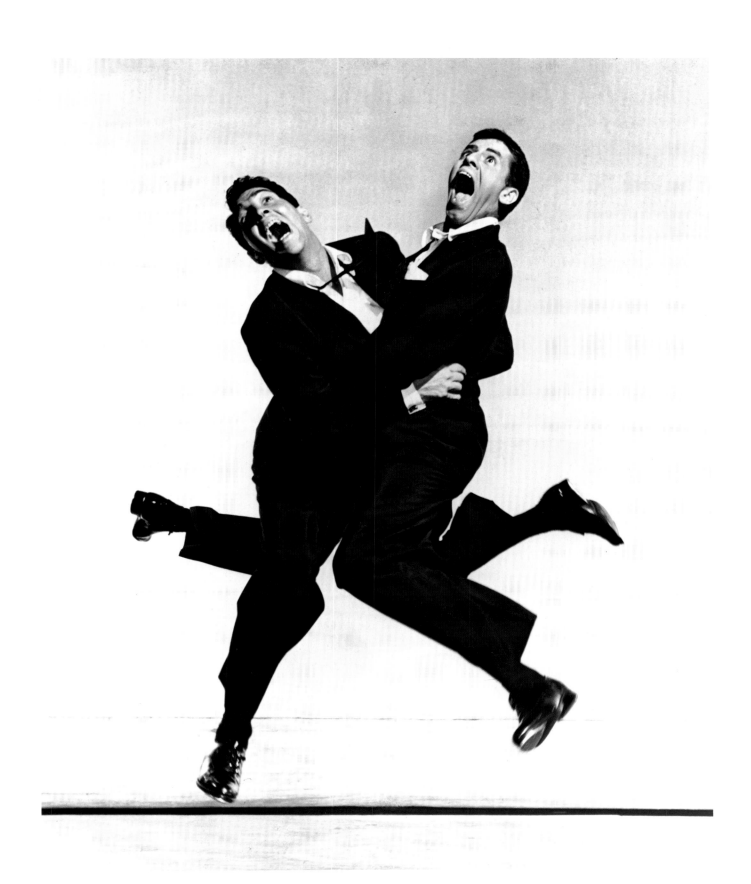

Philippe Halsman 1951
Dean Martin and Jerry Lewis on tour.

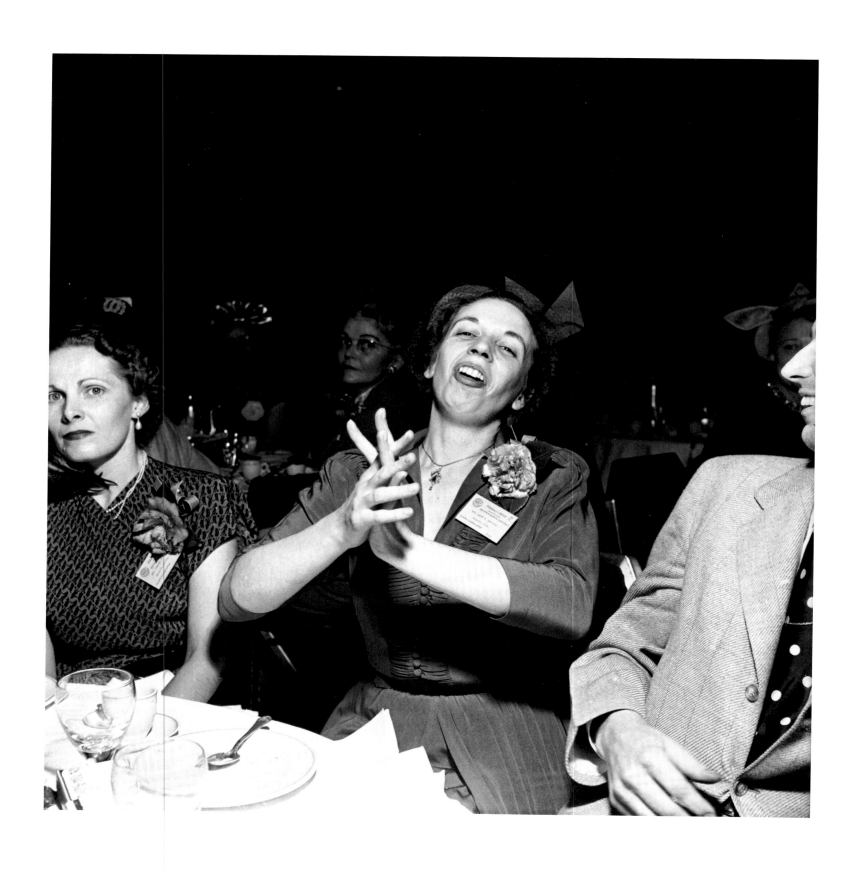

Martha Holmes 1949
Winner of the annual Pillsbury Bake-Off contest
expresses joy at prize of $50,000.
LIFE December 26, 1949

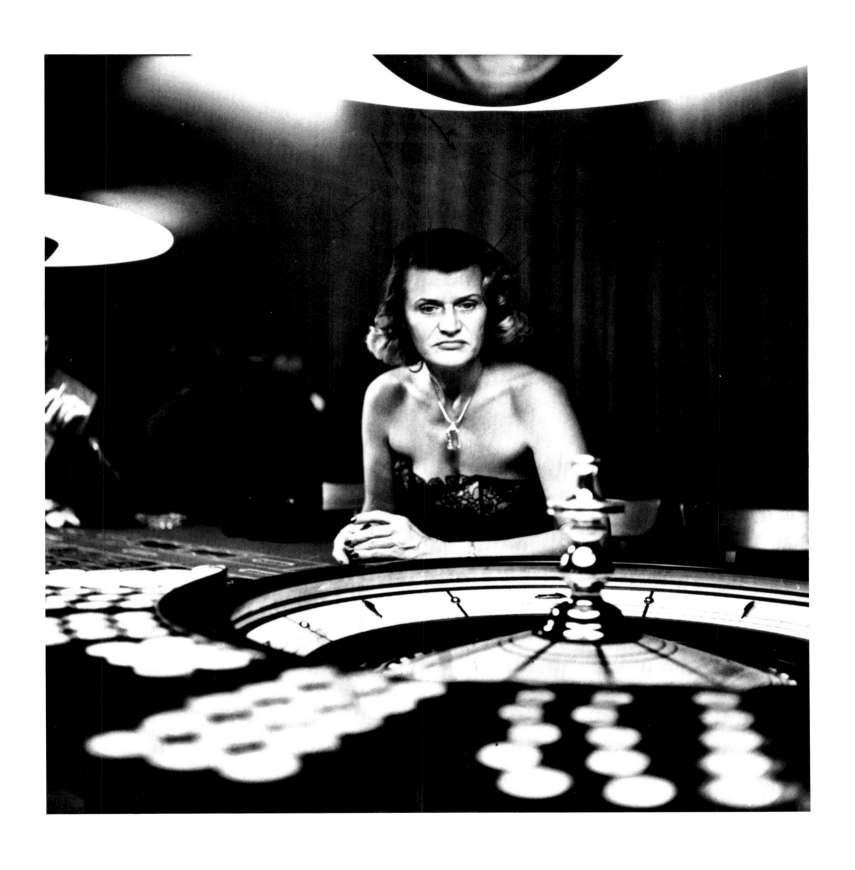

Gordon Parks 1949
Woman at roulette table in the gambling salon
of the Caribe Hilton in Puerto Rico.
LIFE March 16, 1953

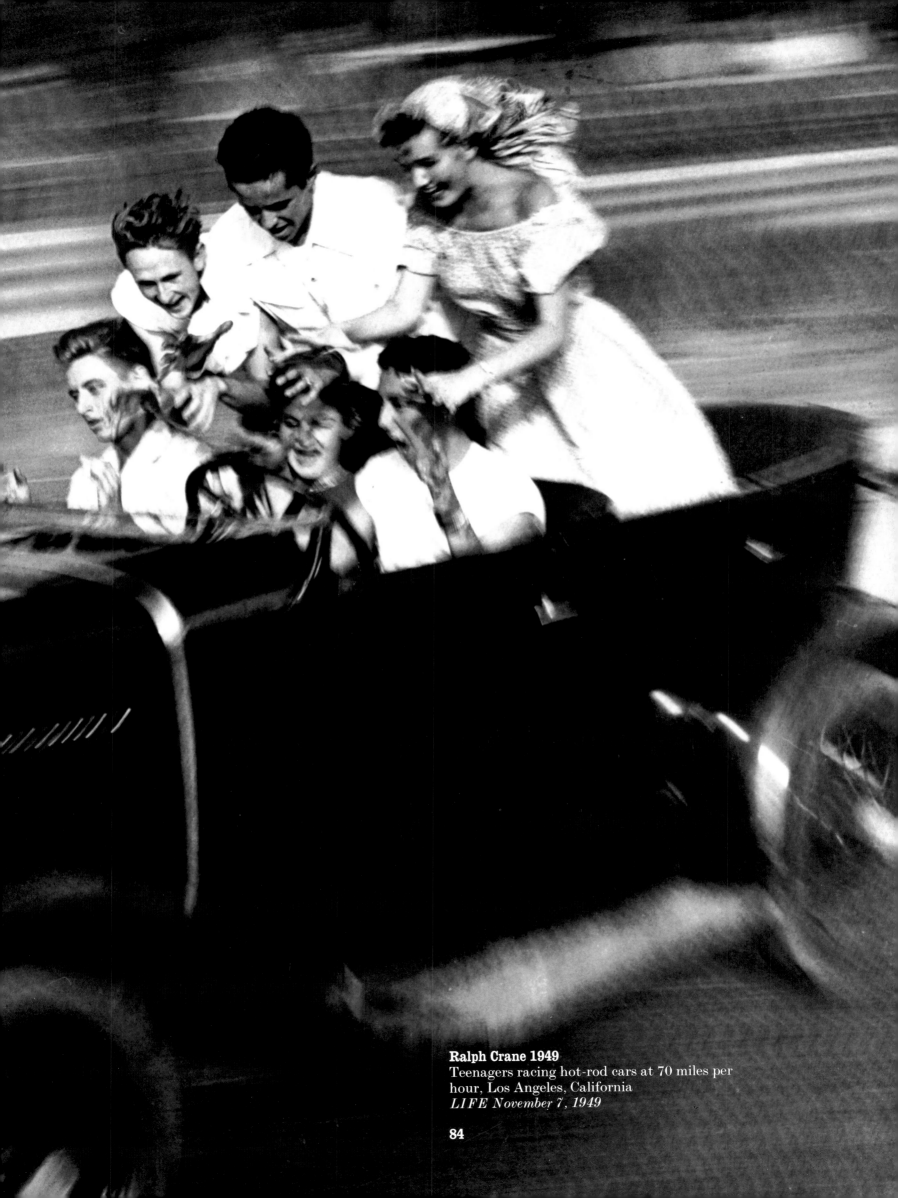

Ralph Crane 1949
Teenagers racing hot-rod cars at 70 miles per
hour, Los Angeles, California
LIFE November 7, 1949

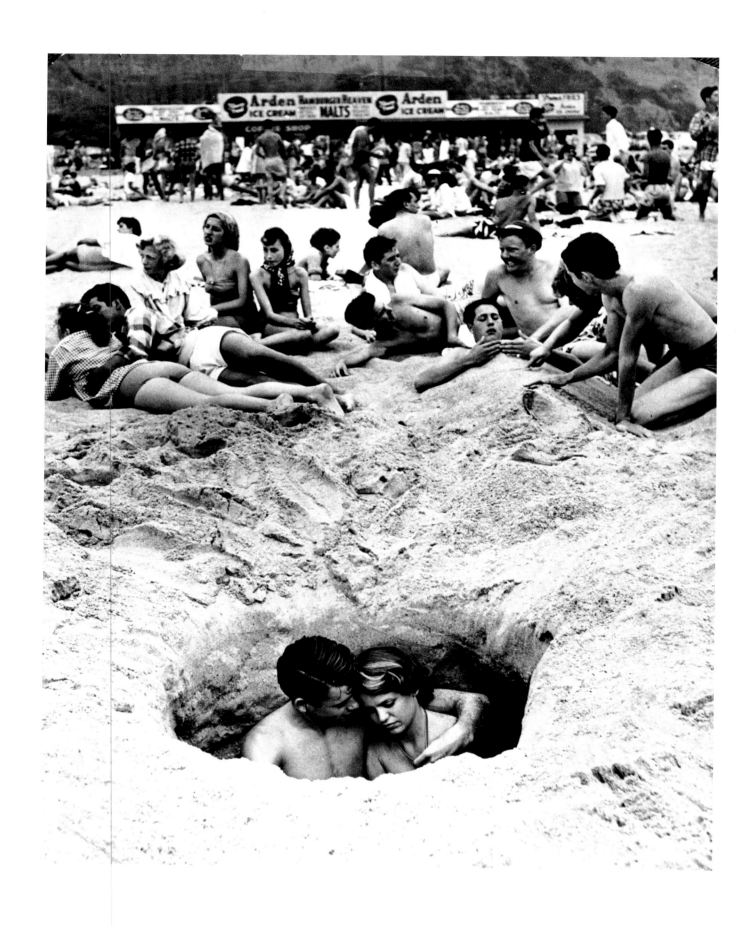

Ralph Crane 1950
Fourth of July weekend on the beach at Santa
Monica, California.

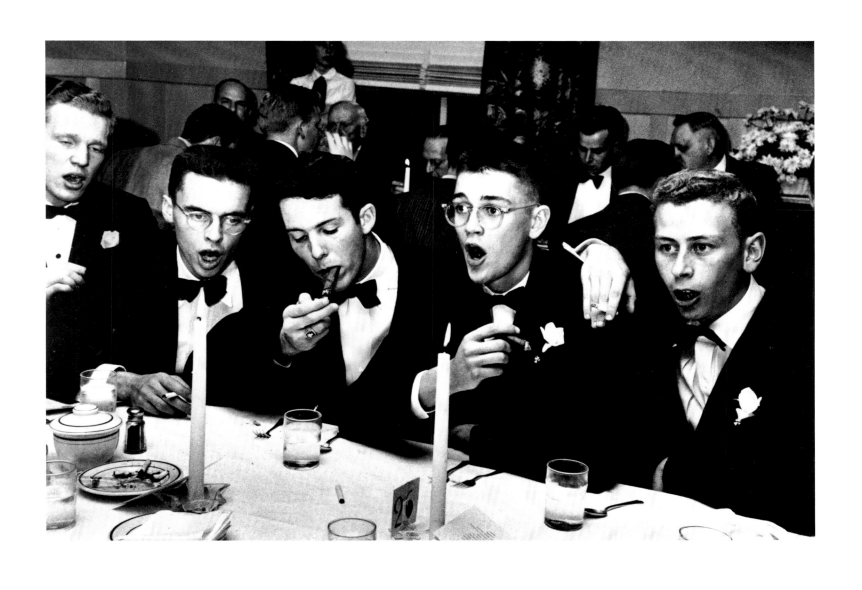

Leonard McCombe 1949
Sigma Chi members at Missouri's Westminster
College sing of the girl of their dreams.
LIFE February 6, 1950

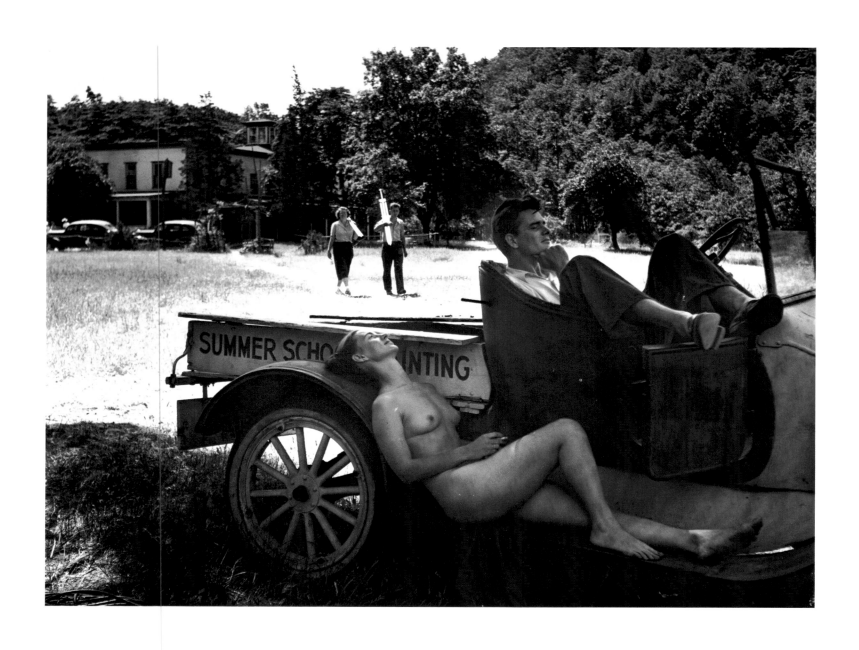

Loomis Dean 1946
At a summer art school in Connecticut, the
model takes her five-minute rest period.

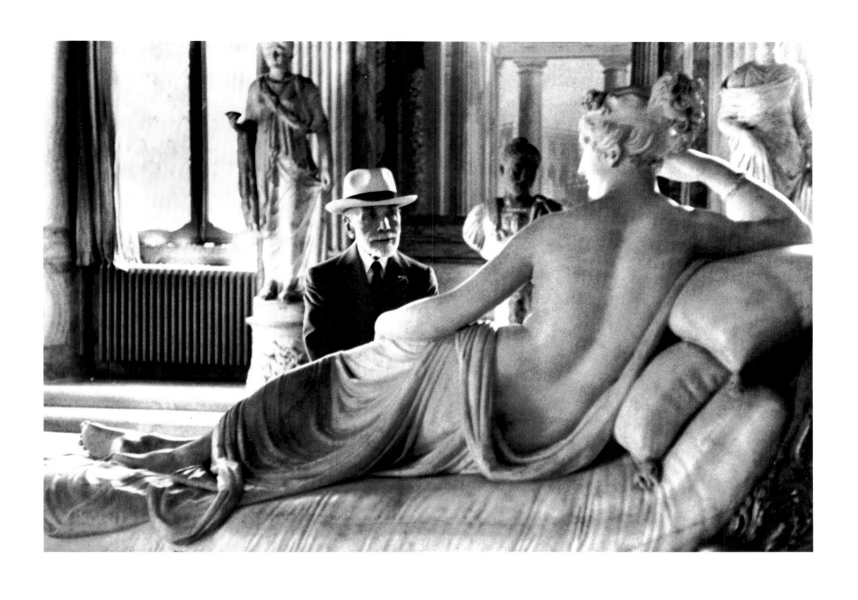

David Seymour 1955
Bernard Berenson contemplating the sculpture,
Pauline Borghese Bonaparte as Venus, by
Canova at the Borghese Gallery, Rome.

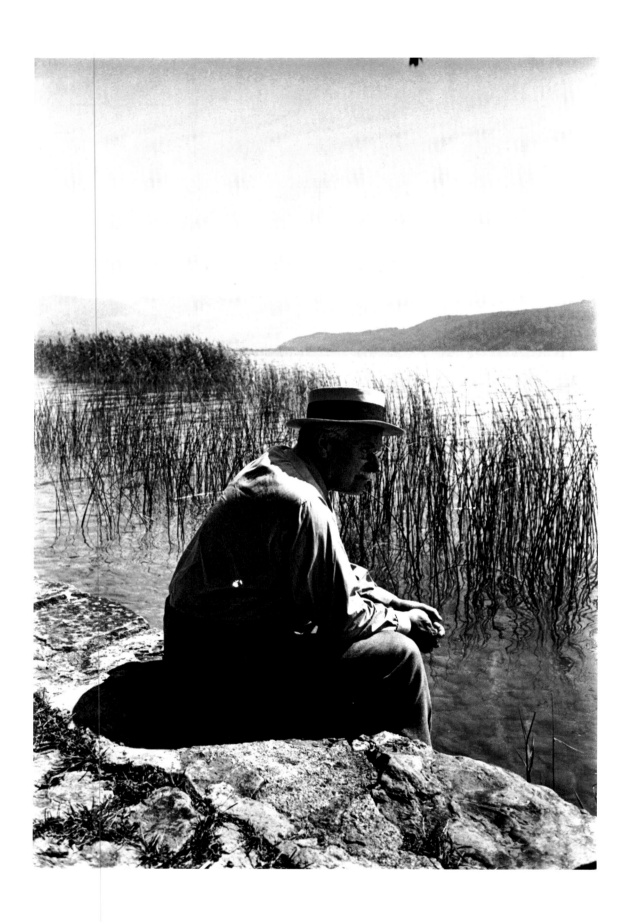

Dmitri Kessel 1949
Carl Jung sits by the shore of Lake Zurich at
Bollingen, Switzerland.

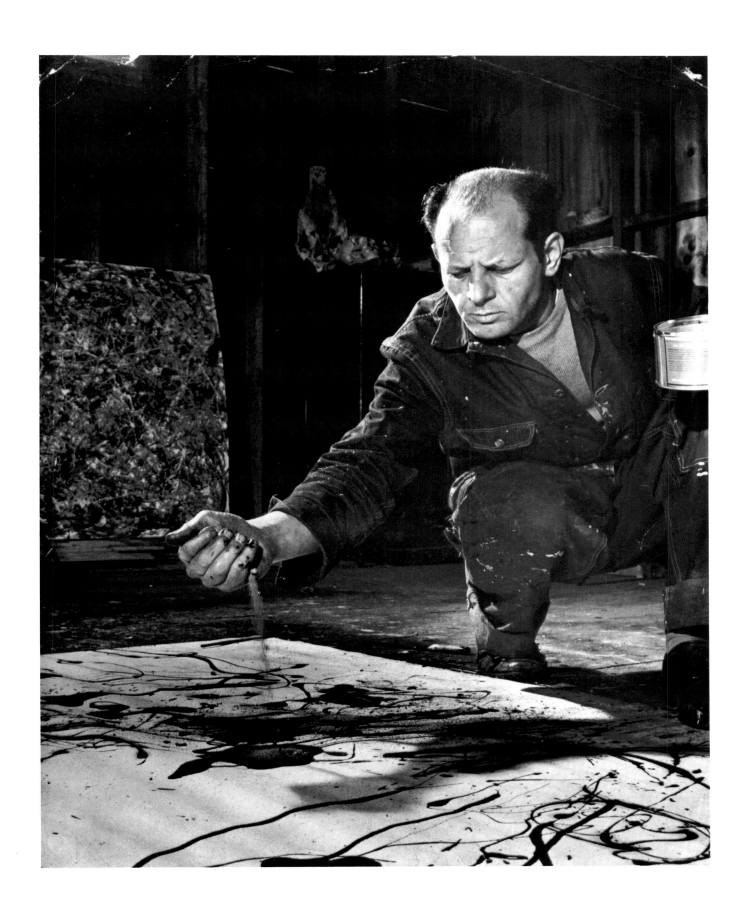

Martha Holmes 1949
Jackson Pollock dribbling sand on one of his
works while paint is still wet.
LIFE August 8, 1949

Gjon Mili 1949
In a darkened room and before the
photographer's open lens, Pablo Picasso traces a
wild beast in the air with his flashlight.
LIFE January 30, 1950

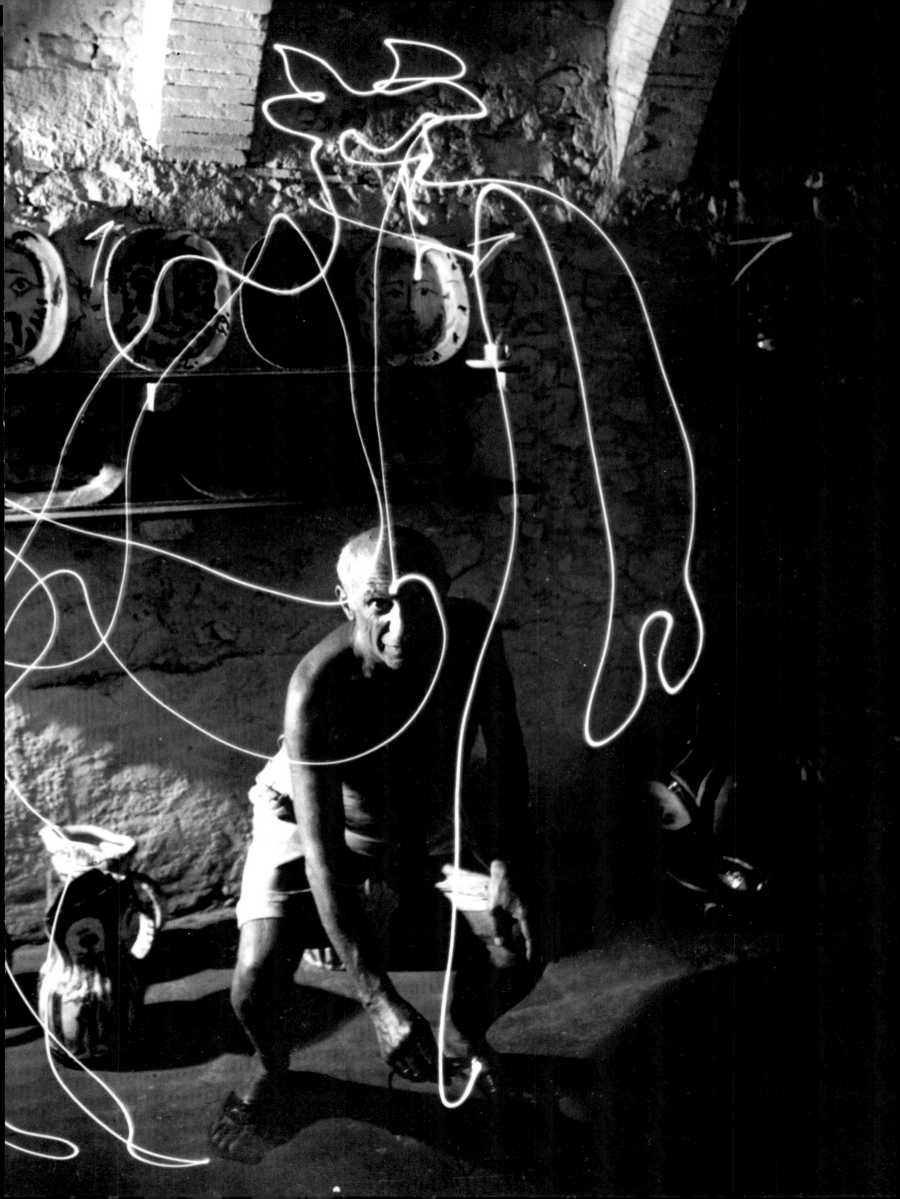

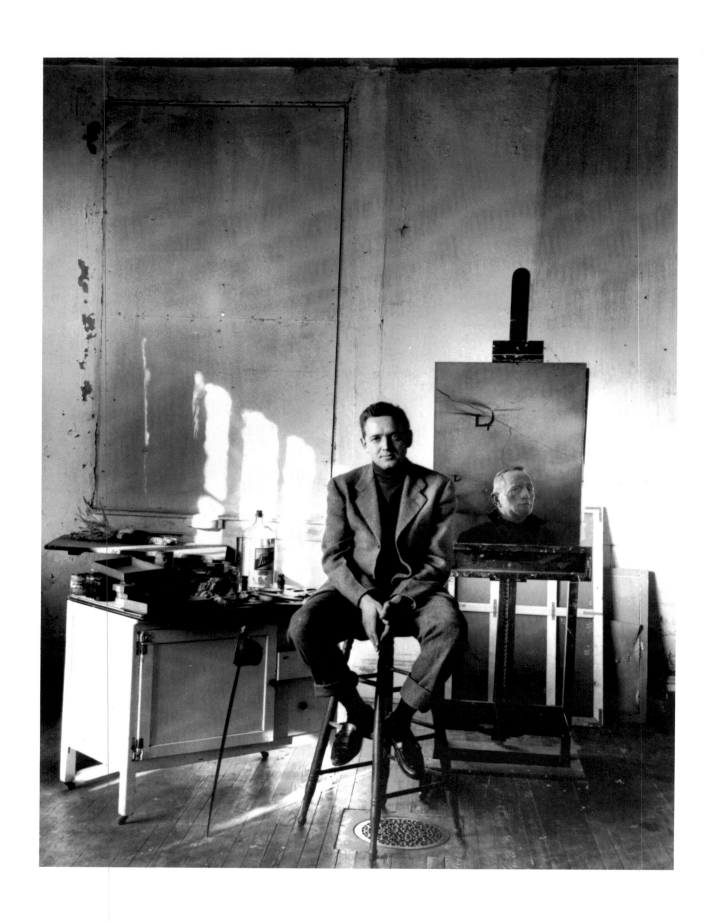

© **Arnold Newman** 1948
Andrew Wyeth in his studio at Chadds Ford.
Pennsylvania.
LIFE May 17, 1948

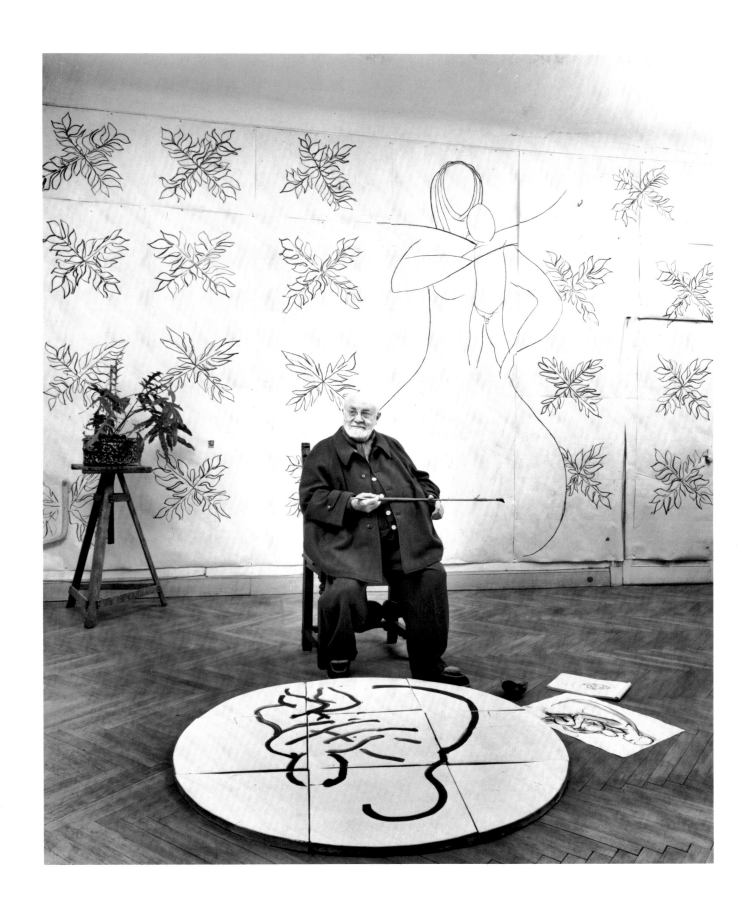

Dmitri Kessel 1950
Henri Matisse in his studio in southern France,
drawing a medallion of the Virgin and Child for
the chapel at Vence, a few miles away.

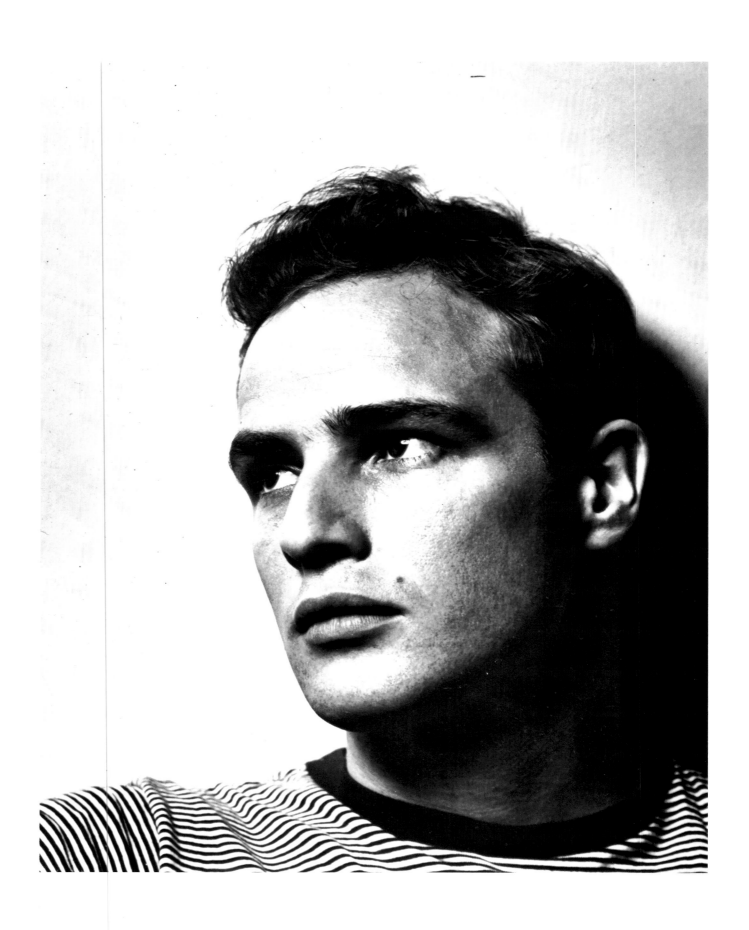

Philippe Halsman 1950
Marlon Brando.
LIFE July 31, 1950

94

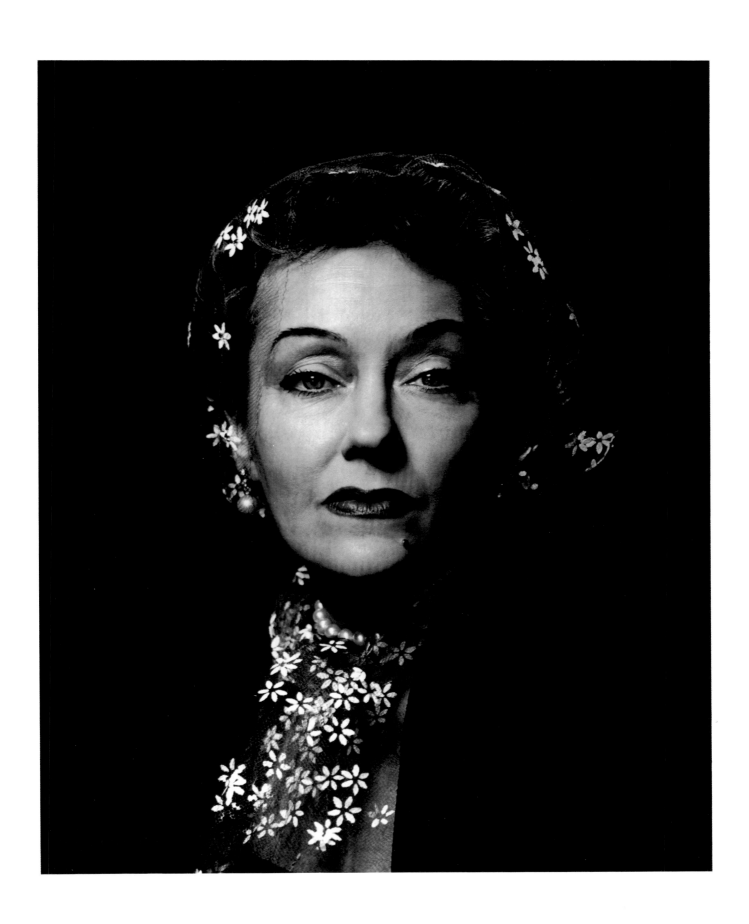

Philippe Halsman 1950
Gloria Swanson.

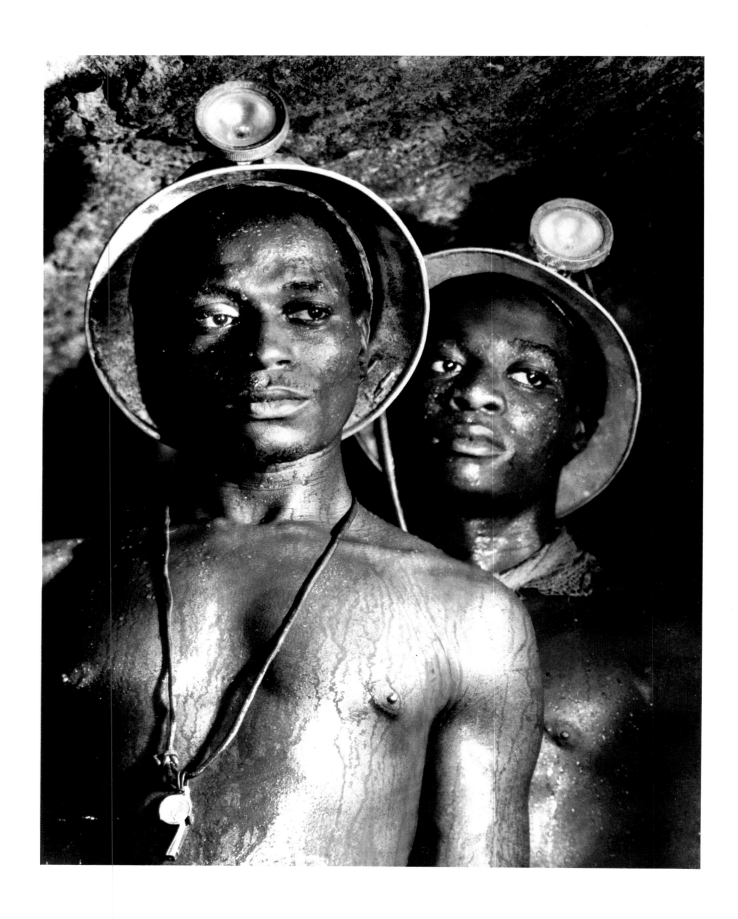

Margaret Bourke-White 1950
Gold miners of Johannesburg, Union of South
Africa, stand in 95° heat in a tunnel more than a
mile underground.
LIFE September 18, 1950

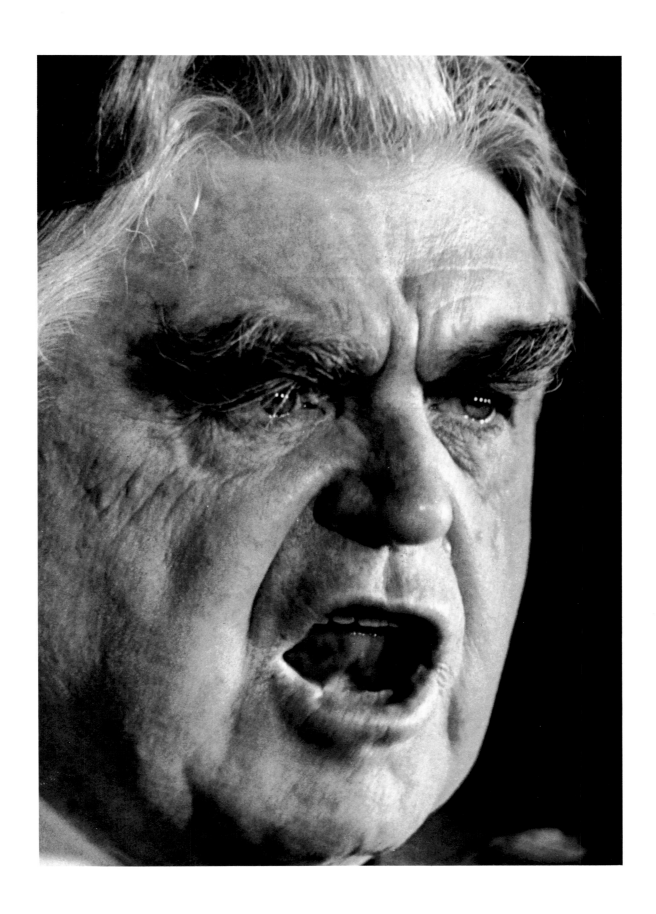

Martha Holmes 1950
John L. Lewis gives testimony before a
congressional committee, following the death of
111 miners in the Centralia, Illinois mine
disaster.
LIFE October 23, 1950

97

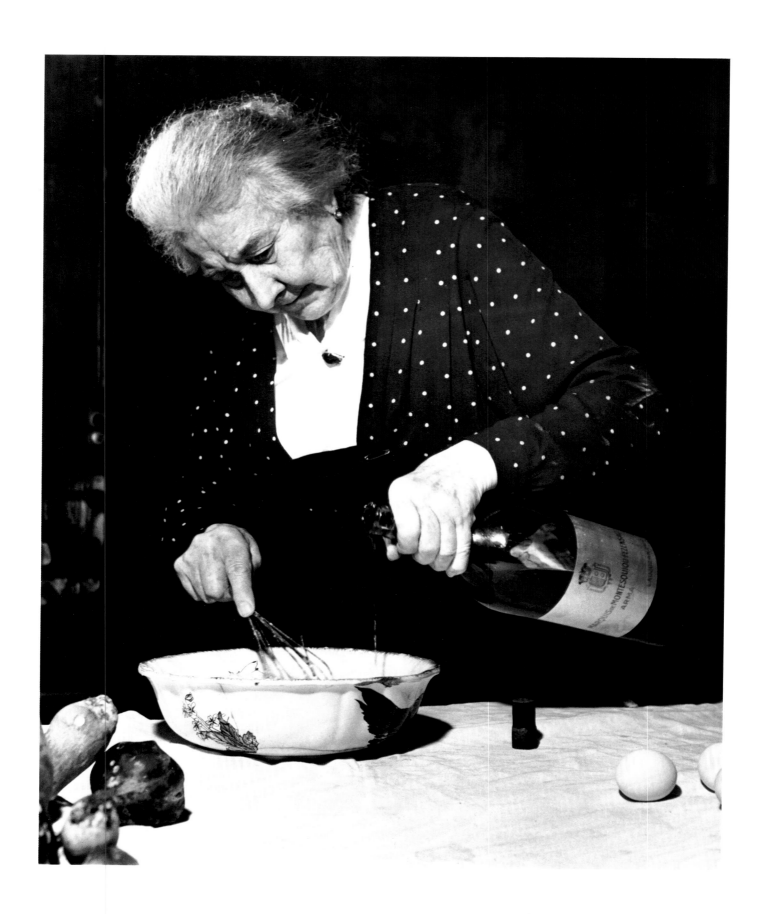

John Phillips 1949
Antoinette, cook at the Chateau de Marsan en
Fezensac, pours a large helping of Armagnac
into pancake batter to improve the flavor.
From essay on the France of Proust.

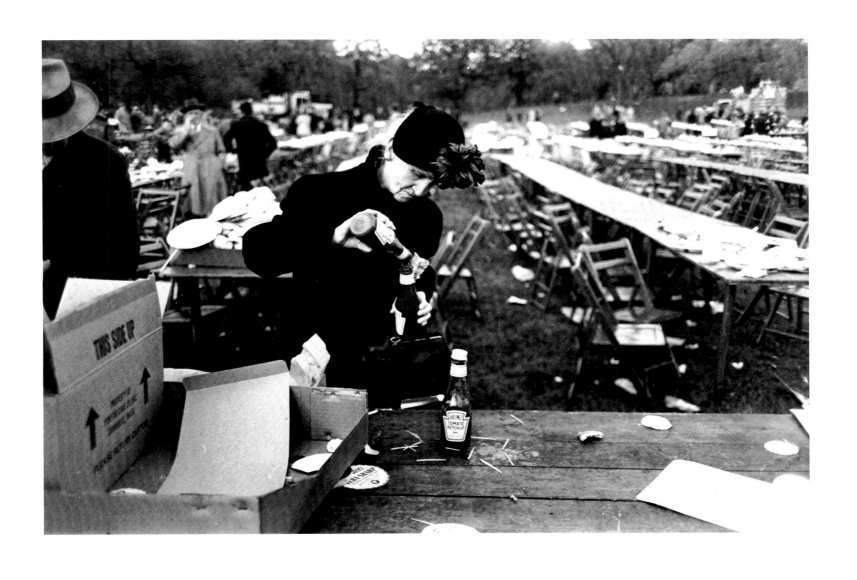

Yale Joel 1950
Elderly woman collects leftover ketchup after
bean supper on Boston Common.

99

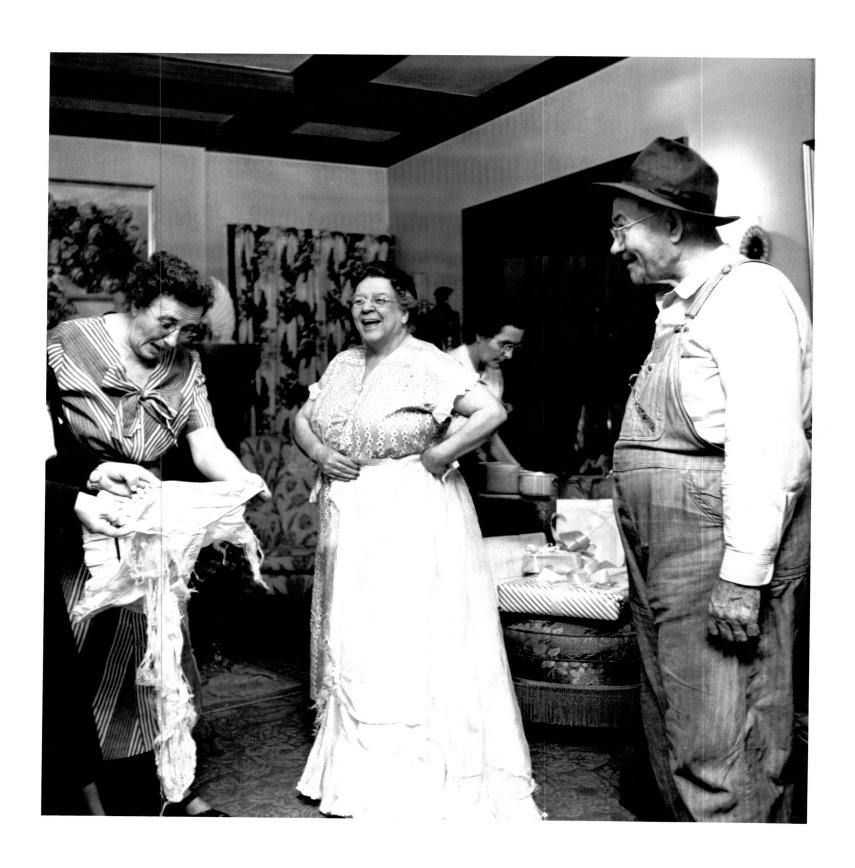

A.Y. Owen 1950
Nebraska farm woman realizes, as she prepares
for her Golden Wedding celebration, that her
wedding dress will no longer fit her.
LIFE October 23, 1950

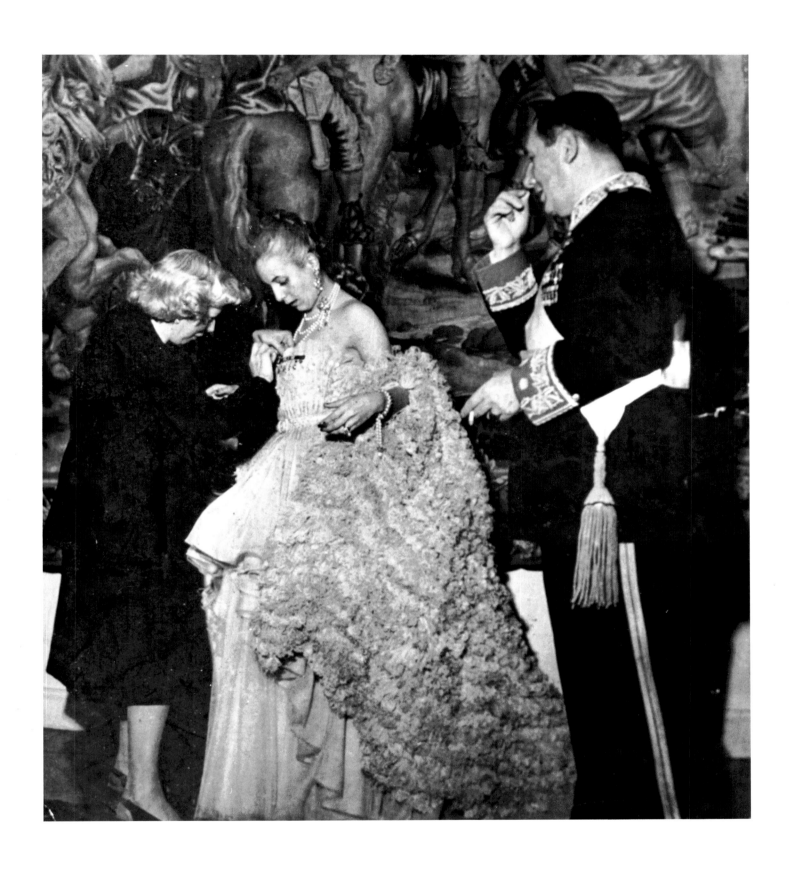

Gisèle Freund 1950
Maid attaches medals to Eva Peron's evening
gown as she and General Peron leave for the
theater in Buenos Aires.
LIFE December 11, 1950

101

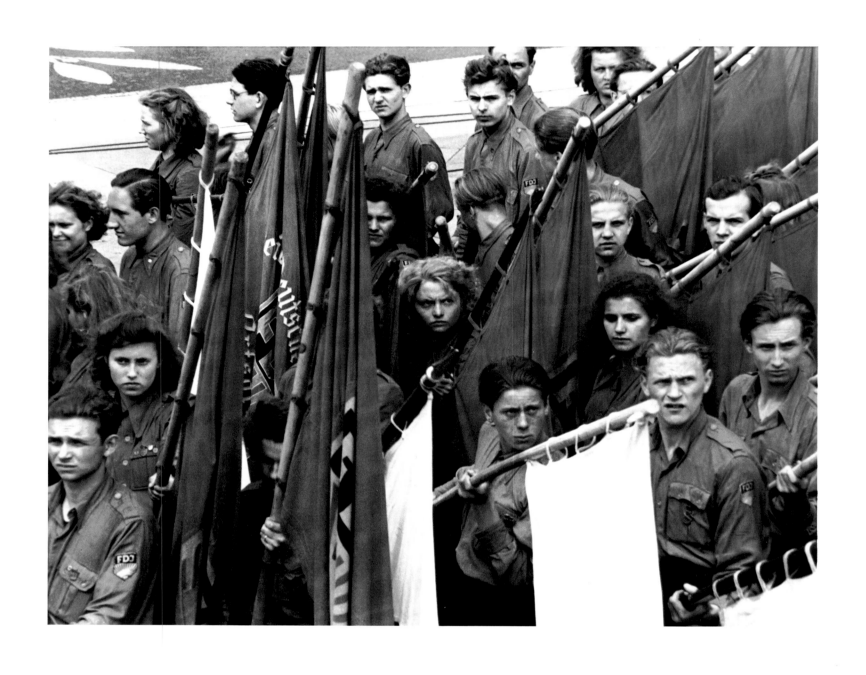

N. R. Farbman 1950
Communist youth parade in East Berlin.
LIFE June 12, 1950

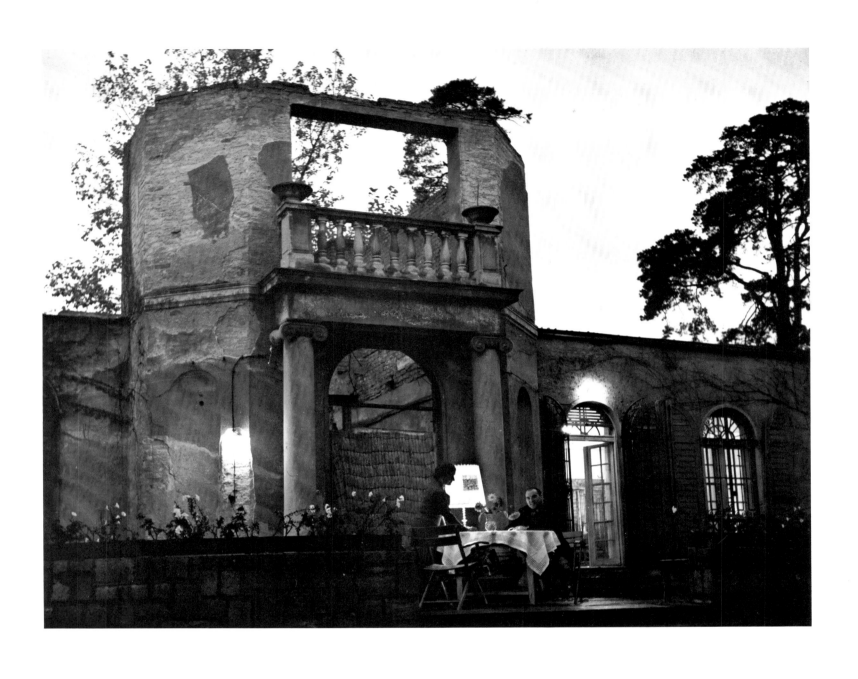

Nína Leen 1950
Herr and Frau Fritz Kehl dine on terrace of
their bombed-out villa in West Berlin.
LIFE December 4, 1950

103

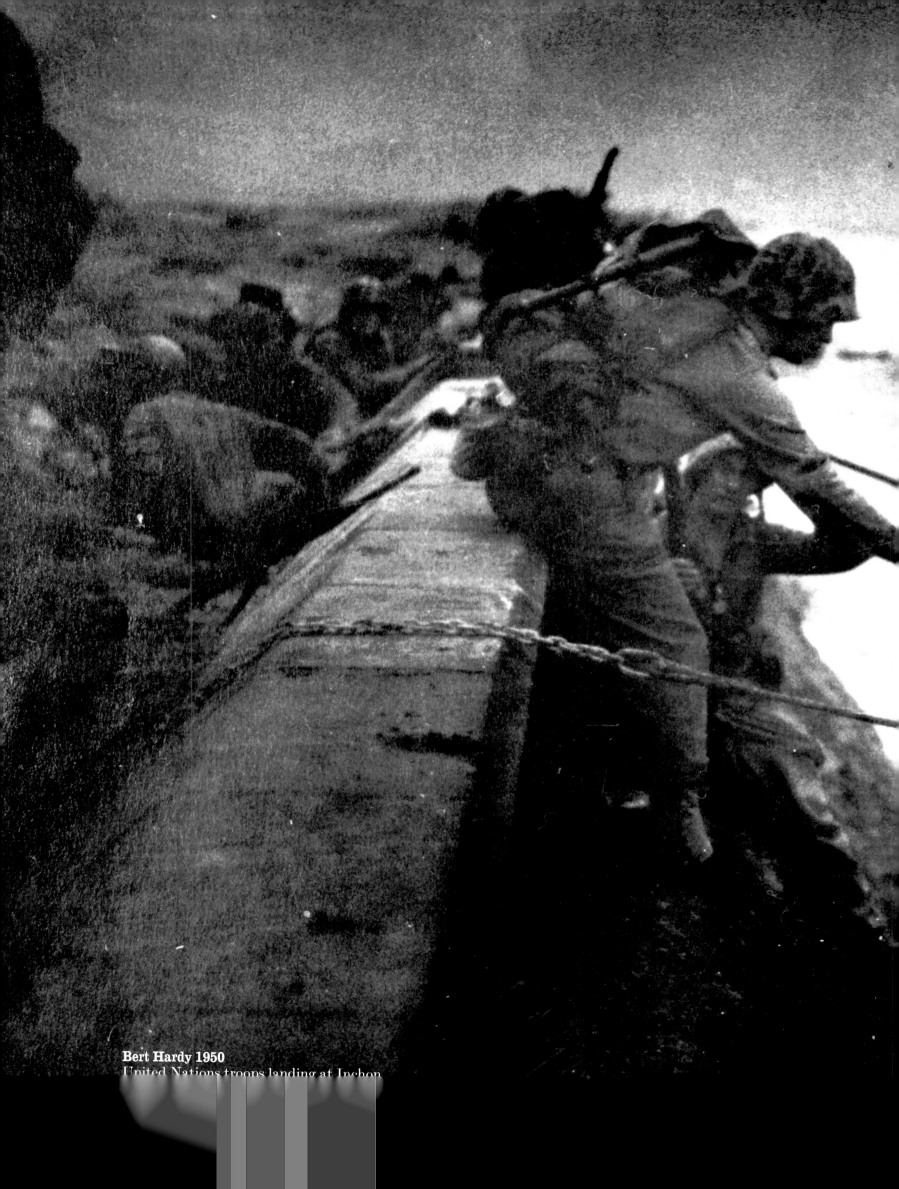

Bert Hardy 1950
United Nations troops landing at Inchon

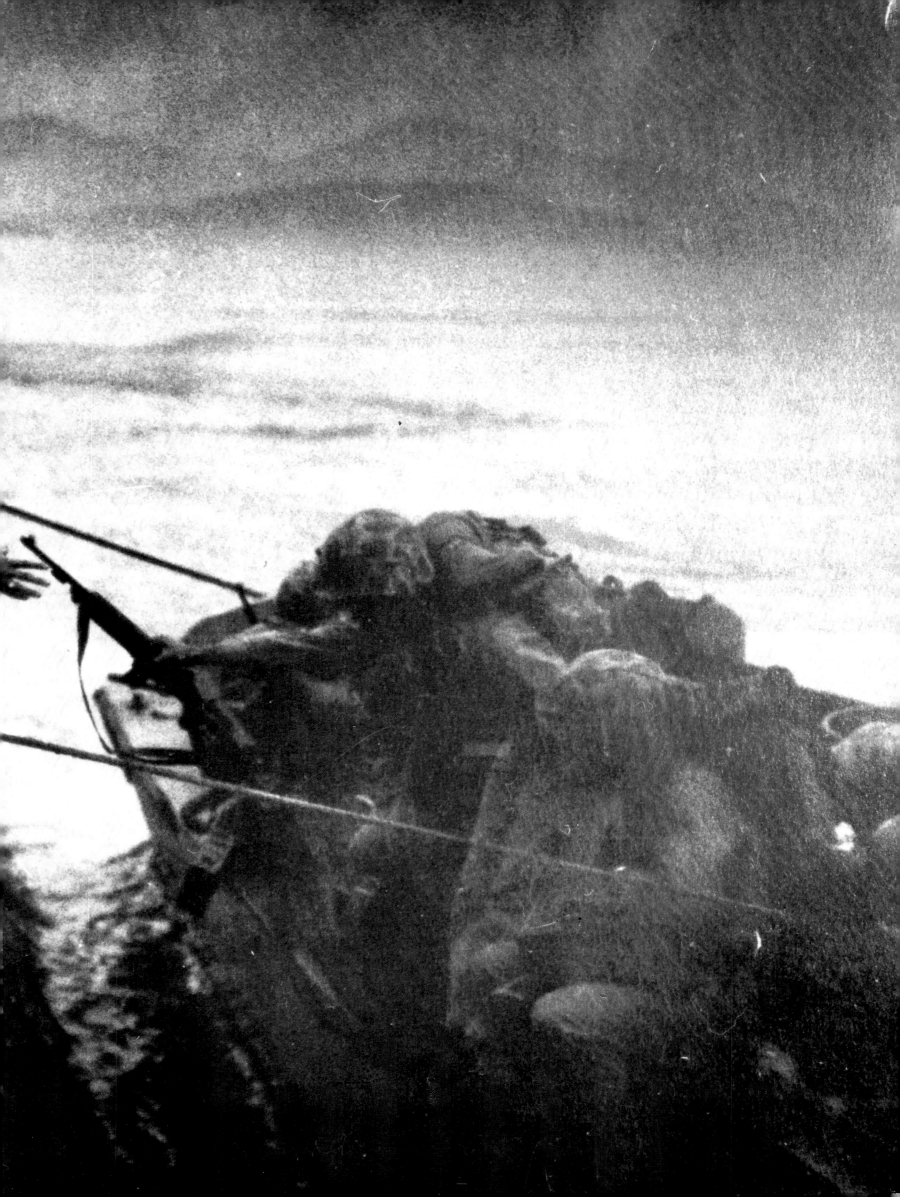

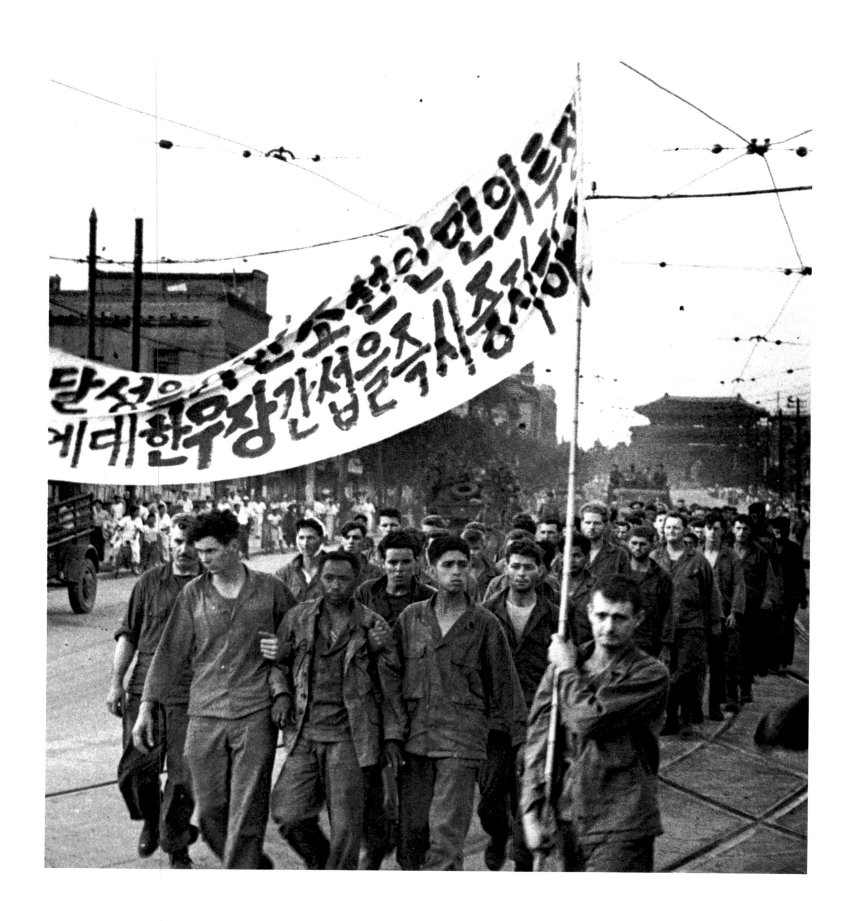

Photographer unknown 1950
American GIs taken prisoner by Red army in
the opening days of the Korean War were
paraded through Seoul and forced to carry
banners praising the Communist cause.
LIFE May 11, 1953

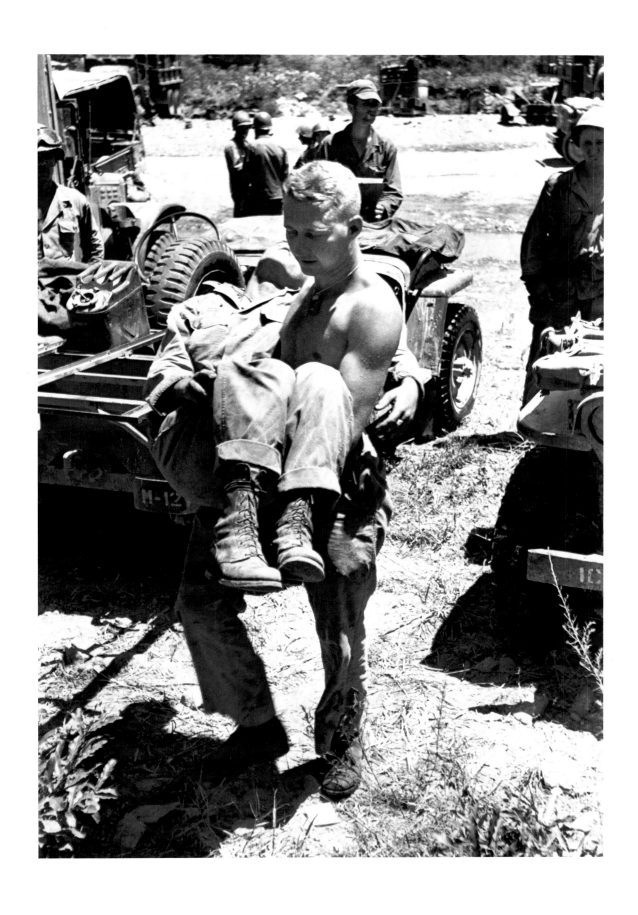

Carl Mydans 1950
Corpsman carries wounded GI from Jeep to
medical station near Kwan-ni, Korea.
LIFE August 14, 1950

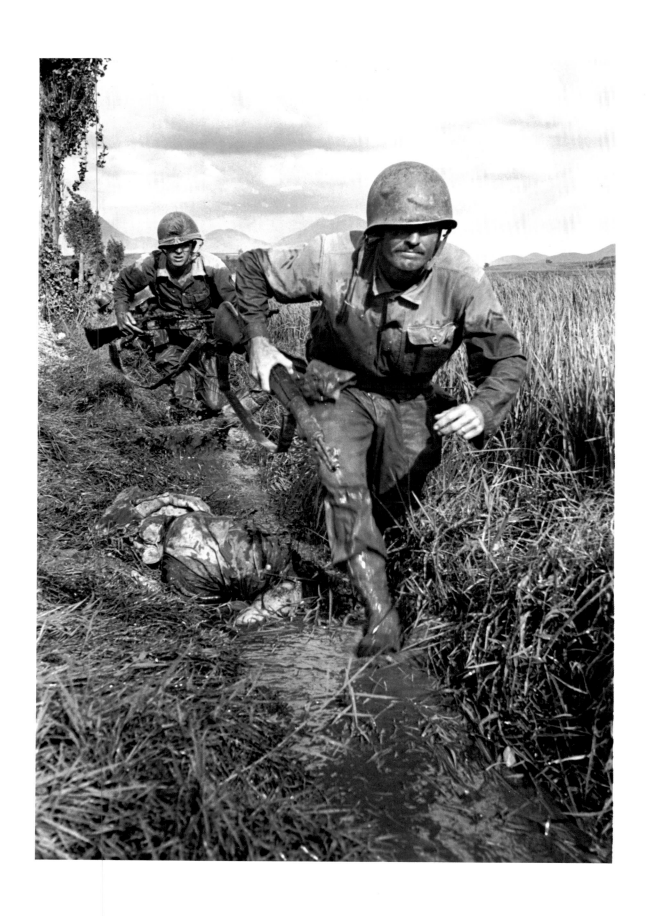

David Douglas Duncan 1950
Marines advancing in the Naktong River area,
Korea.
LIFE September 18, 1950

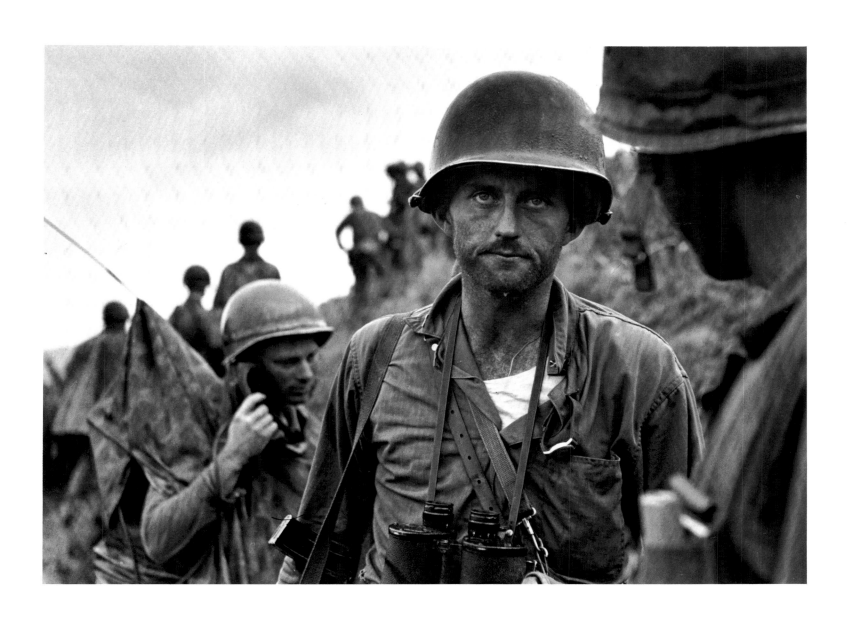

David Douglas Duncan 1950
Marine captain learns he is out of ammunition
during heavy North Korean attack.
LIFE September 18, 1950

108

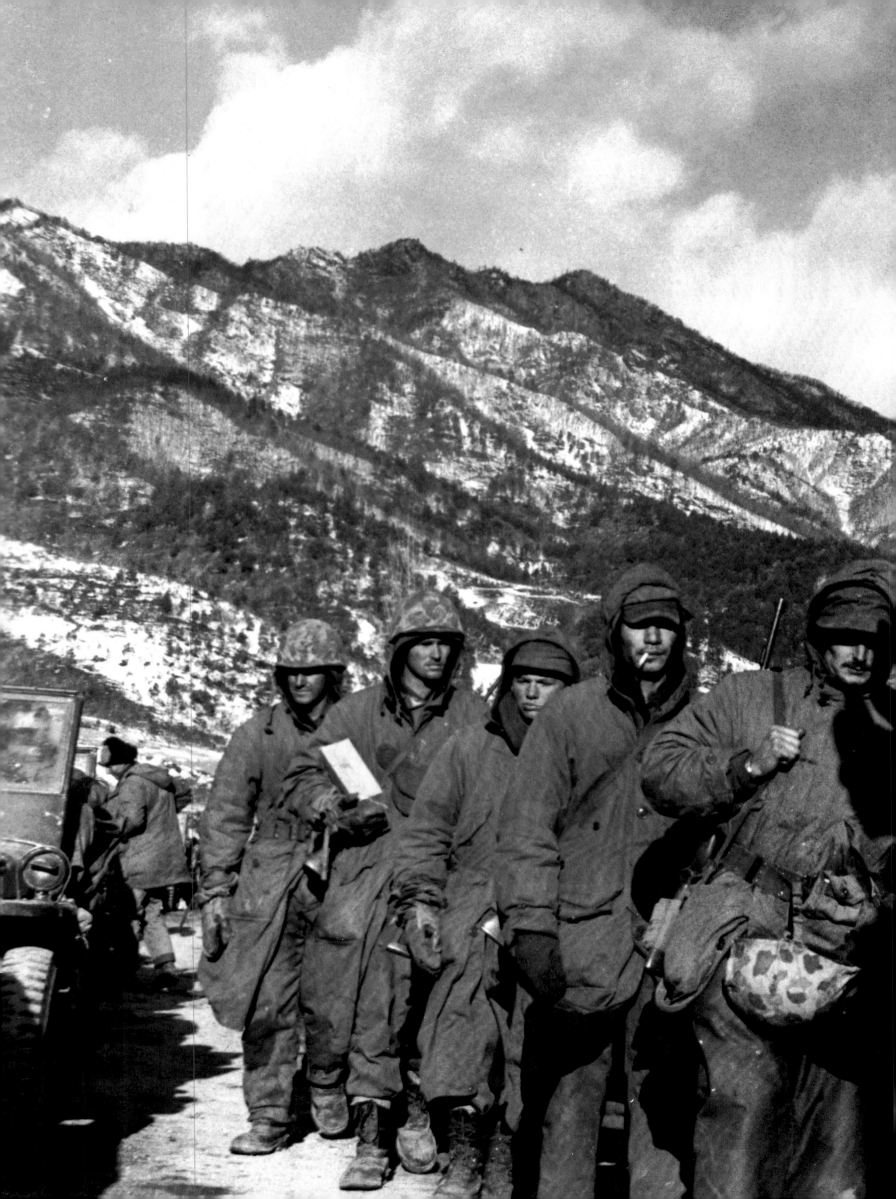

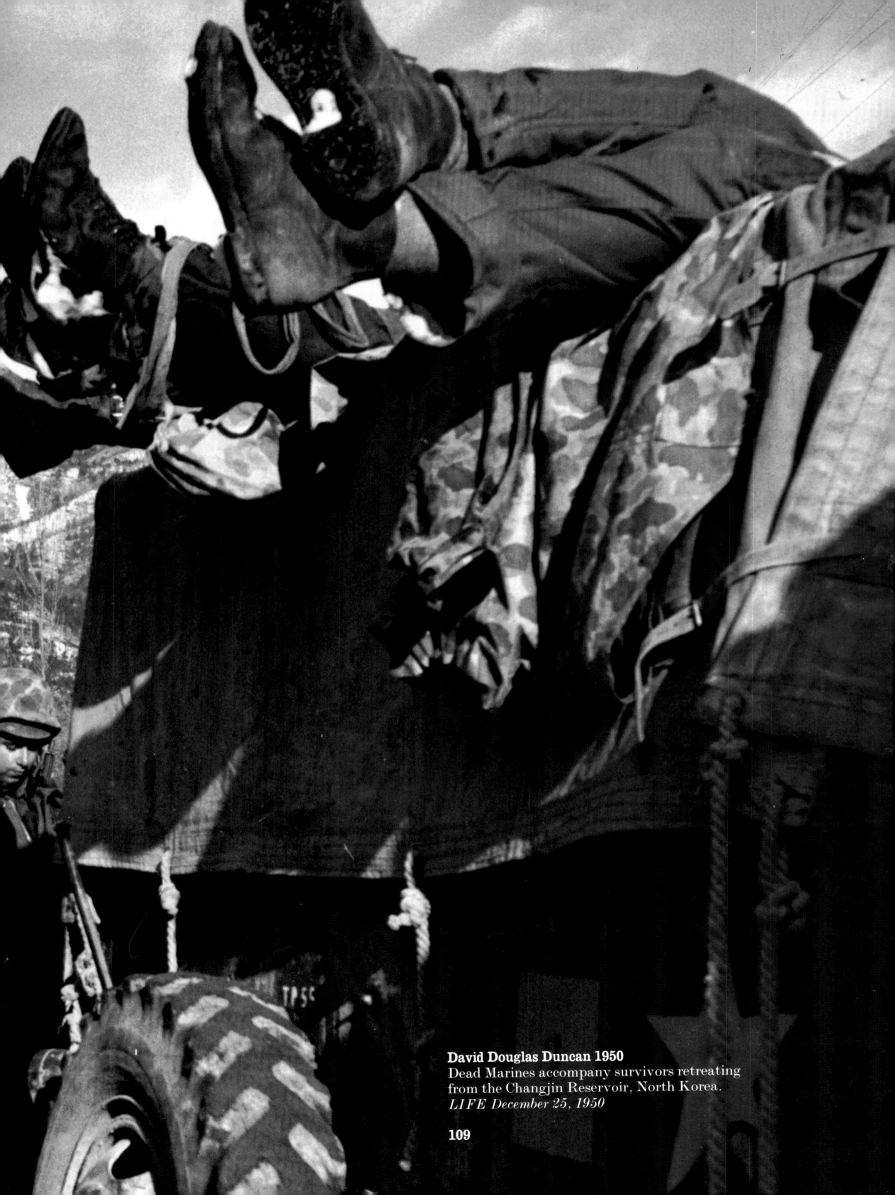

David Douglas Duncan 1950
Dead Marines accompany survivors retreating
from the Changjin Reservoir, North Korea.
LIFE December 25, 1950

109

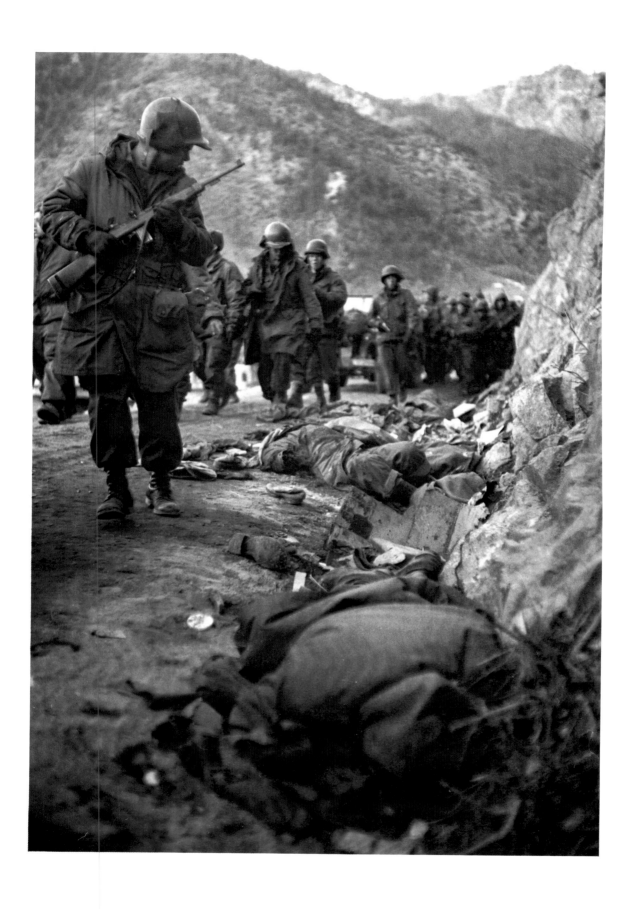

David Douglas Duncan 1950
Retreating Marines pass the bodies of other GIs
caught in the Red ambush, Korea.
LIFE December 25, 1950

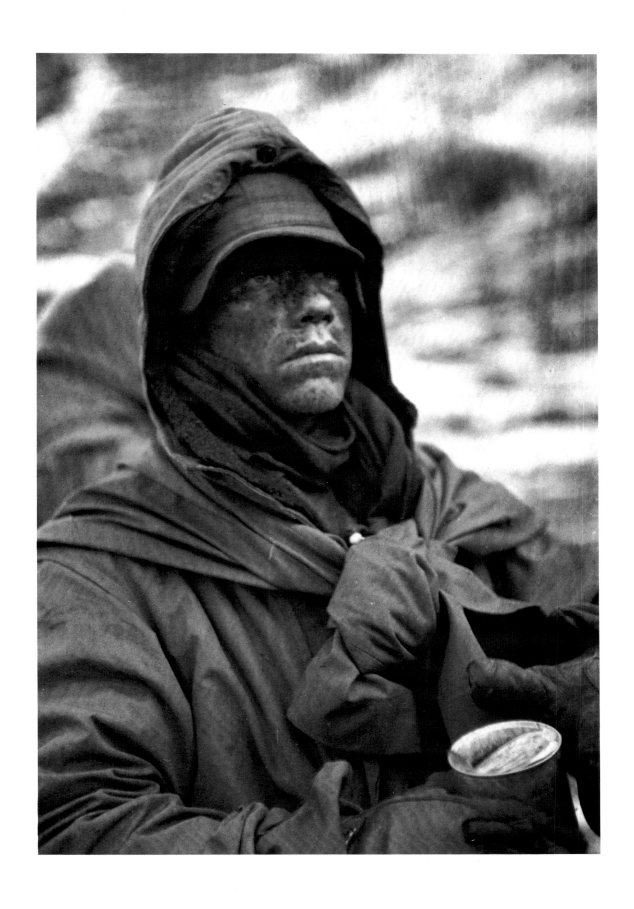

David Douglas Duncan 1950
Young Marine exhausted by harrowing retreat
from the Changjin Reservoir, North Korea.
LIFE December 25, 1950

111

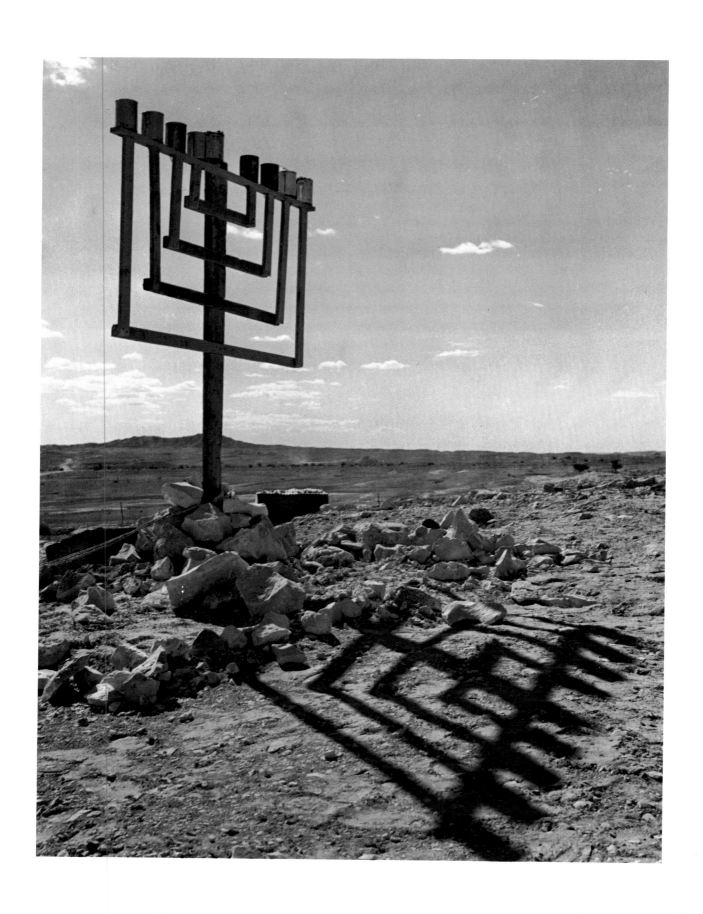

Robert Capa 1950
Menorah in Negev Desert made by Israeli troops
during Hanukkah, 1950.
LIFE May 14, 1951

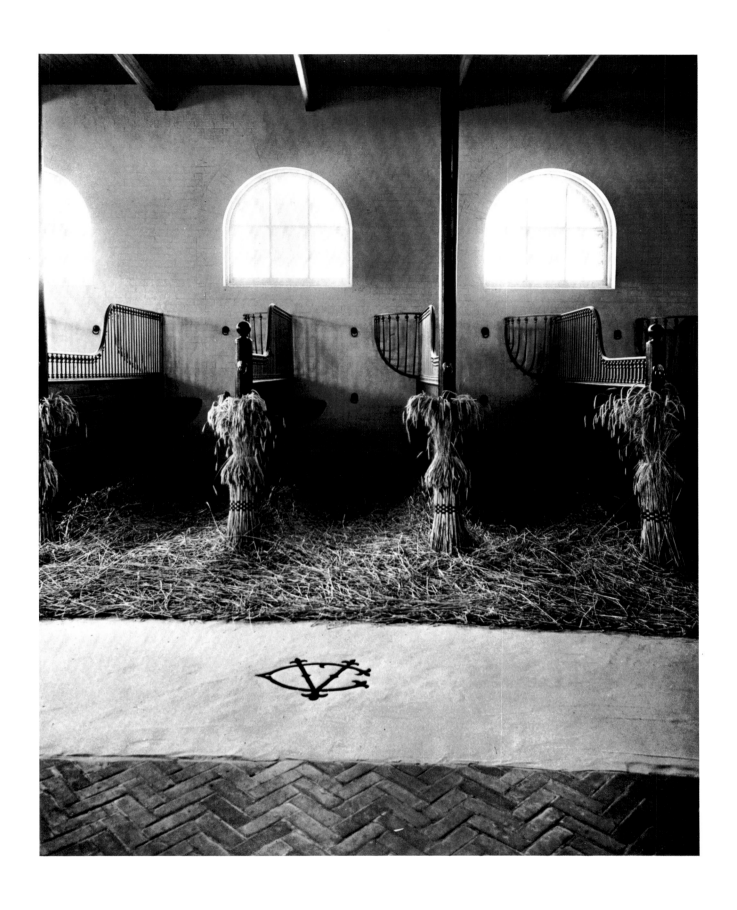

© **Arnold Newman 1950**
Stables on the Newport estate of Cornelius
Vanderbilt.
LIFE July 23, 1951

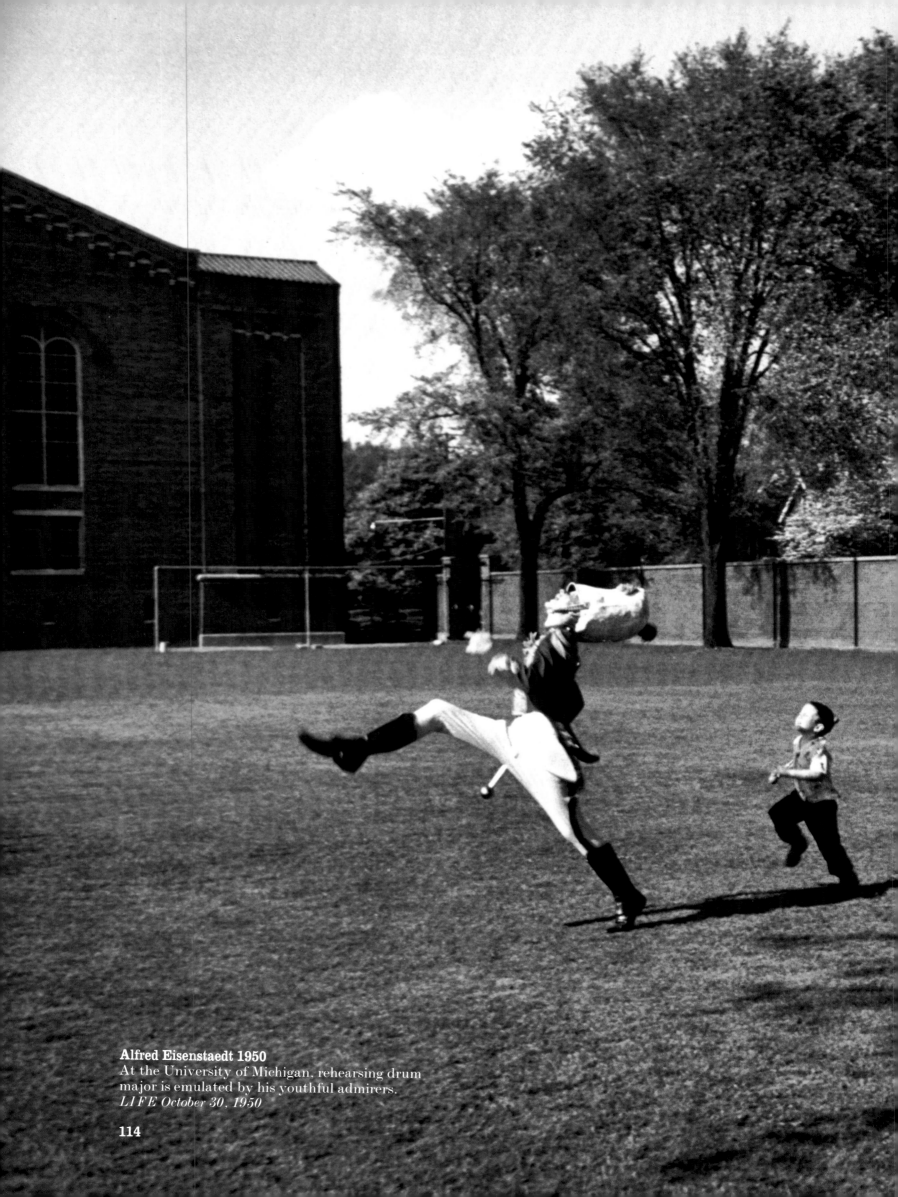

Alfred Eisenstaedt 1950
At the University of Michigan, rehearsing drum
major is emulated by his youthful admirers.
LIFE October 30, 1950

114

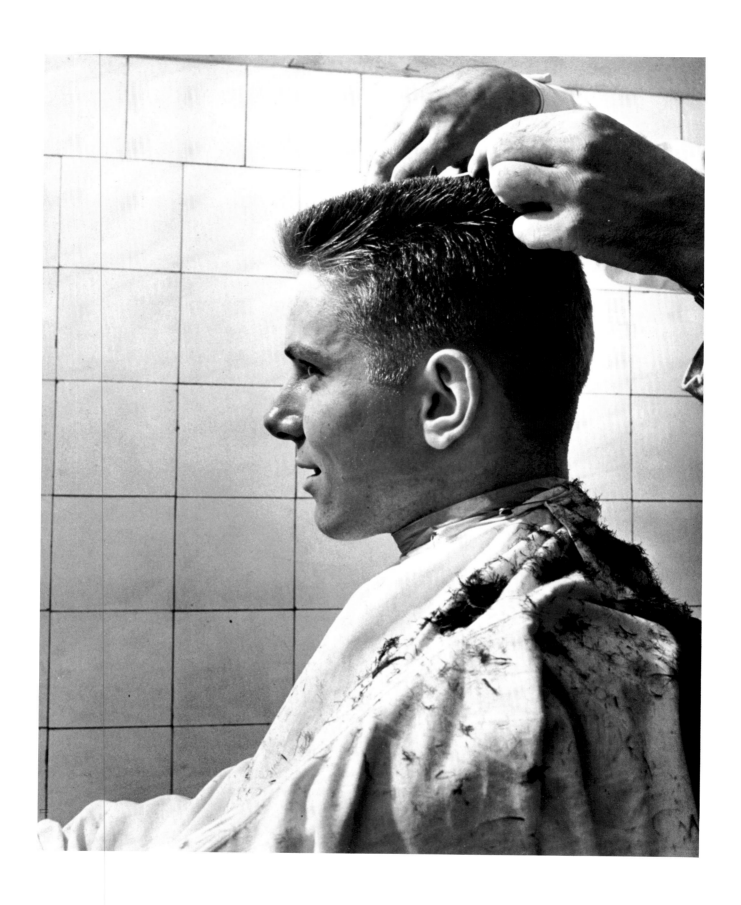

Gordon Parks 1951
Teenager getting a crew cut.

115

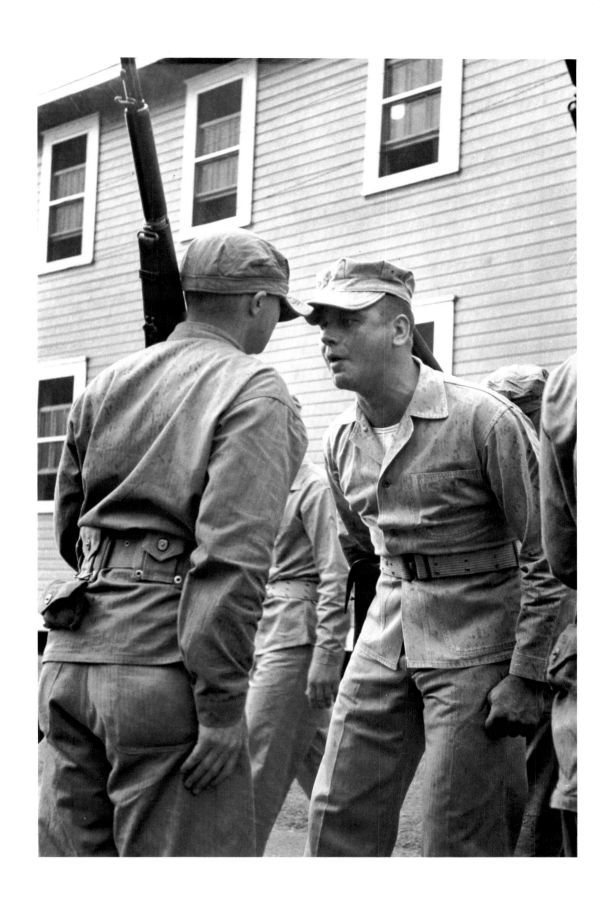

Mark Kauffman 1951
Drill instructor at Parris Island, South Carolina,
chews out a recruit he hopes to turn into a
Marine.
LIFE October 8, 1951

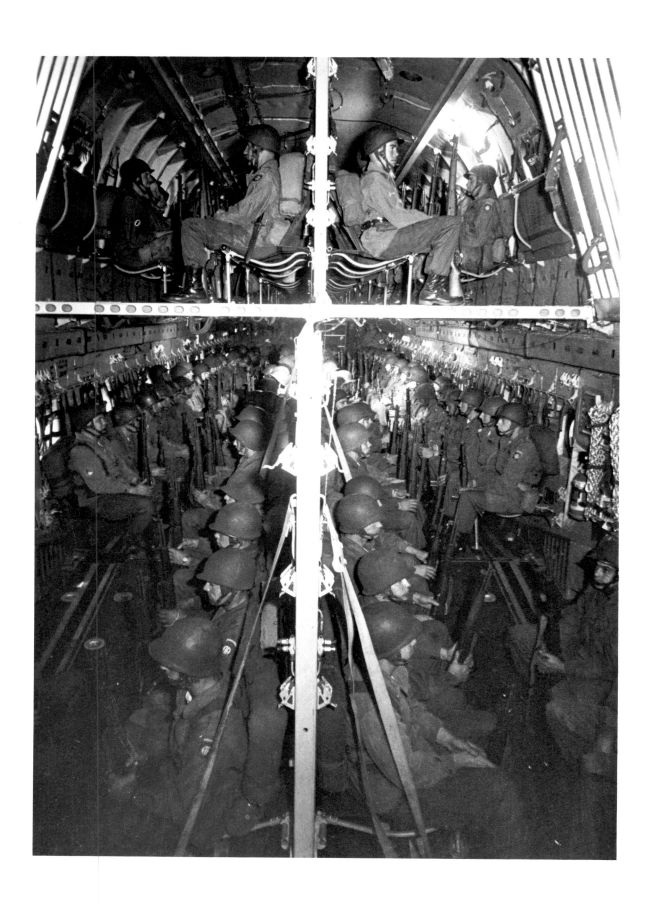

Hank Walker 1951
Two hundred paratroopers sit in the
double-decker hold of a C-124.
LIFE May 28, 1951

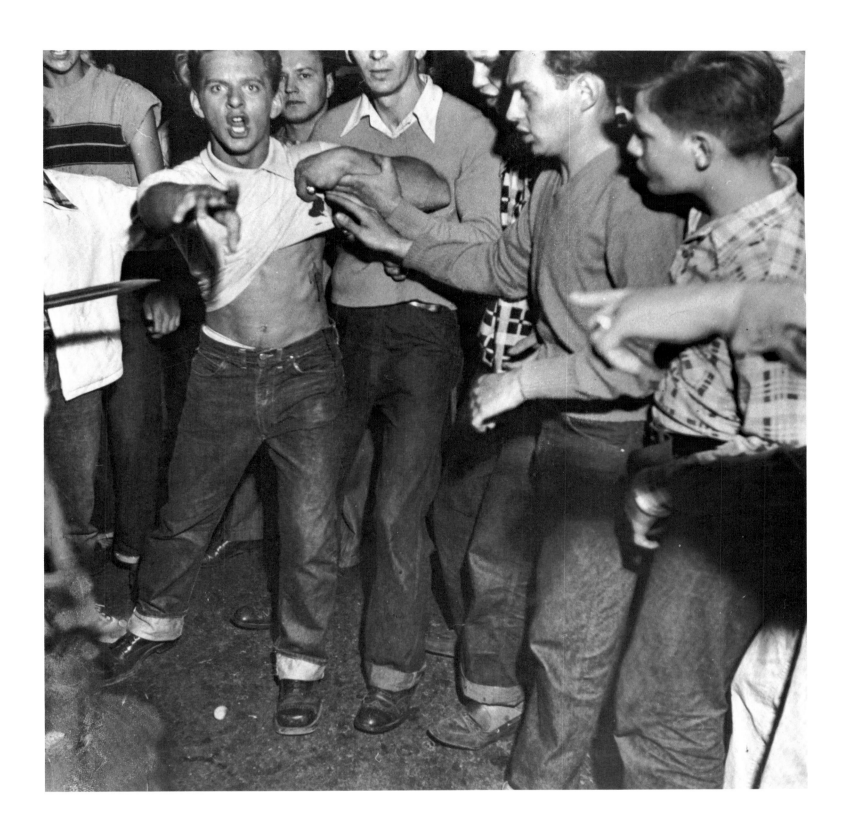

Wallace Kirkland 1951
During a race riot in Cicero, Illinois, one of the
mob curses and lifts his shirt to show a wound he
says was inflicted by a National Guardsman's
bayonet.
LIFE July 23, 1951

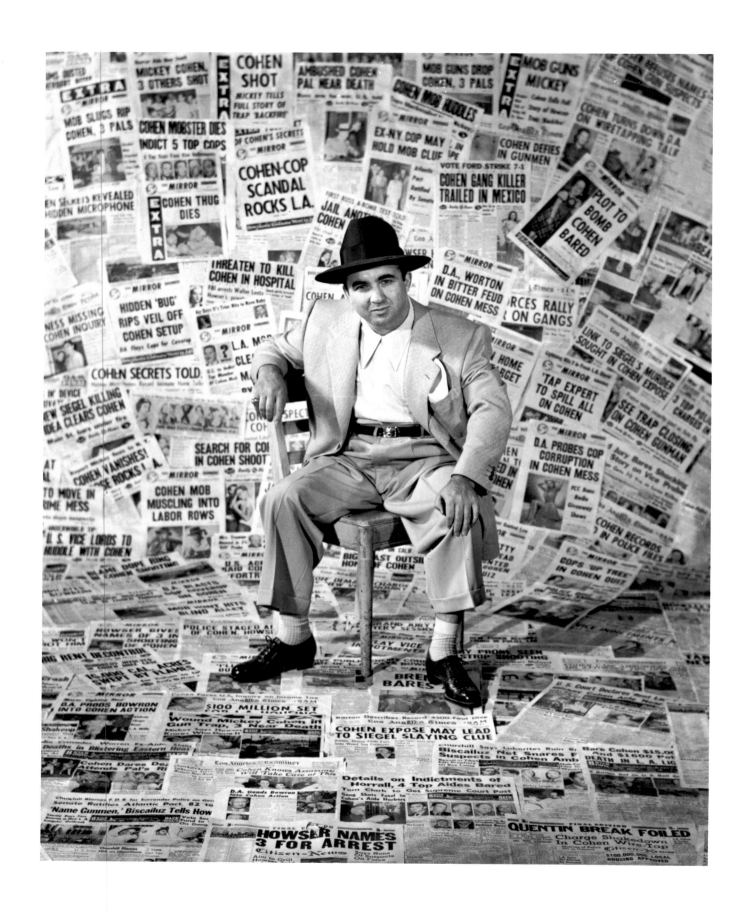

Edward Clark 1949
Gangster Mickey Cohen sits among the front
pages that helped make him Los Angeles' most
infamous citizen.
LIFE January 16, 1950

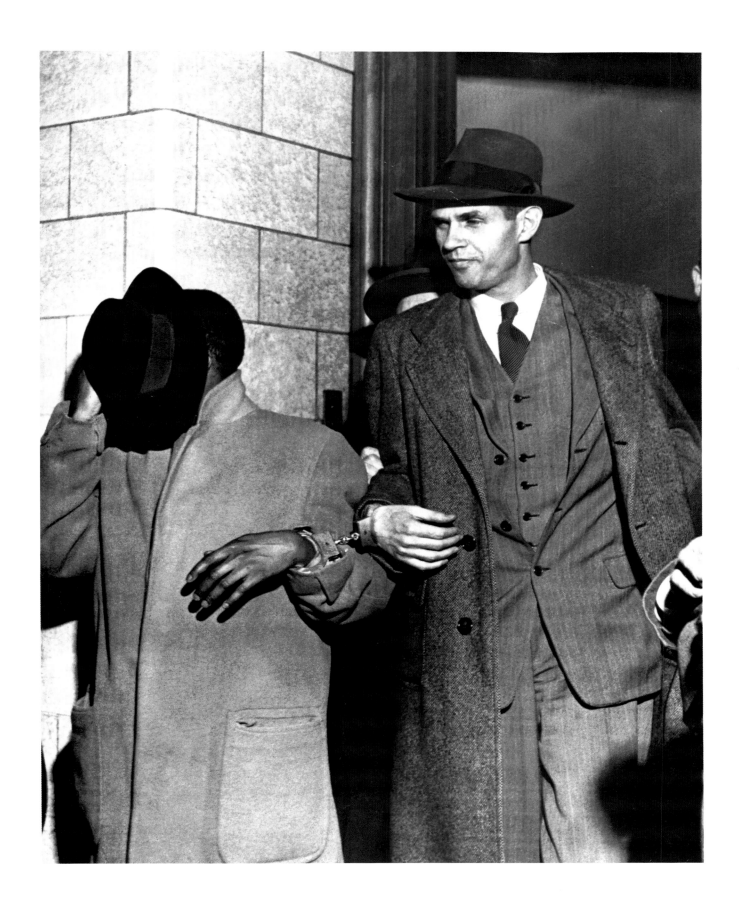

Jack Birns 1951
Alger Hiss, handcuffed to a petty thief, leaves
New York's Federal courthouse to begin serving
a five-year sentence for perjury in denying he
had ever been a Communist.
LIFE December 6, 1954

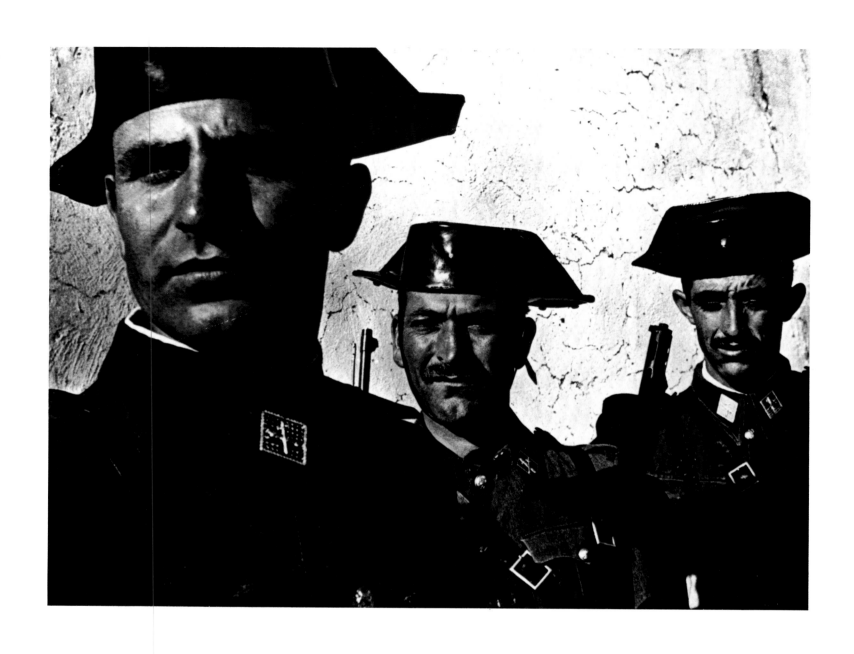

W. Eugene Smith 1951
Three members of Franco's Guardia Civil in
rural Spain. From the essay "Spanish Village".
LIFE April 9, 1951

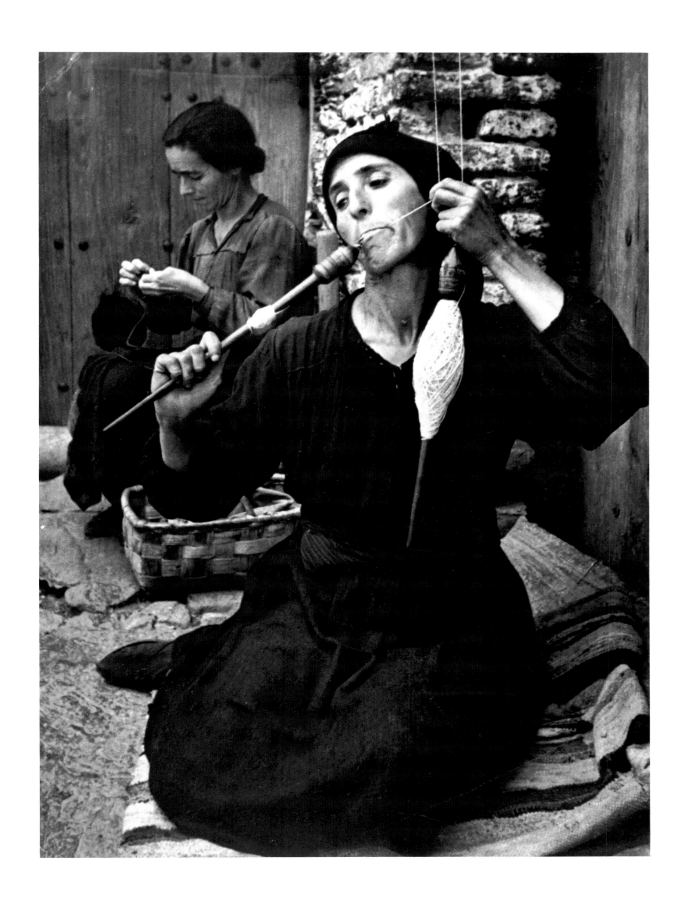

W. Eugene Smith 1951
A Spanish peasant uses ancient methods
to spin flax into thread. From the essay
"Spanish Village".
LIFE April 9, 1951

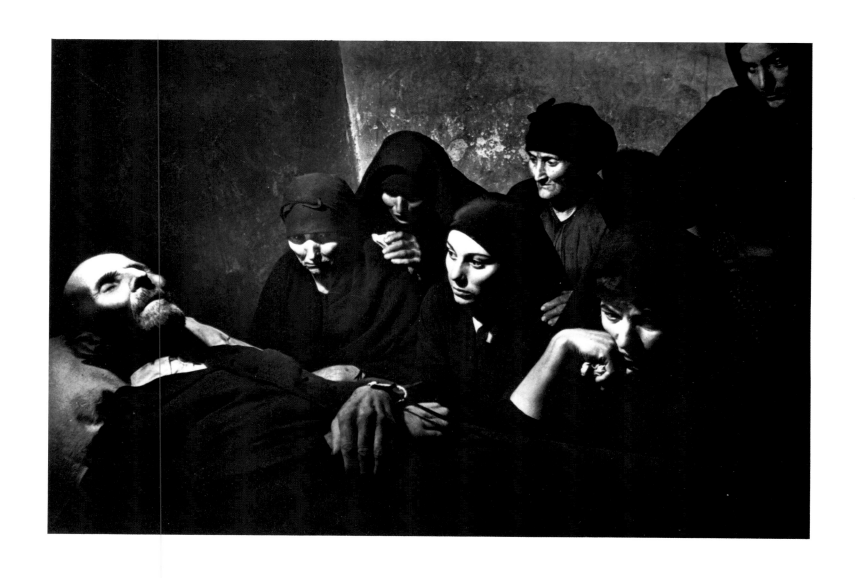

W. Eugene Smith 1951
Women of a Spanish village gather to mourn an
old man's death. From the essay "Spanish
Village".
LIFE April 9, 1951

123

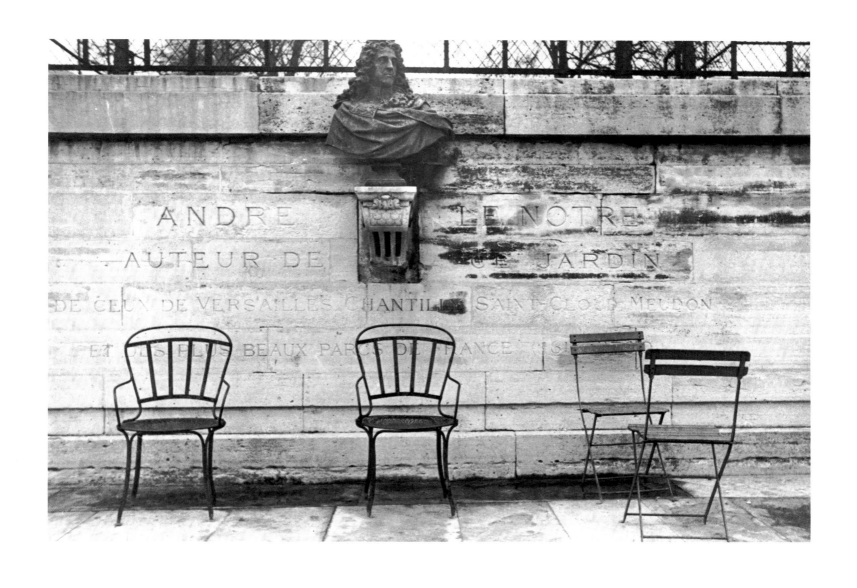

Robert Frank 1951
Four chairs rest in front of wall in the Tuileries.
Inscription commemorates work of André Le Nôtre
who designed this and other parks of France.
LIFE May 21, 1951

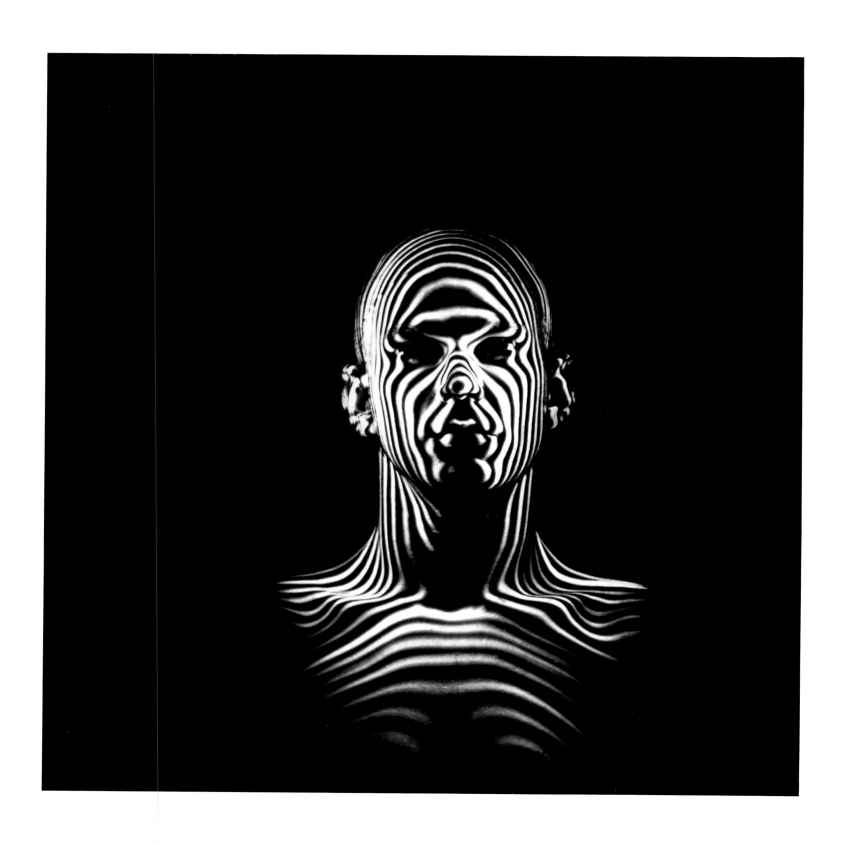

Ralph Morse 1950
A jet-age man is measured for a flight helmet by
means of a light-beam contour map.
LIFE December 6, 1954 Cover

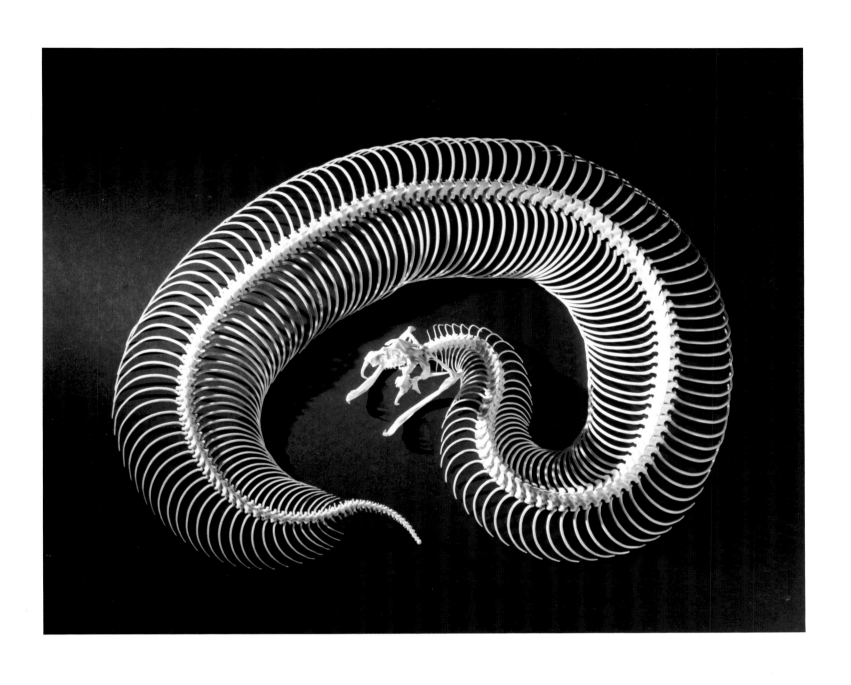

Andreas Feininger 1951
Skeleton of a four-foot-long gaboon viper
showing its 160 pairs of movable ribs.
LIFE October 6, 1952

126

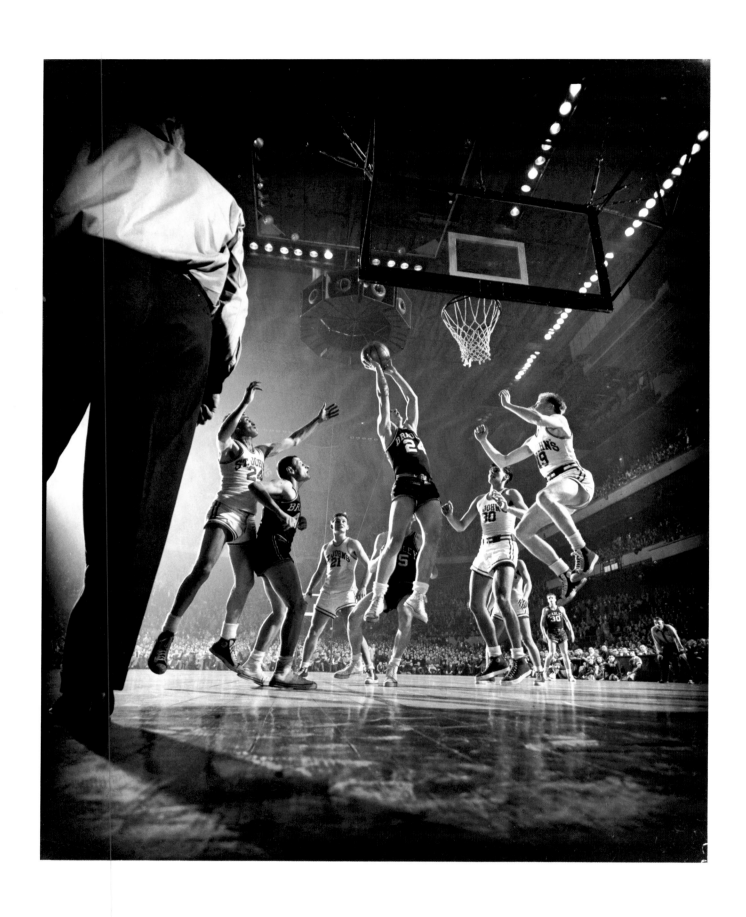

Gjon Mili 1951
St. John's defeating Bradley in a basketball
game in Madison Square Garden.
LIFE January 29, 1951

127

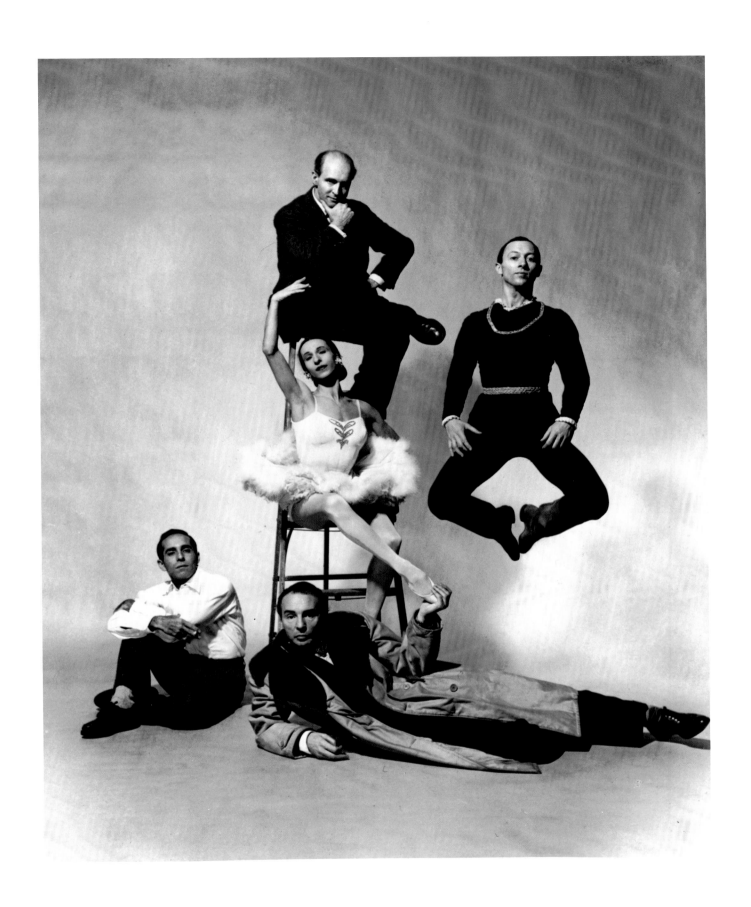

Philippe Halsman 1951
Five choreographers of the New York City
Ballet: Jerome Robbins (left), Todd Bolender
(right), Anthony Tudor (top), Ruthanna Boris
(center) and George Balanchine (bottom).
LIFE May 12, 1952

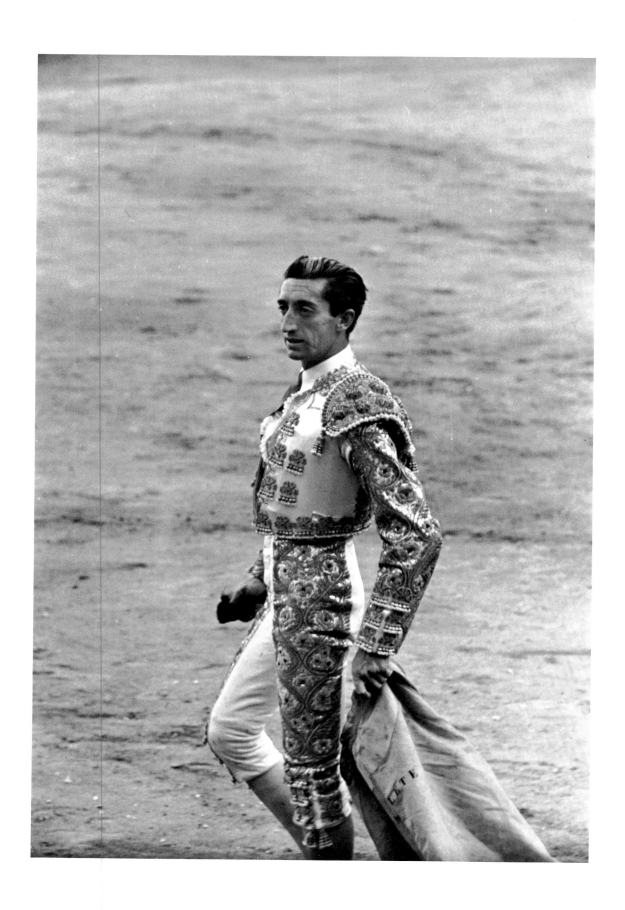

Tony Linck 1947
Manolete, appearing in Pamplona, Spain,
accepts the applause of the crowd after
dispatching his second bull of the afternoon.
LIFE September 5, 1960

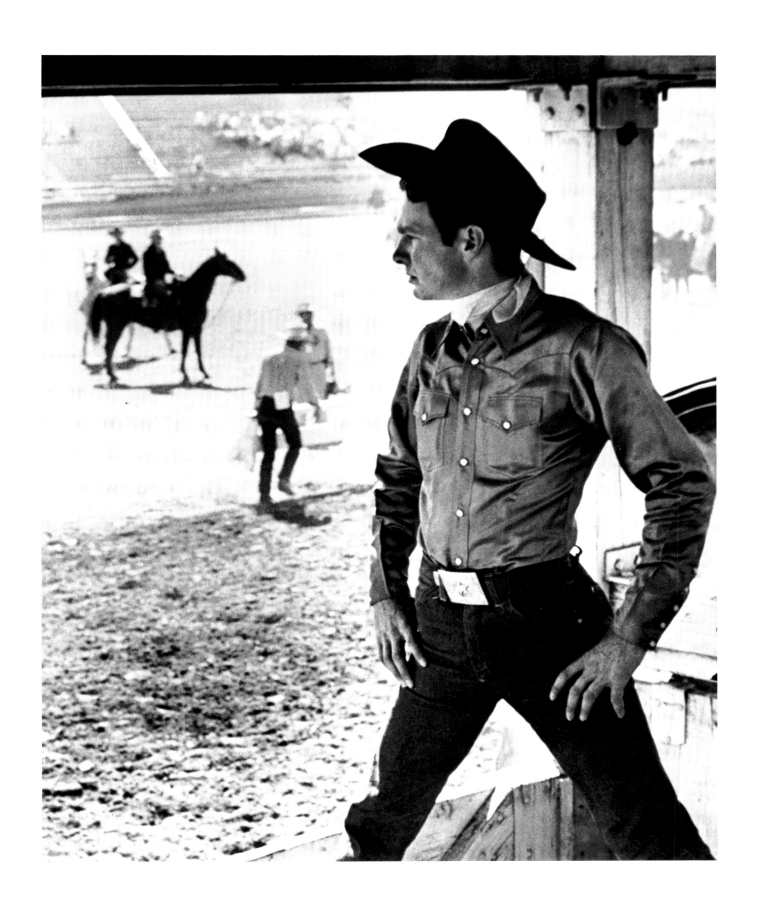

Hy Peskin 1951
Champion bronc rider, Casey Tibbs.
LIFE October 22, 1951 Cover

130

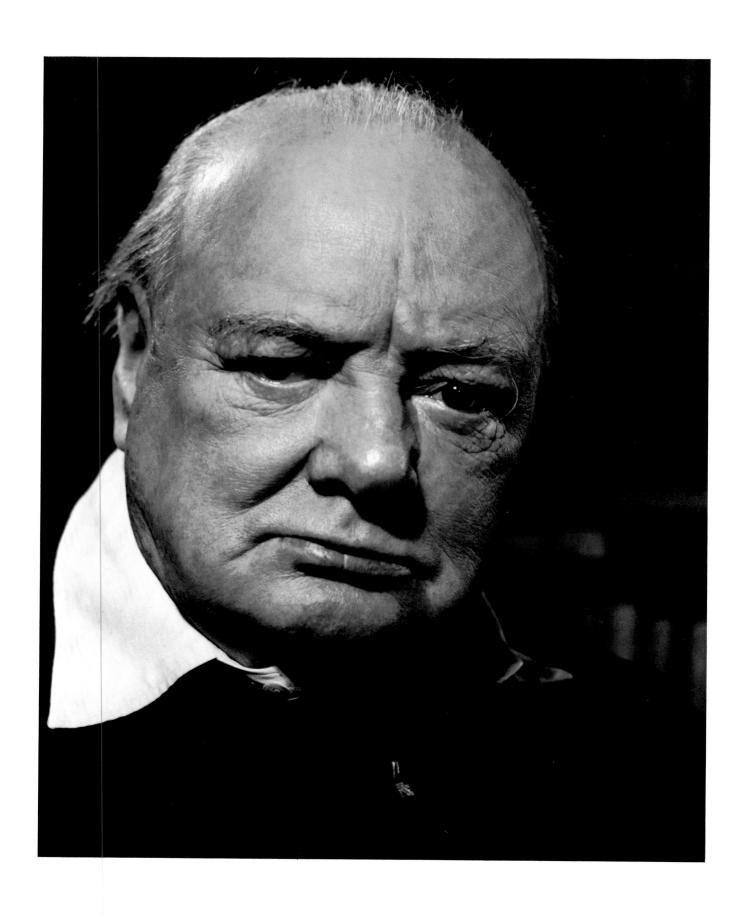

Philippe Halsman 1951
Wearing his World War II siren suit,
Winston Churchill sits for his portrait.
LIFE October 8, 1951

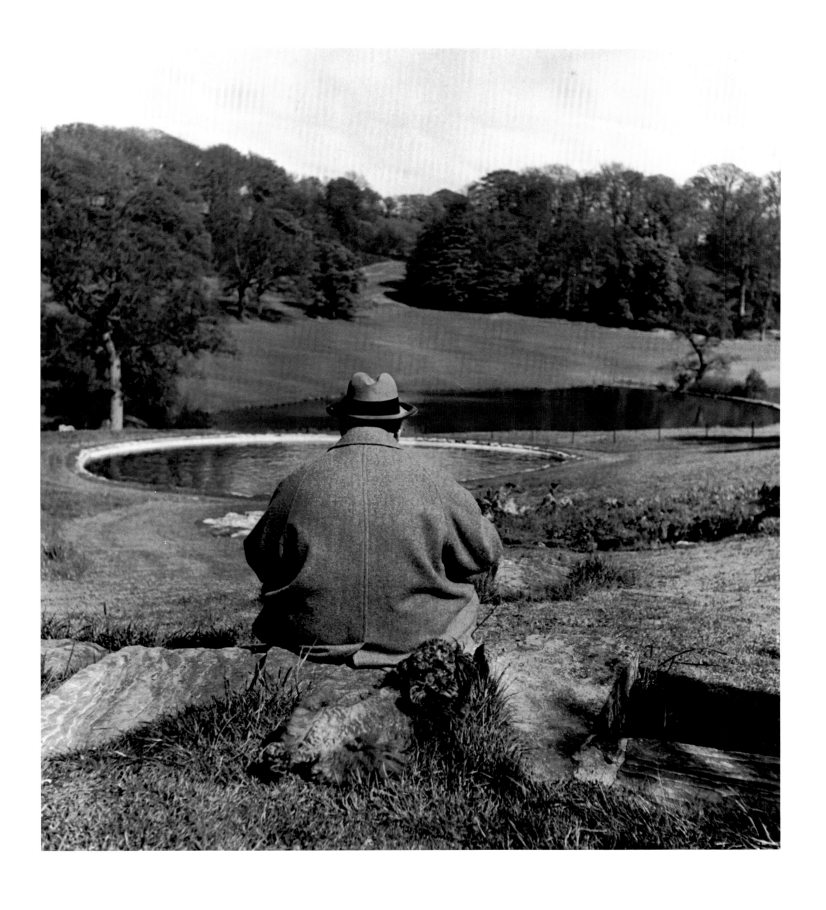

Philippe Halsman 1951
Guarded by his poodle, Rufus, Winston
Churchill at Chartwell, his country home.
LIFE October 8, 1951

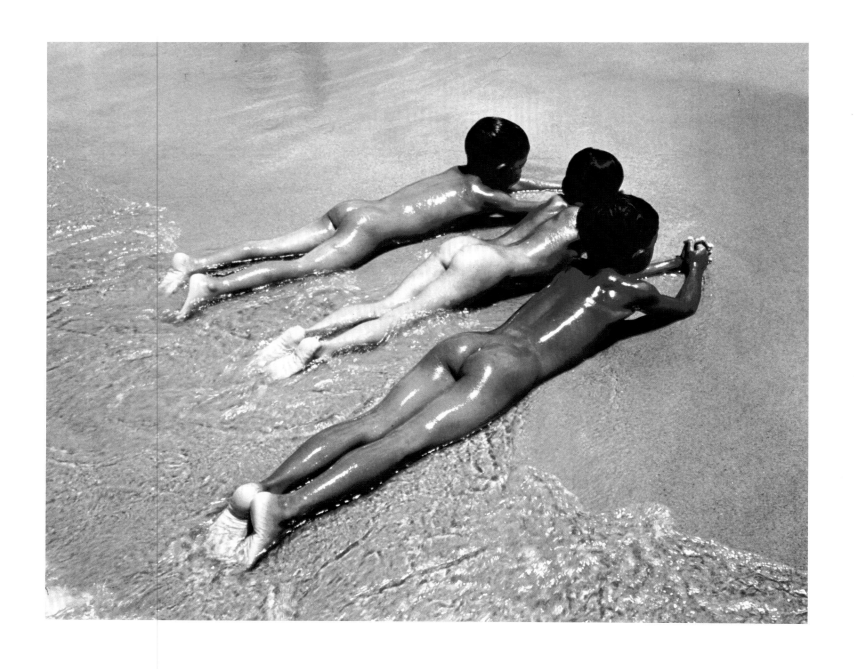

Howard Sochurek 1951
Three native boys sunning themselves at Pantai
Chinta Berahi, Malaya.
LIFE December 31, 1951

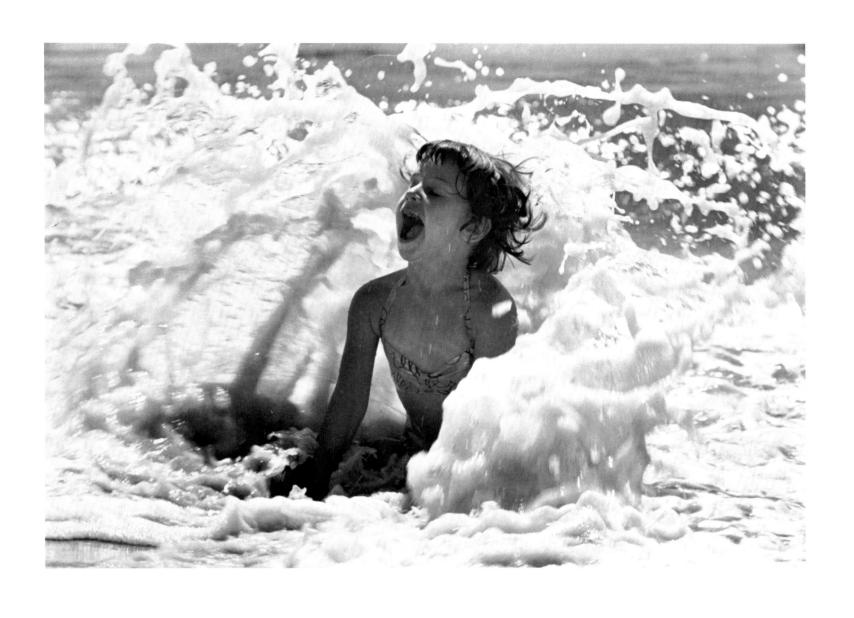

Alfred Eisenstaedt 1951
Exuberant child in surf.

134

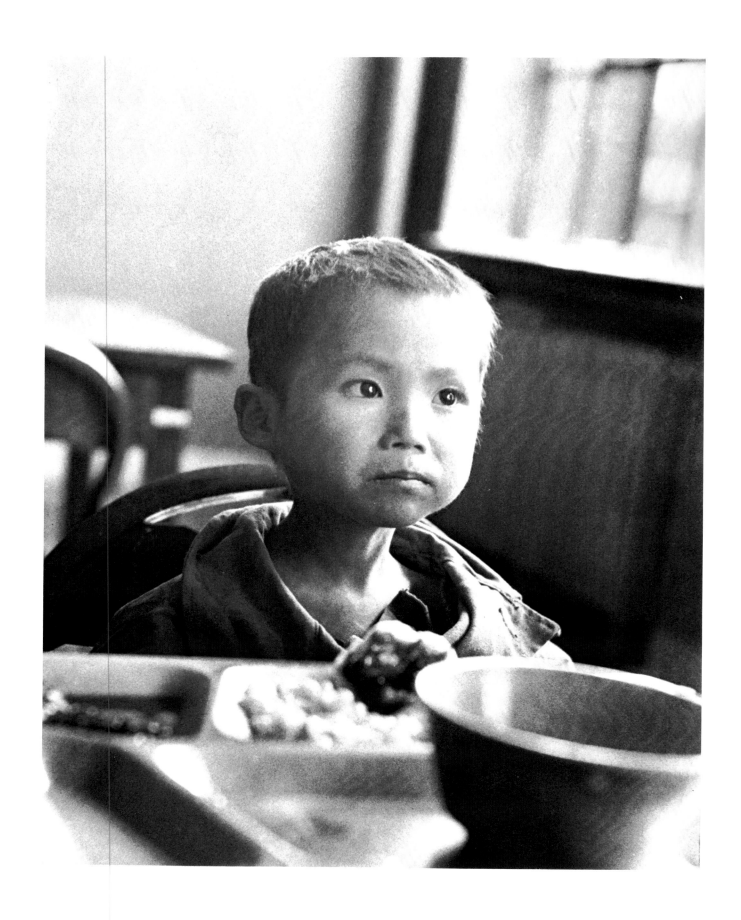

Michael Rougier 1951
Kang Koo Ri, a sad-faced Korean War orphan.
awaits his first meal at the Taegu orphanage.
LIFE July 23, 1951

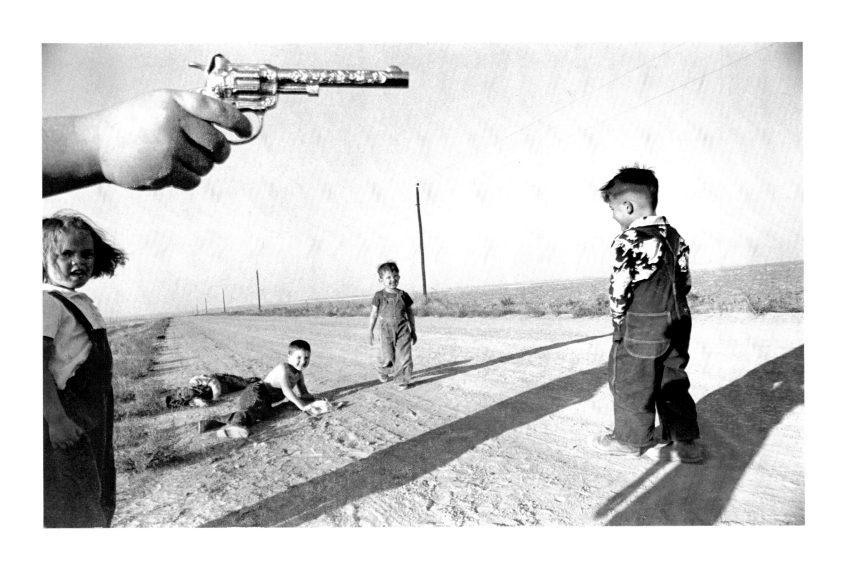

Howard Sochurek 1952
Children with toy gun. From Prairie Country
essay.

136

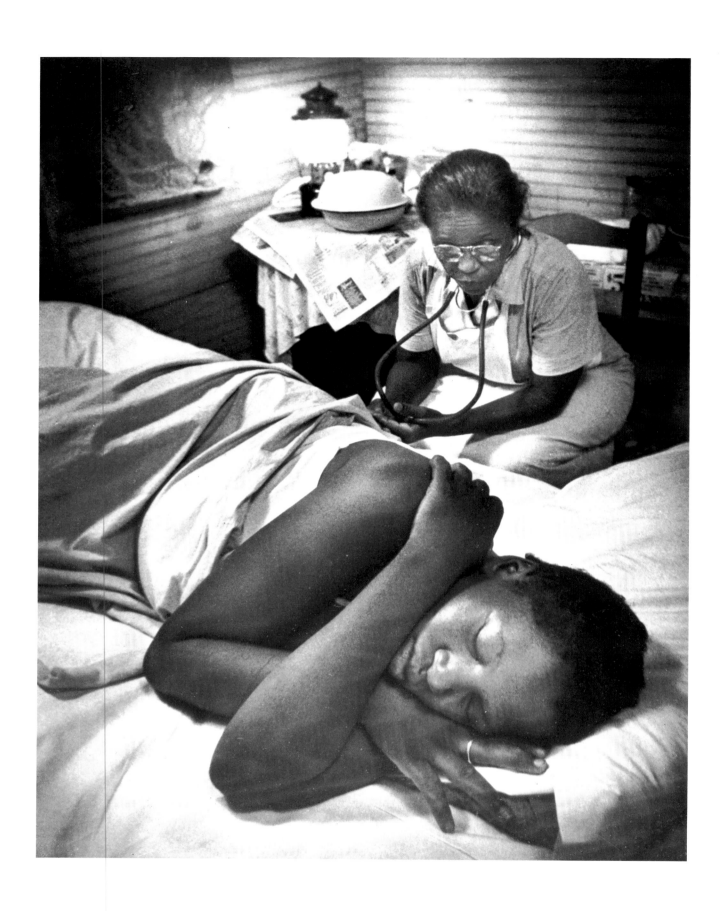

W. Eugene Smith 1951
Midwife attends a woman in labor, South
Carolina. This photograph, and the three
following photographs, are from the essay,
"Maude Callen, Nurse Midwife."
LIFE December 3, 1951

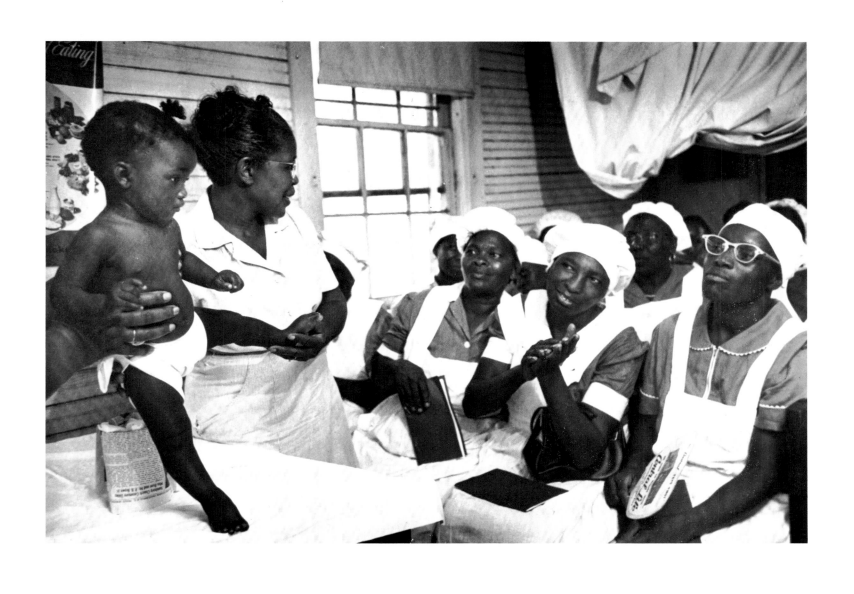

W. Eugene Smith 1951
Maude Callen teaching a class in midwifery.
LIFE December 3, 1951

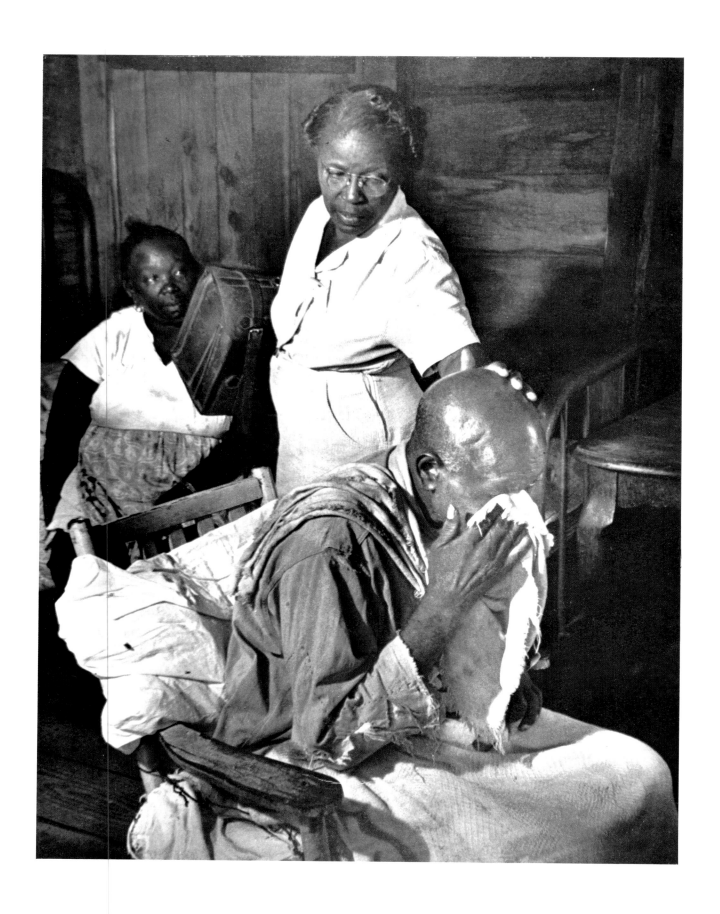

W. Eugene Smith 1951
Maude Callen attends a chair-bound paralytic
who is touched by her kindness.
LIFE December 3, 1951

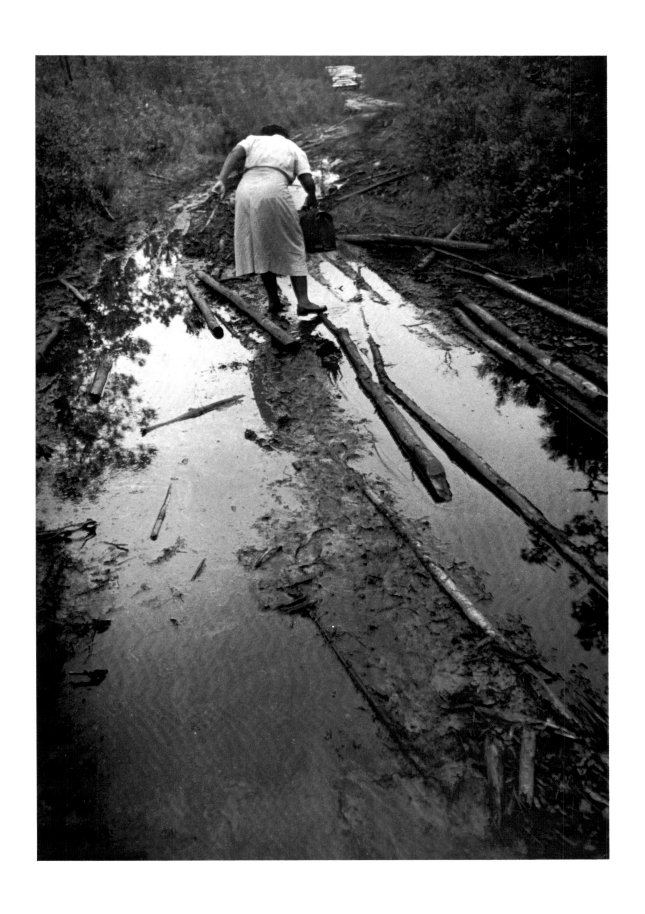

W. Eugene Smith 1951
After paying a house call, Maude Callen works
her way along the muddy road to her car.
LIFE December 3, 1951

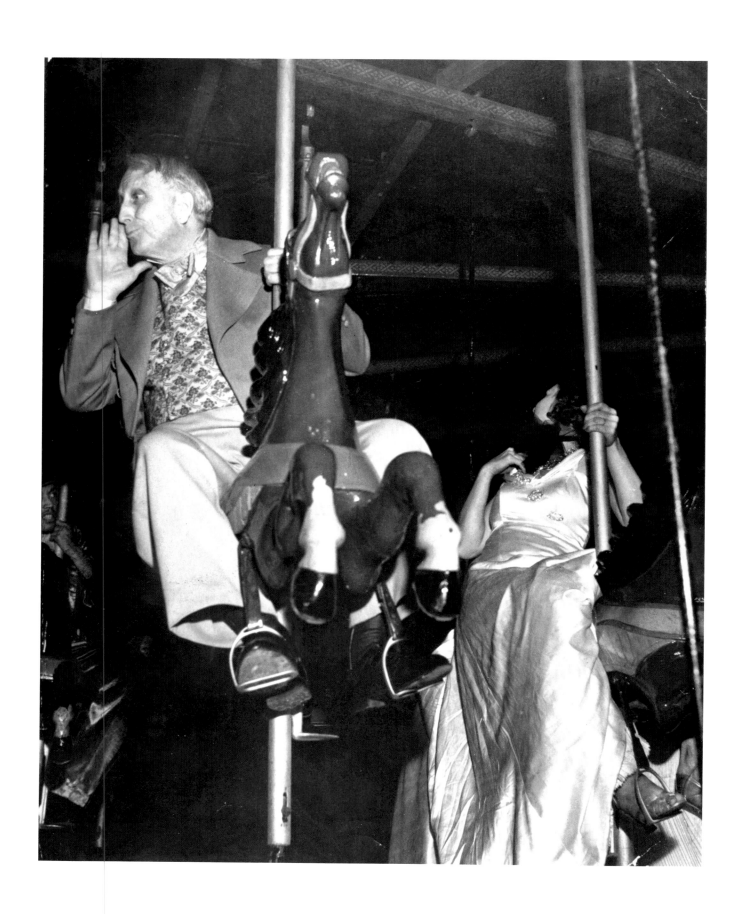

Bob Landry 1951
William Randolph Hearst rides a merry-go-
round at San Simeon during his 88th birthday
party.
LIFE August 27, 1951

141

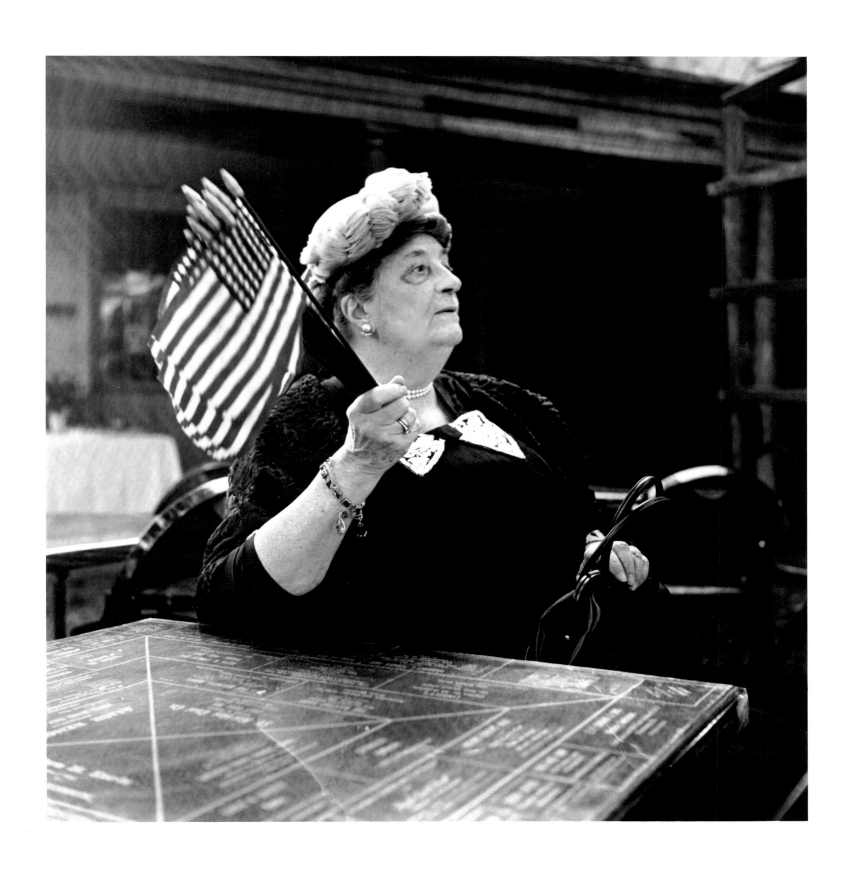

Sam Narcella 1952
Matron at Wister family reunion in Philadelphia.

142

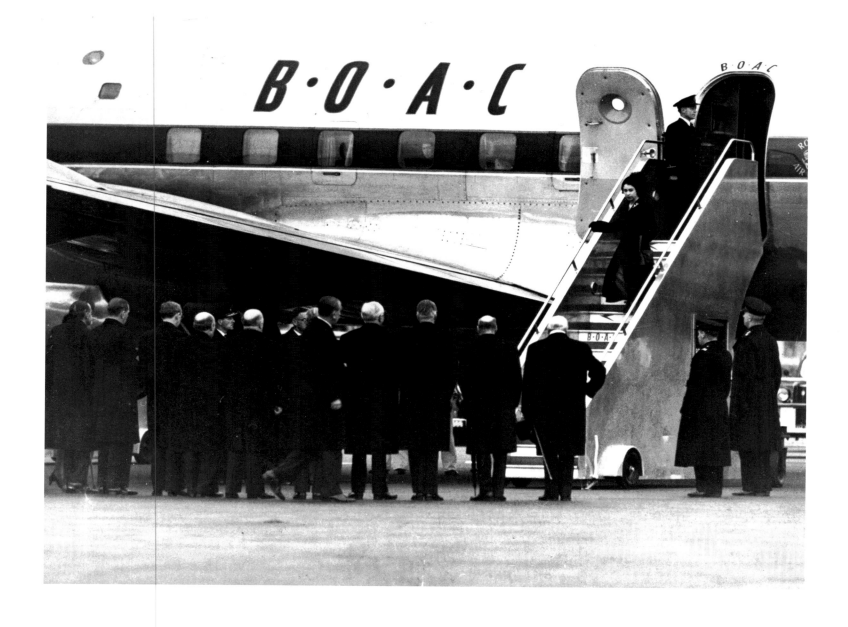

Keystone 1952
Elizabeth, who had flown to Kenya as a princess,
returned to England following the death of her
father, George VI, as Queen Elizabeth II.
Waiting to greet her are, right to left: Winston
Churchill, Clement Attlee, Anthony Eden and
Lord Woolton.
LIFE February 18, 1952

143

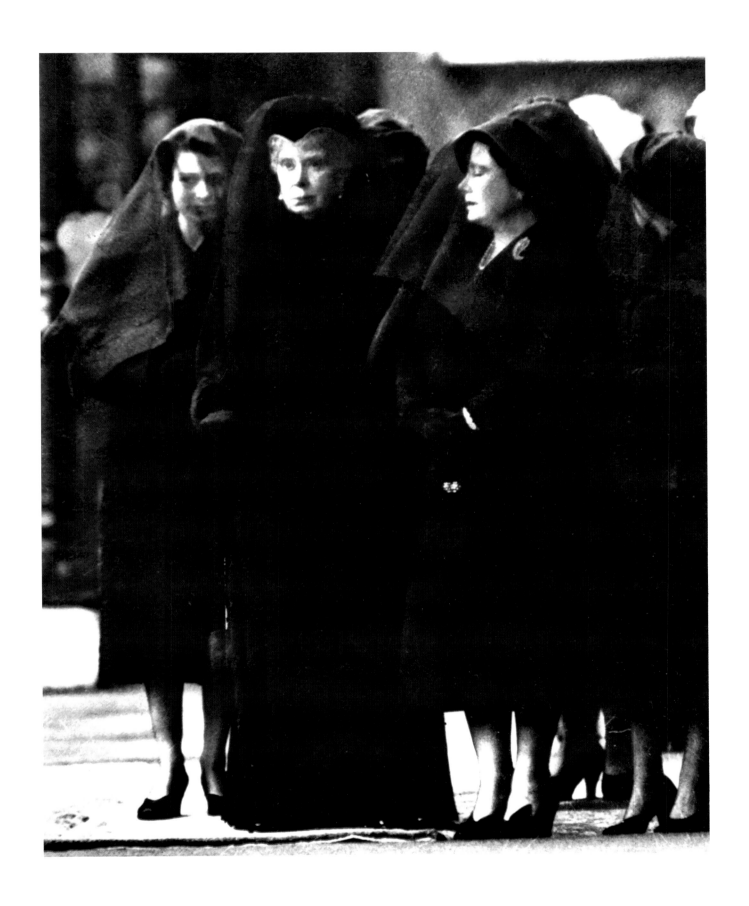

Keystone 1952
Three mourning queens watch the coffin of
George VI being borne into Westminister Hall.
They are, left to right: Queen Elizabeth II, The
Dowager Queen Mary and The Queen Mother
Elizabeth.
LIFE February 25, 1952

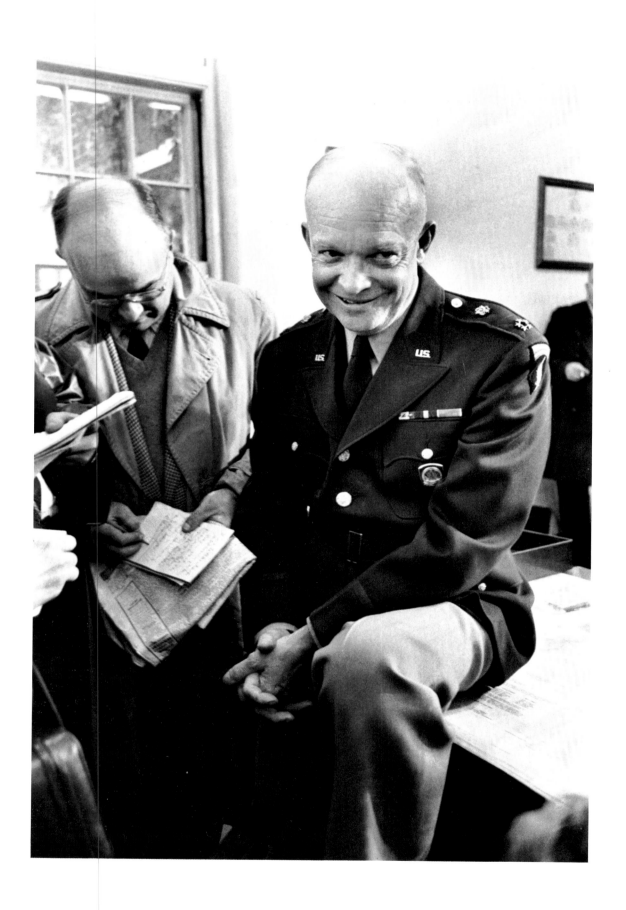

Lisa Larsen 1951
General Eisenhower, on his return from Europe,
evades a reporter's question about his
presidential ambitions.
LIFE November 12, 1951

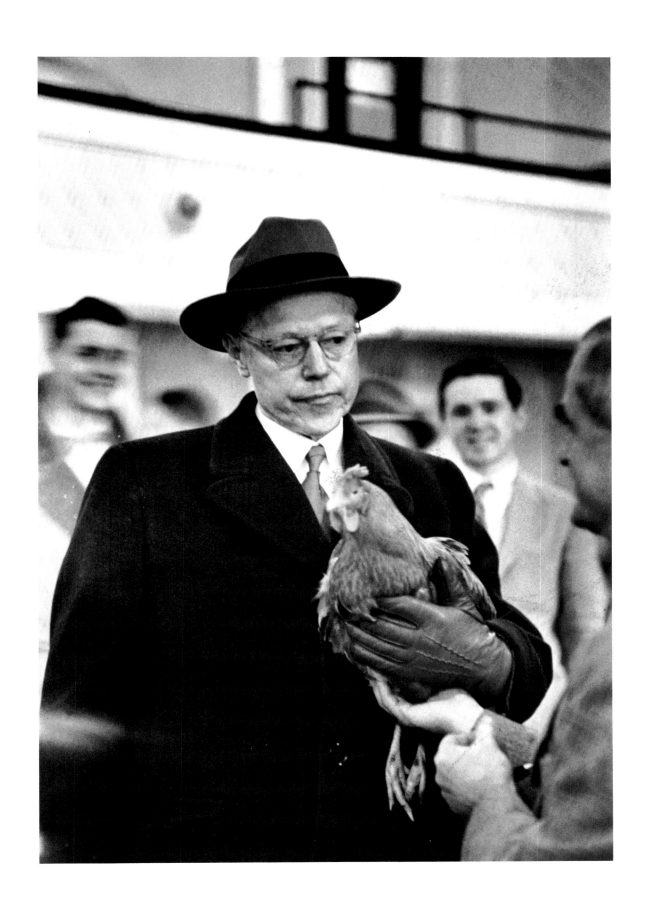

Alfred Eisenstaedt 1952
During his New Hampshire primary campaign,
Robert Taft, presented here with a rooster, looks
dismayed, an expression he was to repeat a few
days later when he learned he had been defeated
in the Republican primary by Dwight Eisenhower.
LIFE March 24, 1952

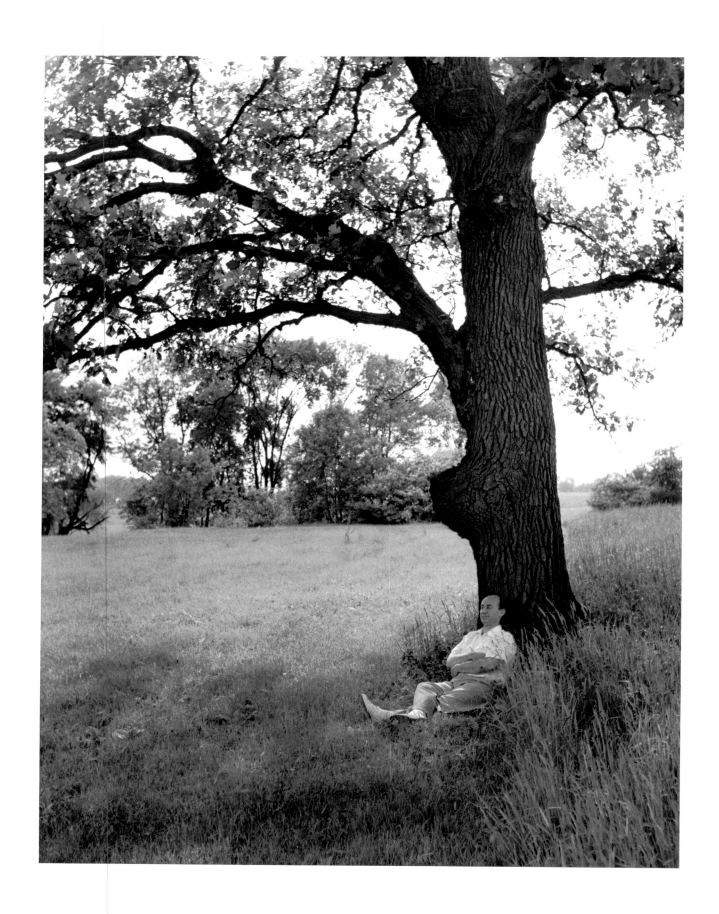

Cornell Capa 1952
Adlai Stevenson sits under an oak tree on his
farm in Illinois considering whether or not to
seek the Democratic party's nomination for the
presidency.
LIFE July 21, 1952

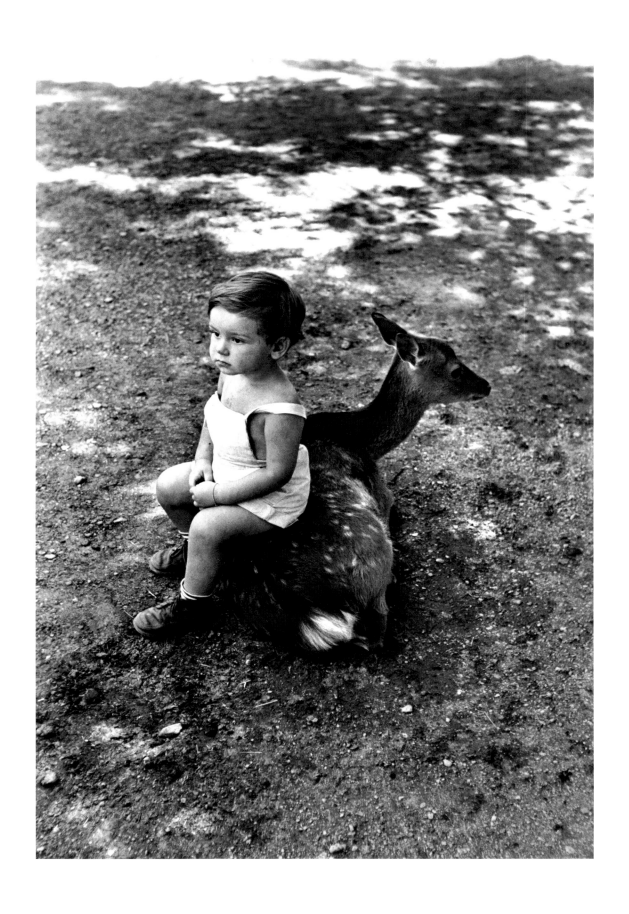

Burt Glinn 1952
Small boy rests at children's game farm.

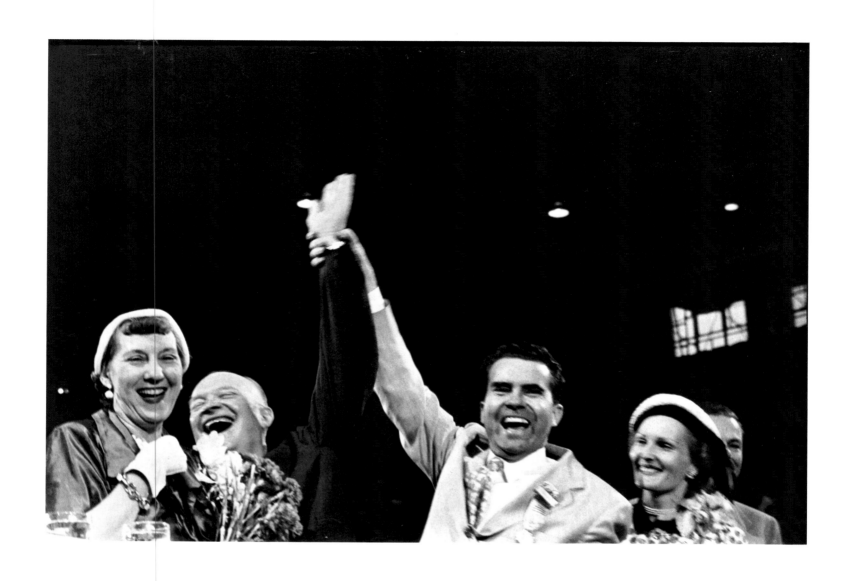

George Skadding 1952
Dwight Eisenhower and Richard Nixon, with
their wives, after being chosen to lead
the Republican presidential ticket, at the
Republican national convention in Chicago.
LIFE July 21, 1952

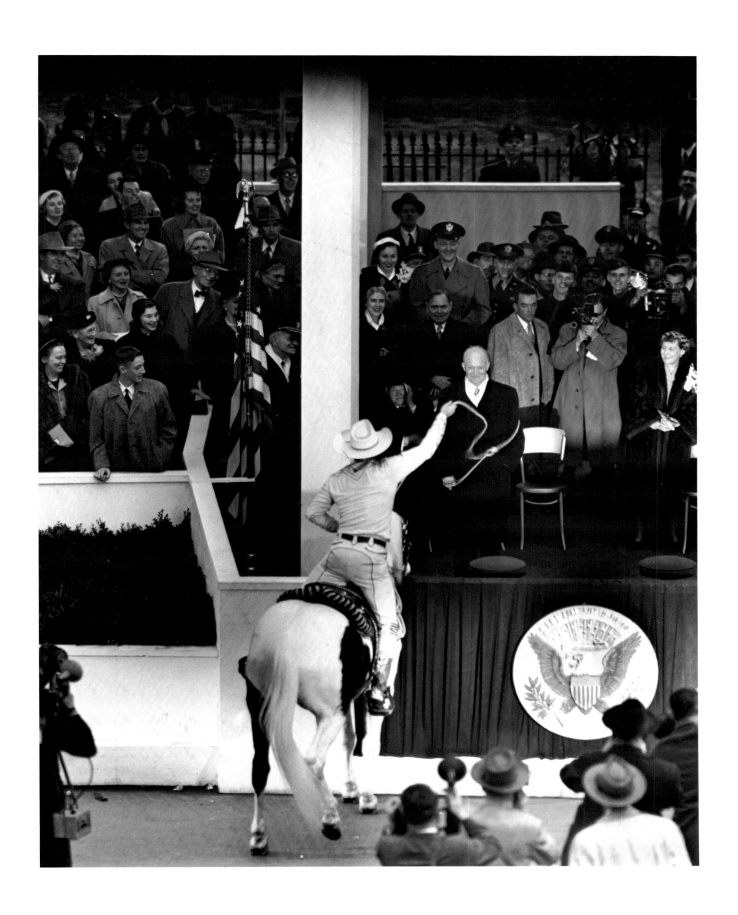

Hank Walker 1953
President Eisenhower, at his inauguration,
is approached by a parade cowboy who, after
asking permission, lassoes him.
LIFE February 2, 1953

150

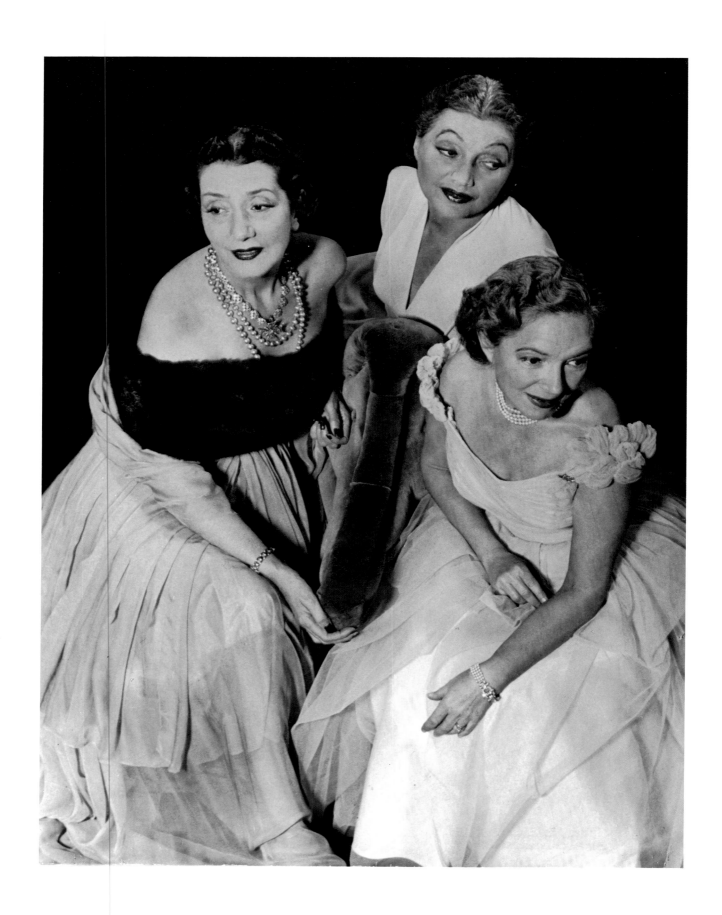

Philippe Halsman 1951
Three leading ladies of the U.S. stage. Left to
right: Lynn Fontanne, Katharine Cornell and
Helen Hayes.
LIFE November 19, 1951 Cover

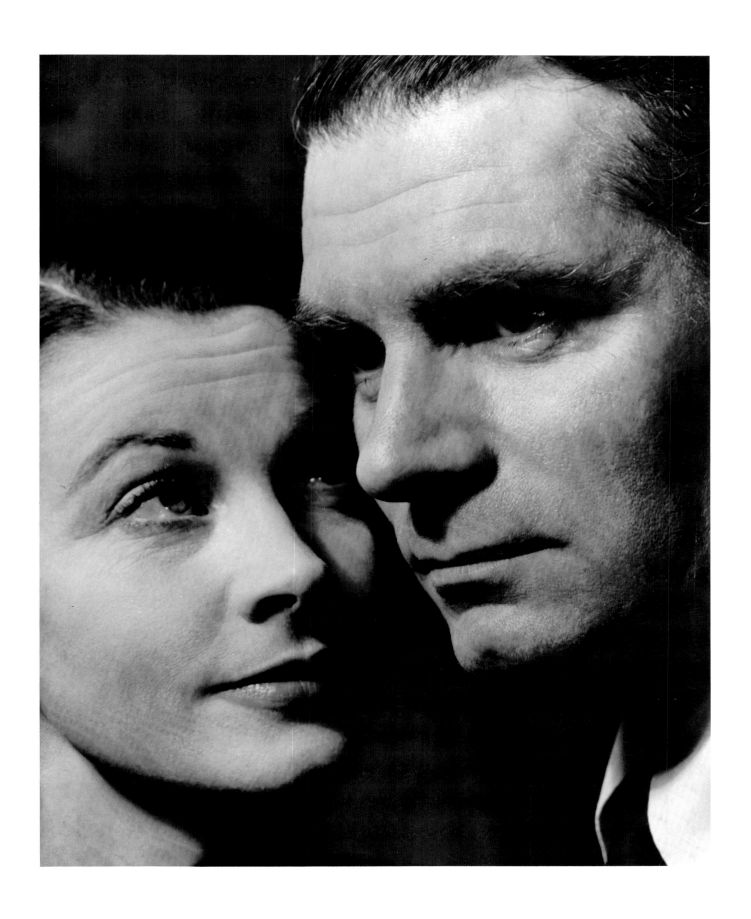

Philippe Halsman 1951
Vivien Leigh and Laurence Olivier.
LIFE December 17, 1951 Cover

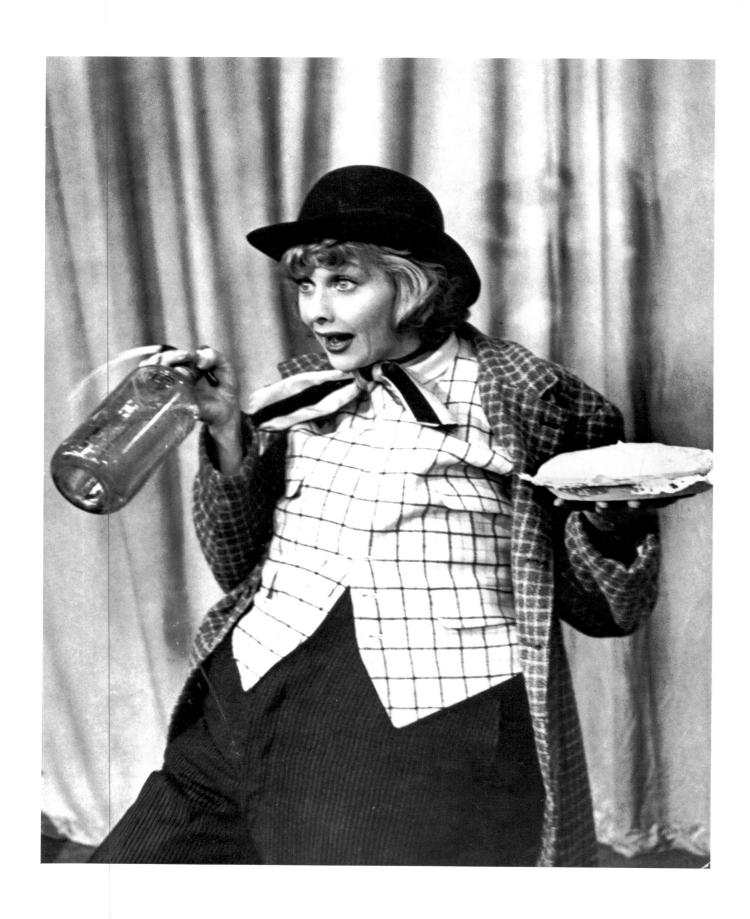

Loomis Dean 1952
On her television show, *I Love Lucy*, Lucille Ball
brandishes some of her typical props.
LIFE February 18, 1952

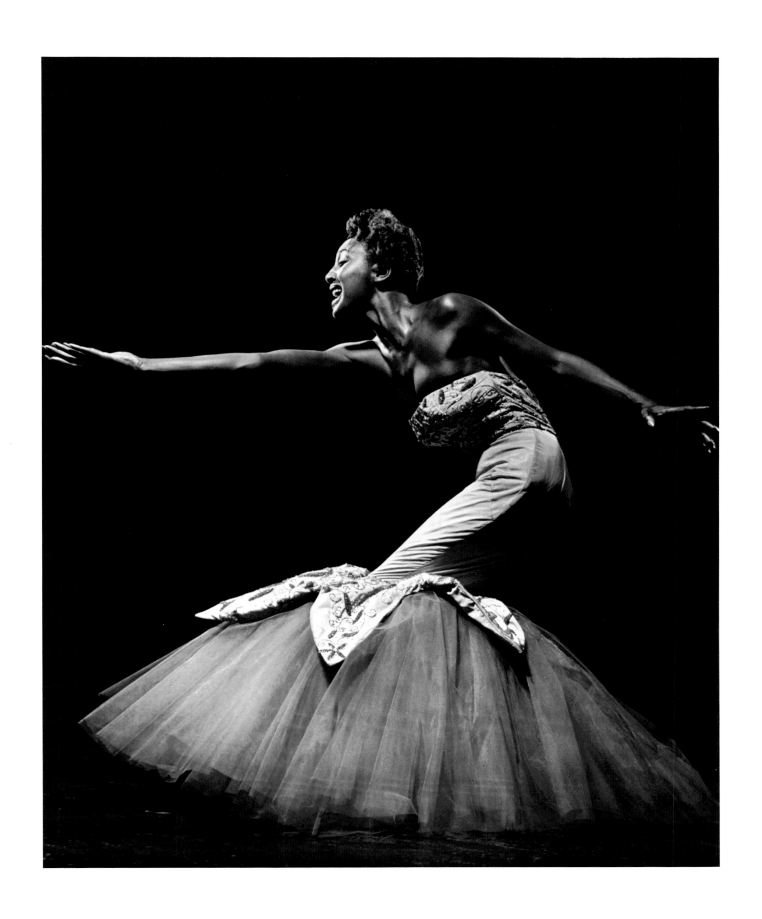

Philippe Halsman 1953
Joyce Bryant belts out a song at New York's
Copacabana nightclub.

154

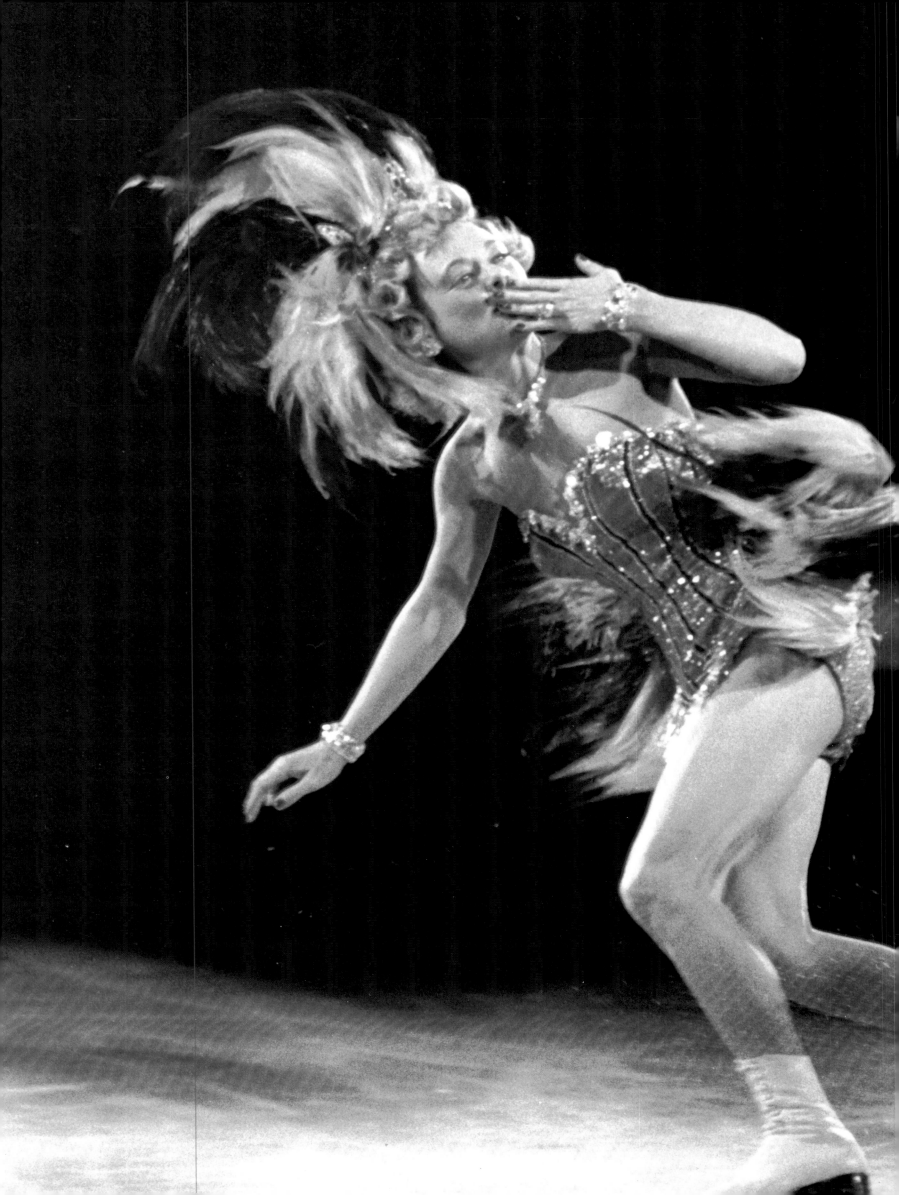

John Dominis 1952
Sonja Henie wafts a kiss
to her audience in
Houston, Texas.
LIFE February 4, 1952

155

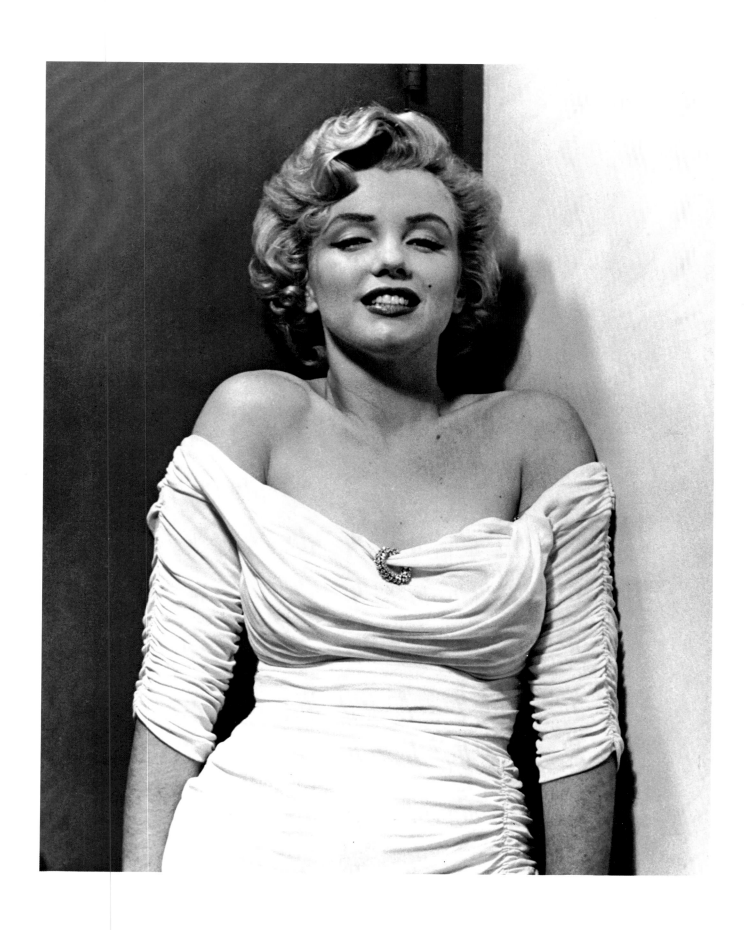

Philippe Halsman 1952
Marilyn Monroe.
LIFE April 7, 1952

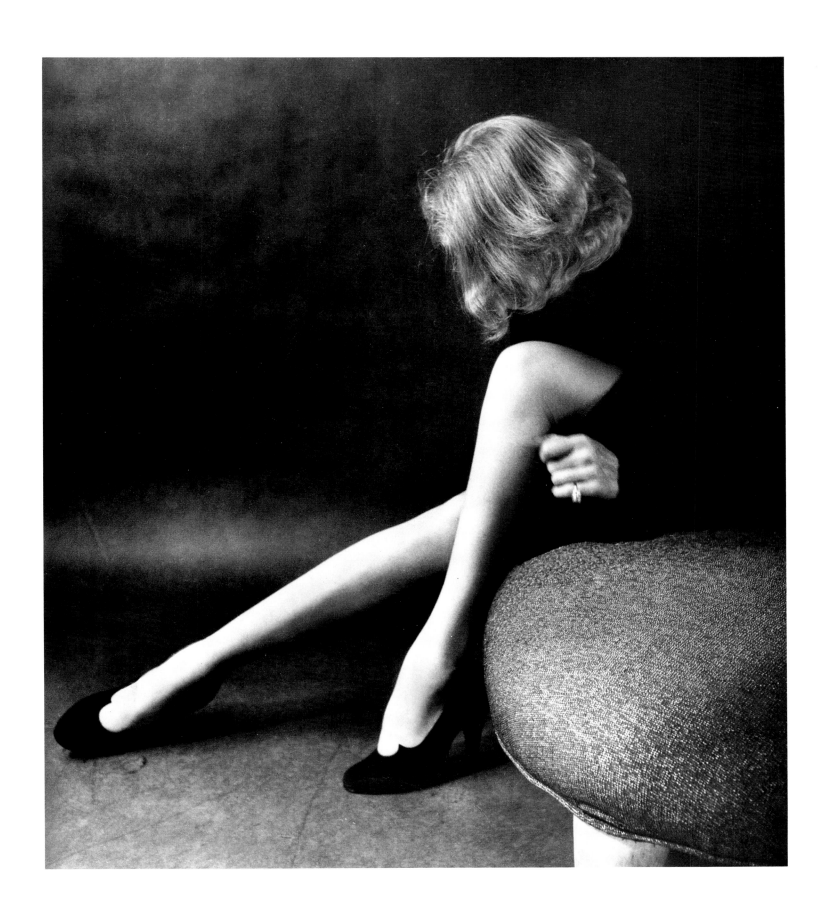

Milton Greene 1952
Marlene Dietrich.
LIFE August 18, 1952

157

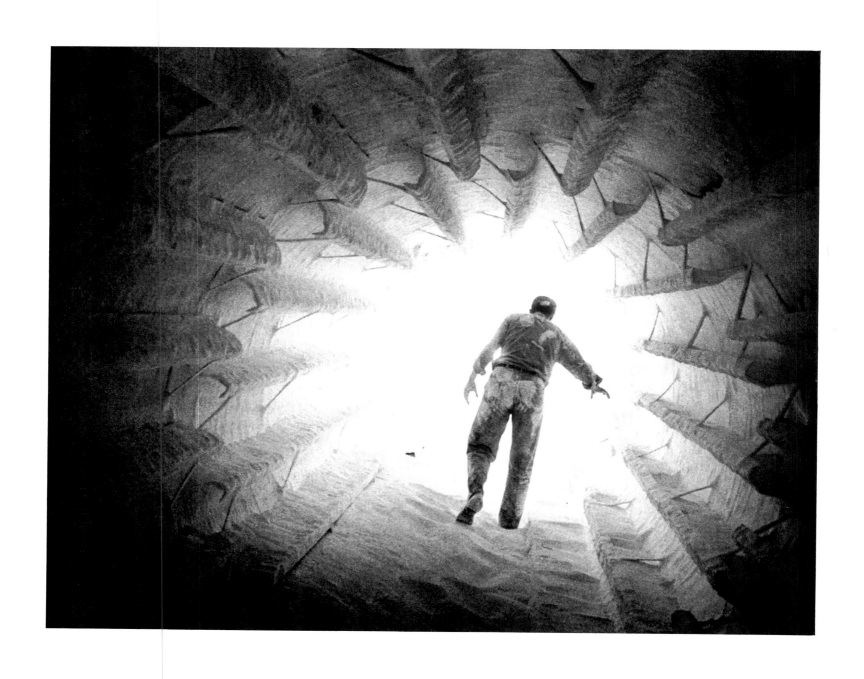

W. Eugene Smith 1952
Monsanto inspector gropes his way into recesses
of a calciner, a furnace that makes phosphates.
LIFE January 5, 1952

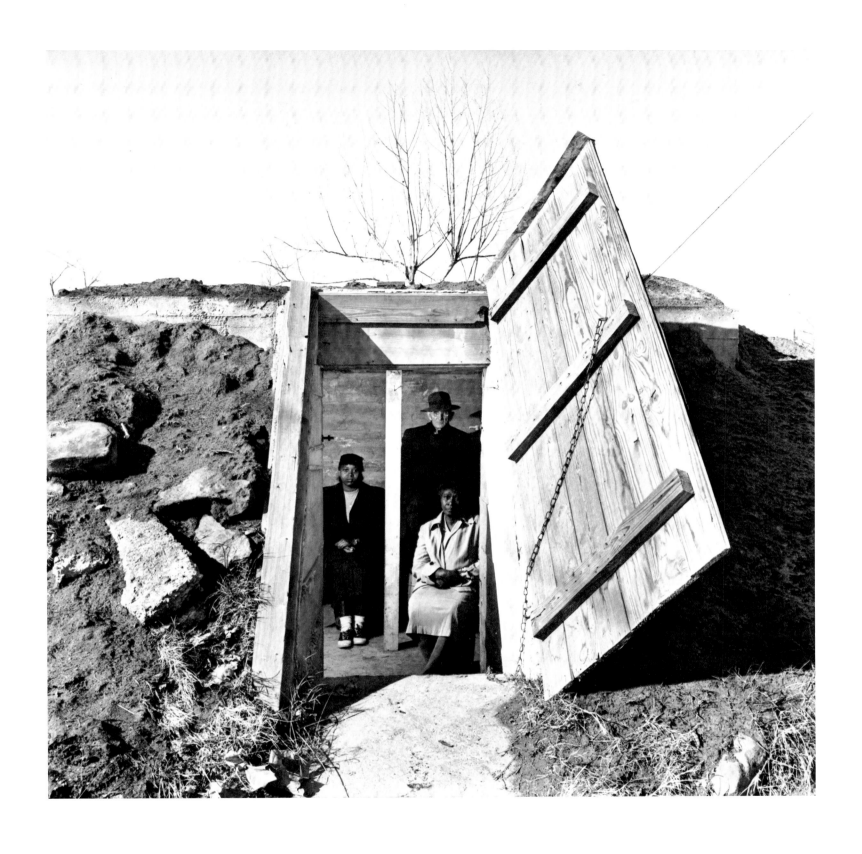

John Dominis 1952
Residents try newly built community storm
shelter, after tornado devastation of Judsonia,
Arkansas.

159

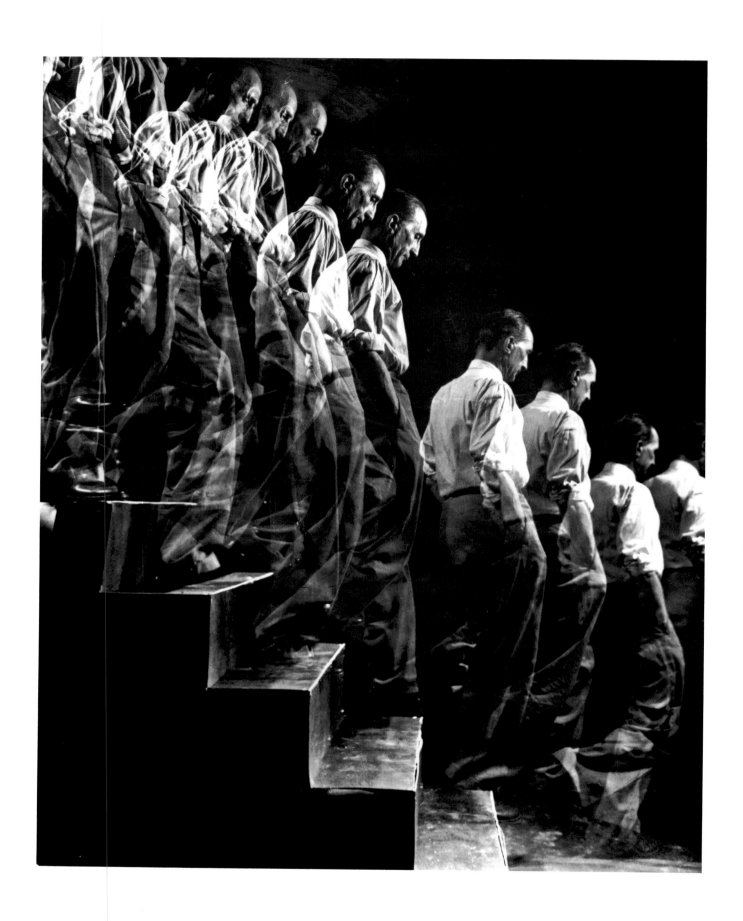

Eliot Elisofon 1952
Marcel Duchamp is photographed descending
stairs in a repetitive flash picture reminiscent
of his Dadaist painting. *Nude Descending A
Staircase*, No. 2.
LIFE April 28, 1952

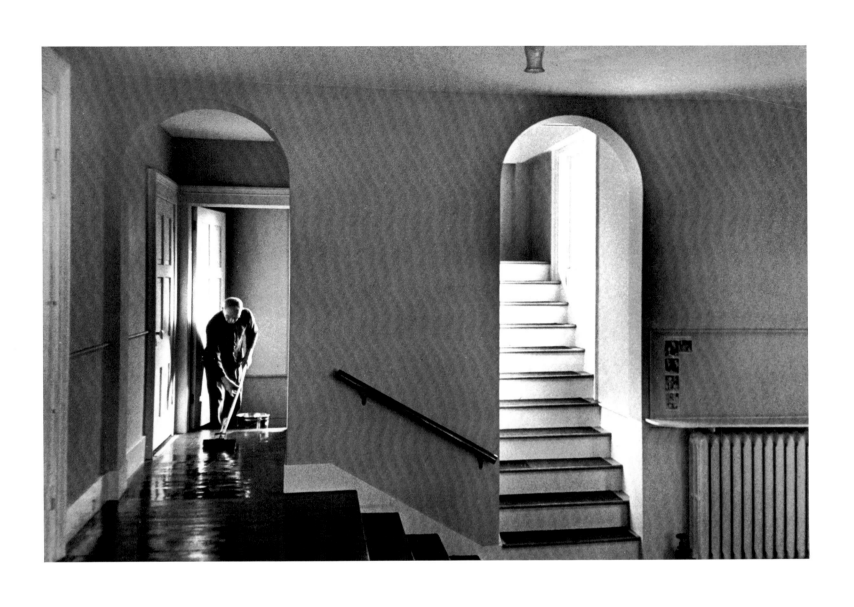

Esther Bubley 1952
Sexton of Congregational church in Middlebury,
Vermont, pursues his duties.
LIFE December 29, 1952

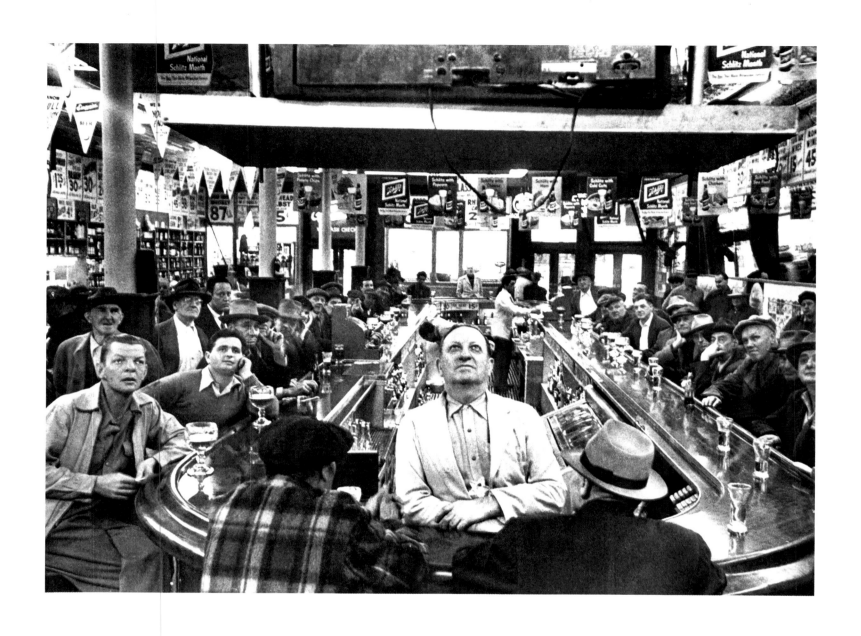

Francis Miller 1952
Customers at a Chicago bar join bartender in
watching seventh game in the 1952 World Series
between Yankees and Dodgers.
LIFE October 20, 1952

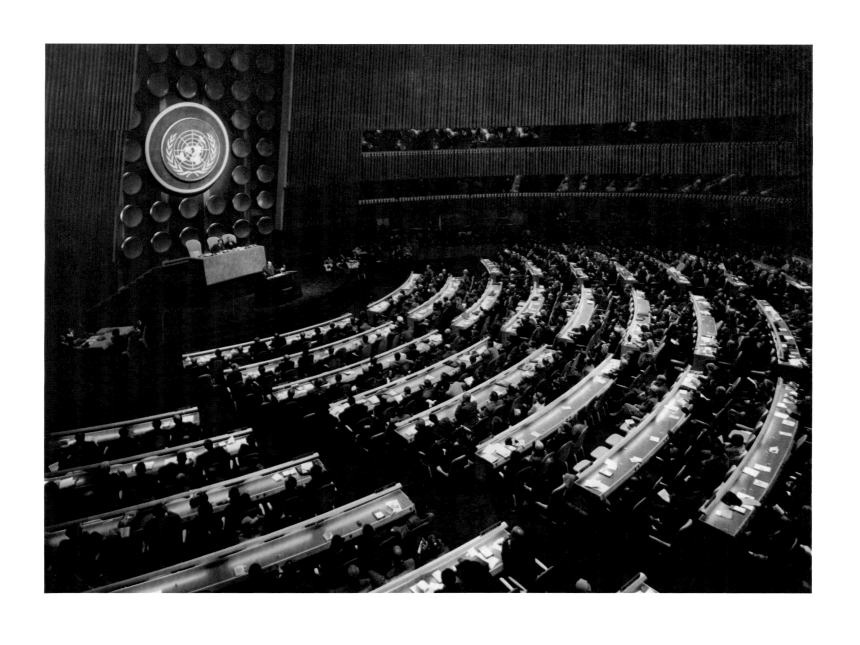

Philippe Halsman 1952
At the opening of the United Nations General
Assembly building in New York, Secretary
General Trygve Lie addresses the audience of
delegates and advisors.
LIFE November 3, 1952

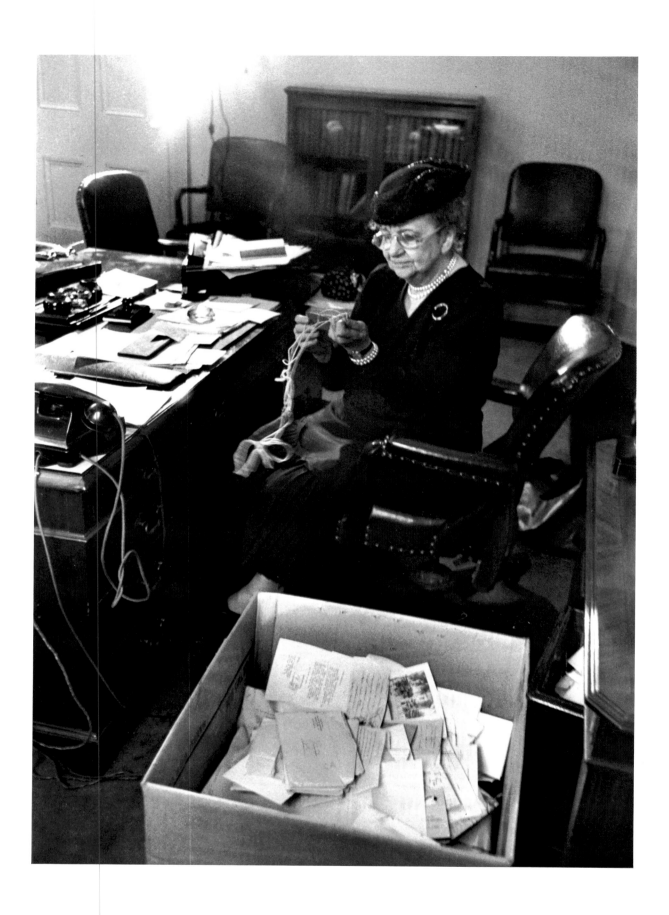

Cornell Capa 1953
Leaving Washington after many years of
government service, former Secretary of Labor
Frances Perkins untangles twine she had saved
in anticipation of a wartime shortage.
LIFE April 20, 1953

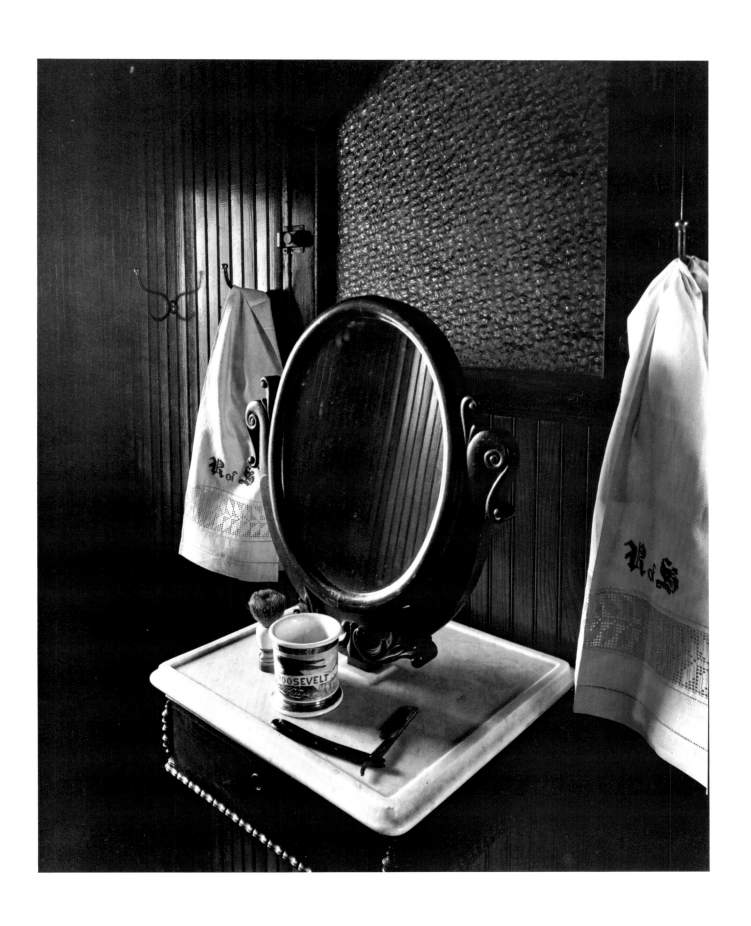

© **Arnold Newman** 1953
Theodore Roosevelt's shaving stand at his home,
Sagamore Hill, in Oyster Bay, New York.
LIFE June 29, 1953

165

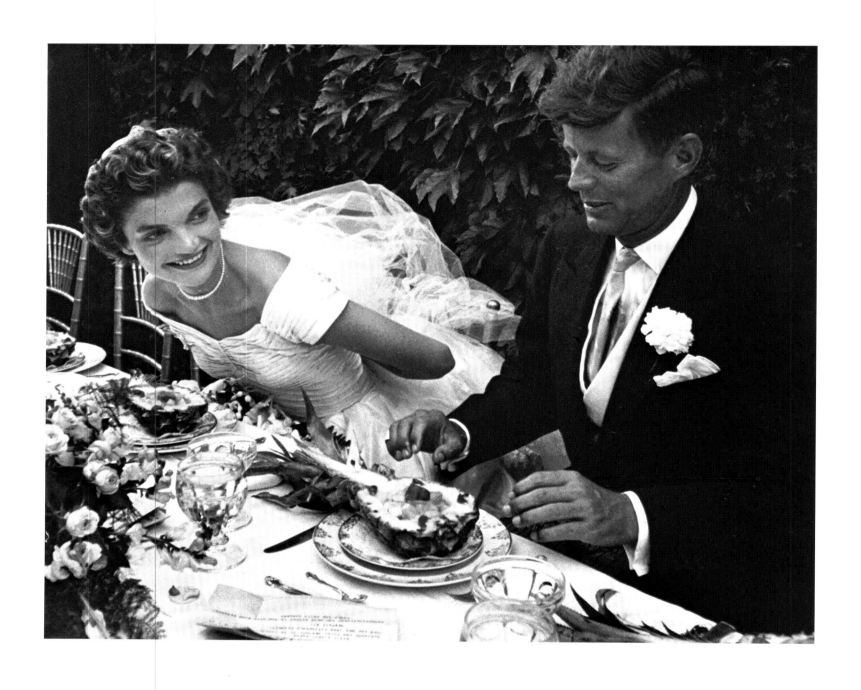

Lisa Larsen 1953
Senator and Mrs. John F. Kennedy sit down to
lunch at their wedding reception in Newport,
Rhode Island.
LIFE September 28, 1953

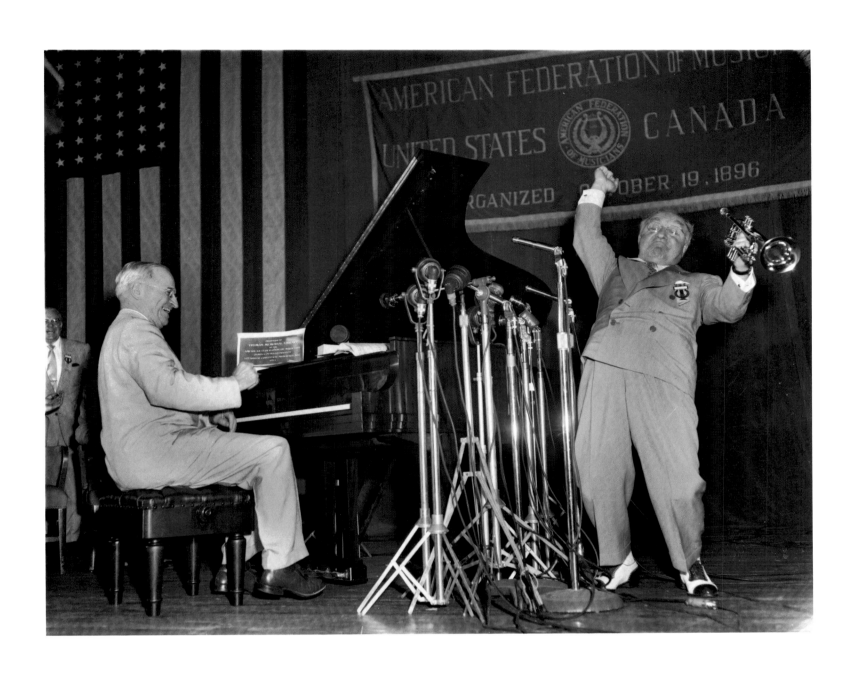

John Ahlhauser 1954
Harry Truman, left, and James Petrillo, right,
give an impromptu concert at convention of
American Federation of Musicians.
LIFE June 28, 1954

167

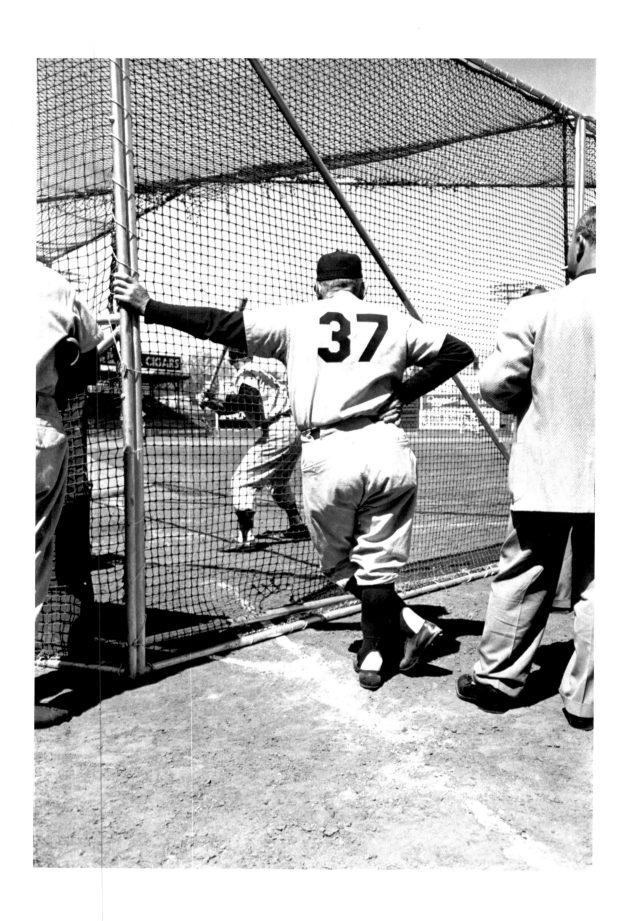

Mark Kauffman 1953
Casey Stengel watches batting practice.

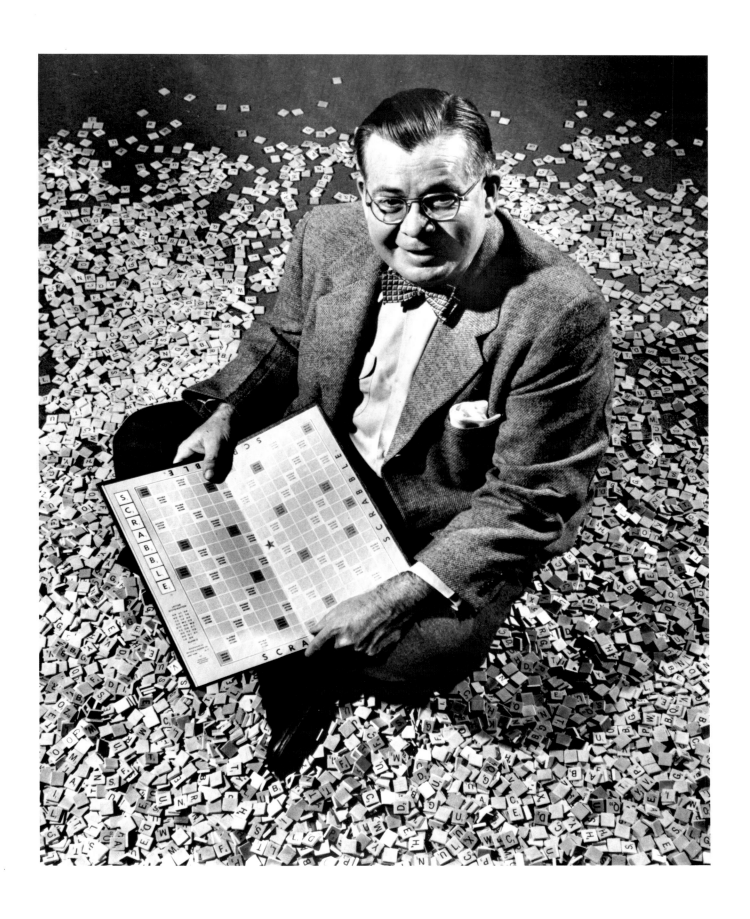

Werner Wolff 1953
Scrabble producer, James Brunet, amidst some
of the 150,000 letters manufactured each day.

169

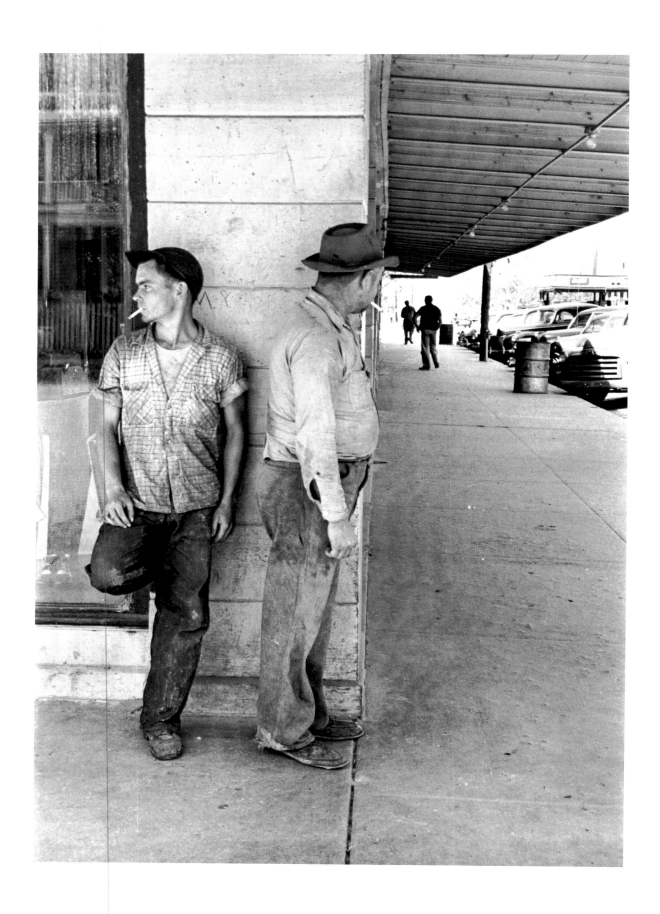

John Dominis 1953
In Louisiana, during a bitter labor fight, two
company men are stranded when their truck
breaks down in a labor town.
LIFE April 13, 1953

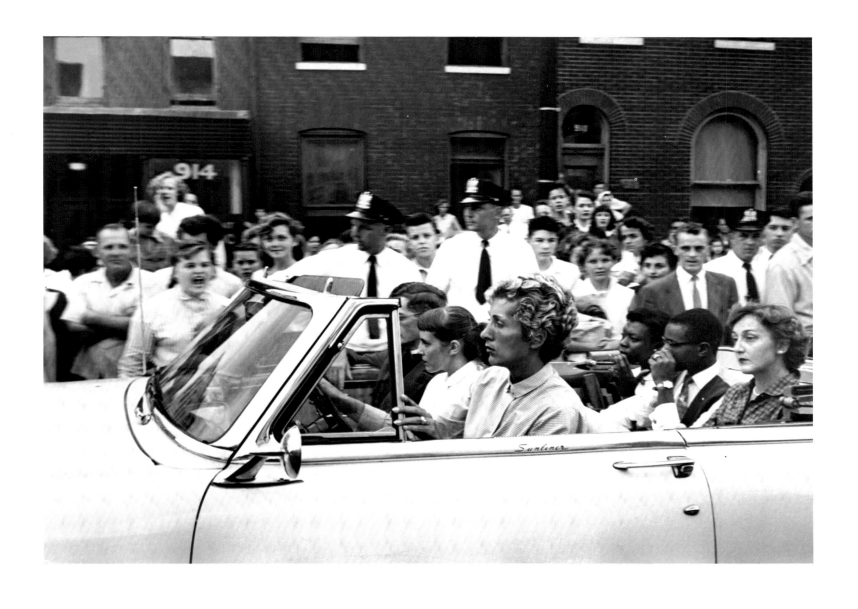

George Skadding 1954
Two schoolteachers and a local minister drive black students home after a day of being subjected to anti-integration rioting at a Baltimore, Maryland high school.

171

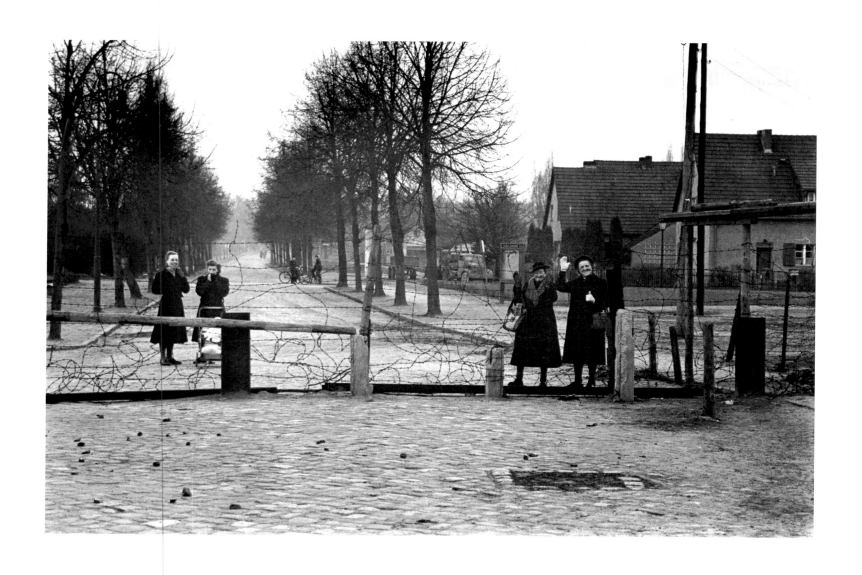

Ralph Crane 1953
At an early stage of the Berlin Wall, East Berlin
women wave greetings to their West Berlin
friends across a barbed-wire barricade.
LIFE March 9, 1953

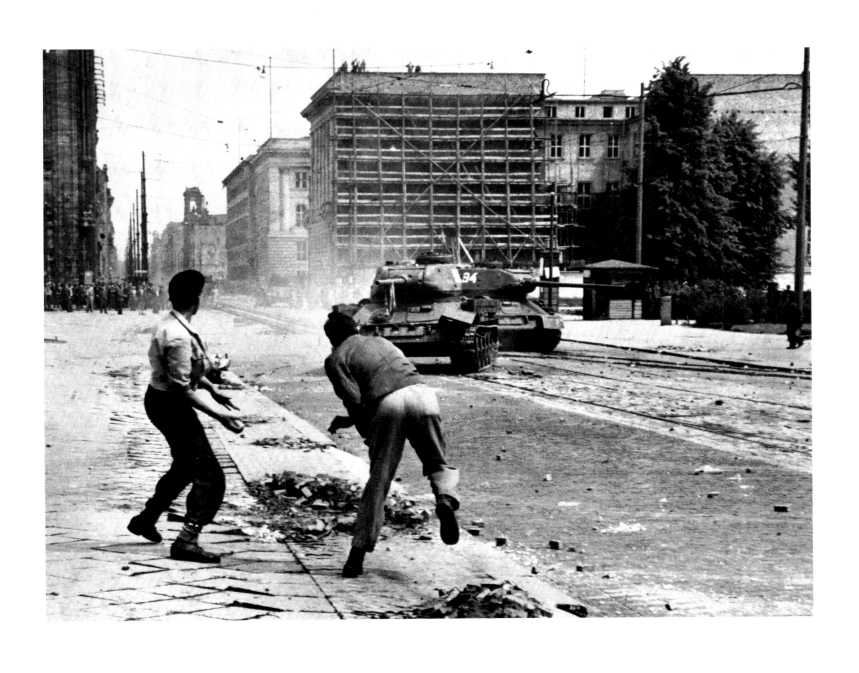

Associated Press 1953
Demonstrators hurl rocks at Soviet tanks when
they move in to put down an anti-Communist
uprising in East Berlin.
LIFE June 29, 1953

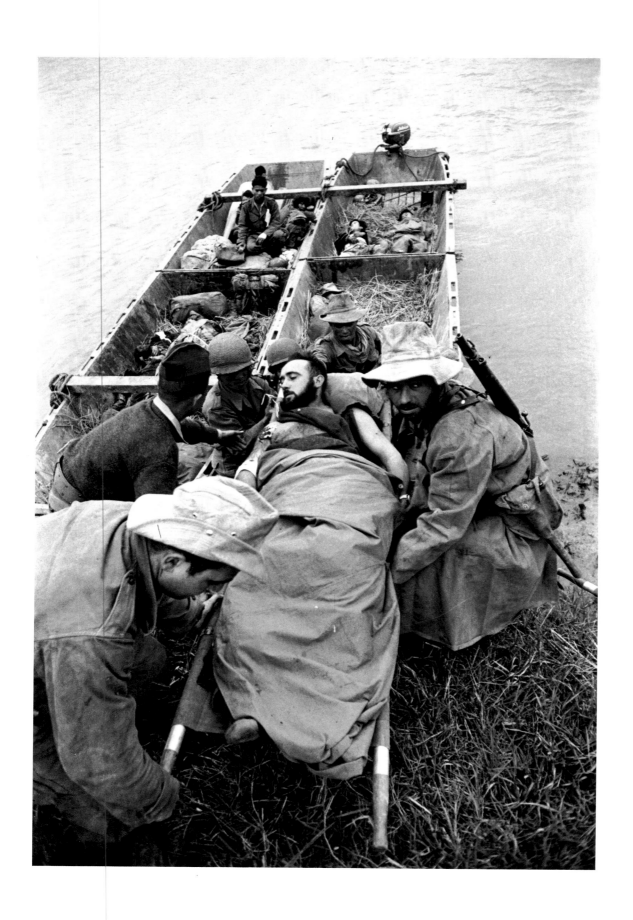

Howard Sochurek 1953
French forces in Indochina evacuate their dead
and wounded in tied-together boats.
LIFE January 11, 1954

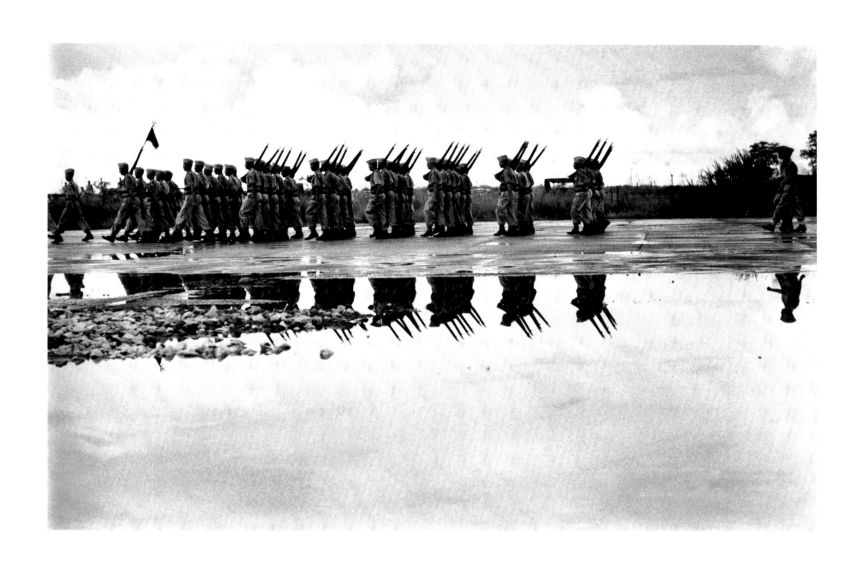

Howard Sochurek 1954
French troops, evacuating Hanoi, are mirrored
in a puddle as they pass in final dress review.
LIFE October 25, 1954

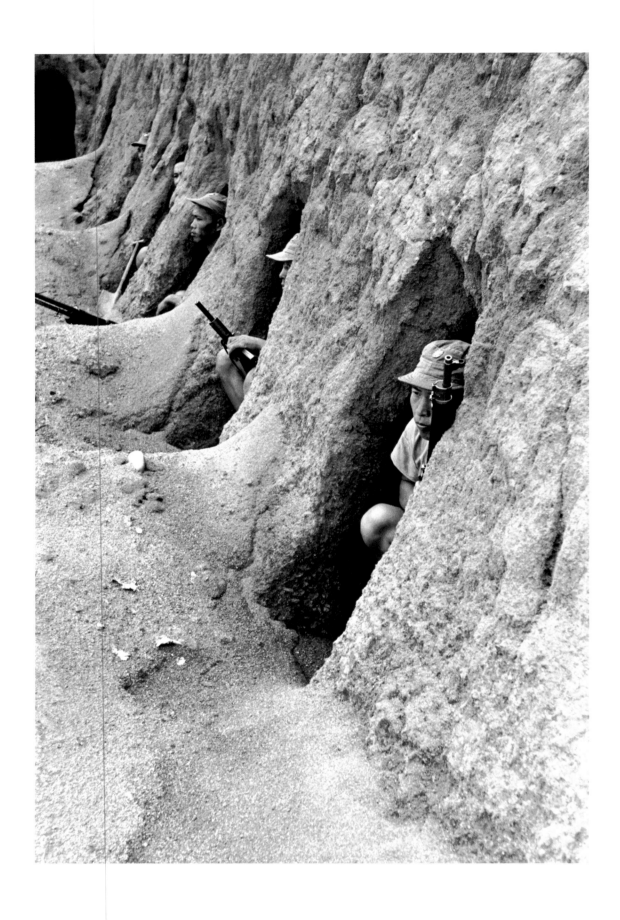

Howard Sochurek 1954
On the island of Quemoy, Nationalist Chinese
soldiers await an attack from Red China.
LIFE January 16, 1954

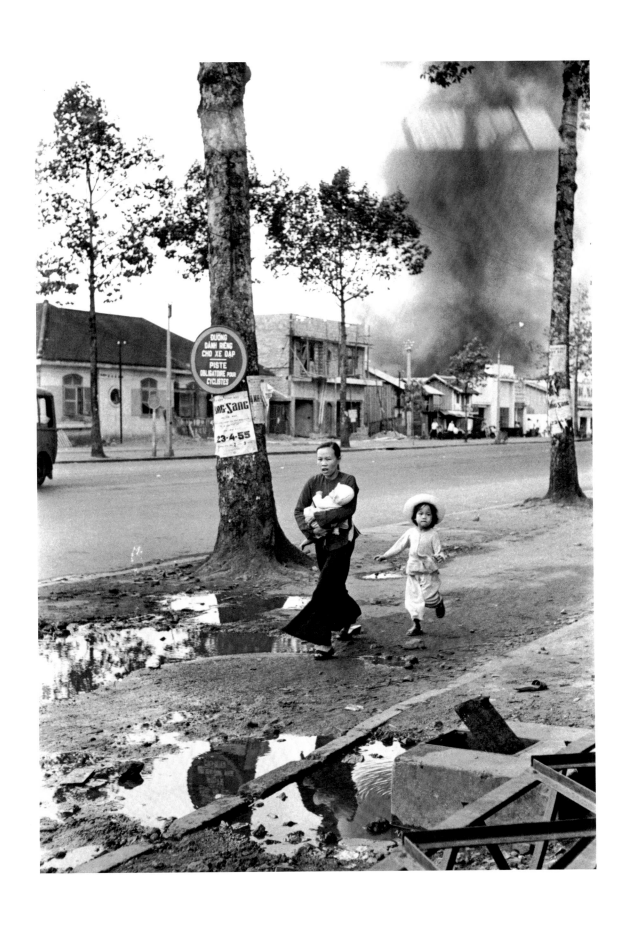

Howard Sochurek 1955
Mother and children flee down a Saigon street
during brief but violent Binh Xuyen uprising in
1955.

177

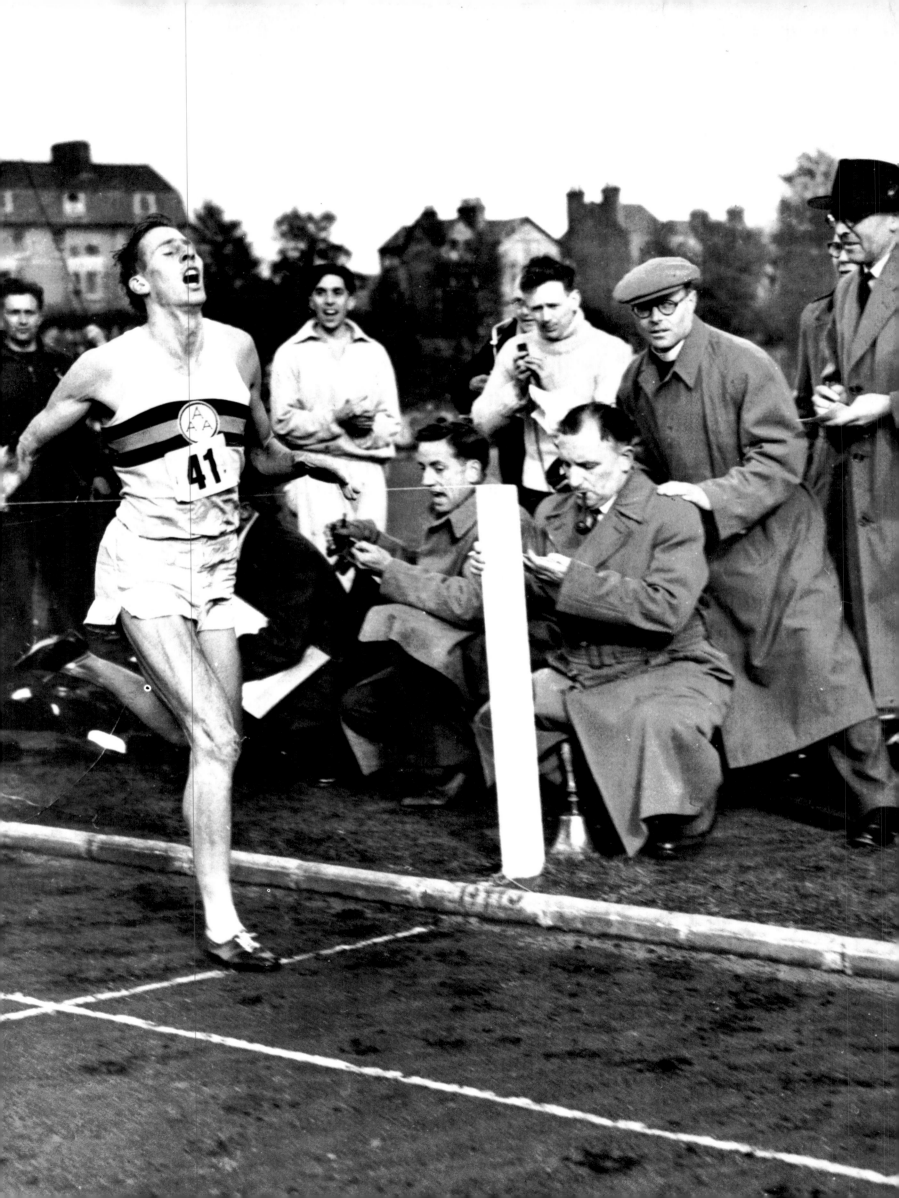

Oxford Mail 1954
Roger Bannister at the finish
of the first four-minute mile.
Timer gasps at Bannister's
3:59.4.
LIFE May 17, 1954

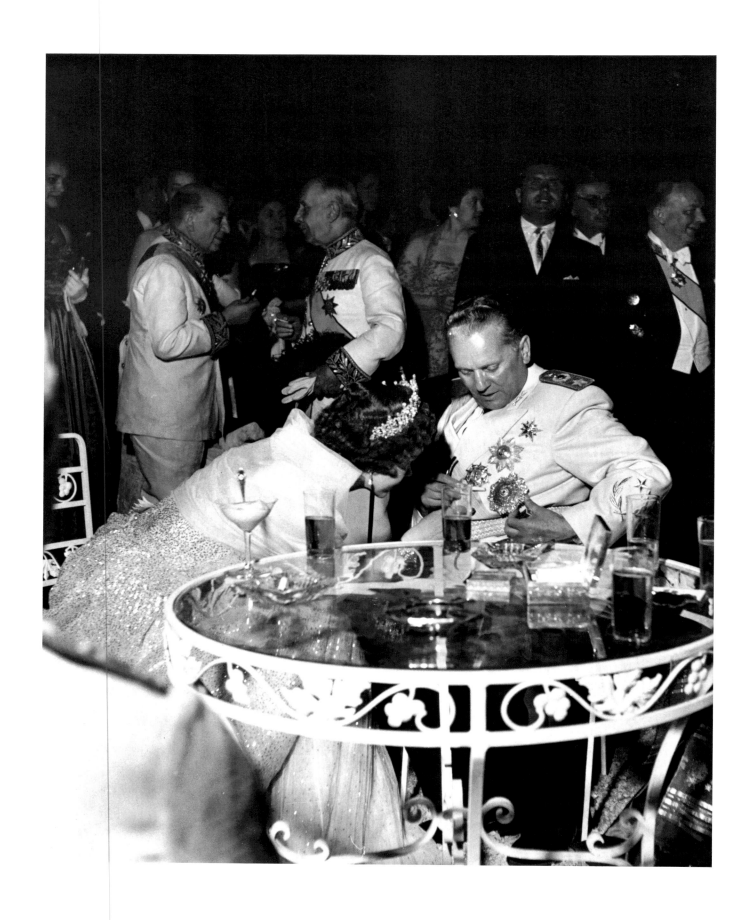

John Phillips 1954
During a reception at the Yugoslavian embassy
in Athens, Marshal Tito of Yugoslavia tells
Greece's Queen Frederika the story behind his
medal of merit, the Yugoslav Star.
LIFE June 21, 1954

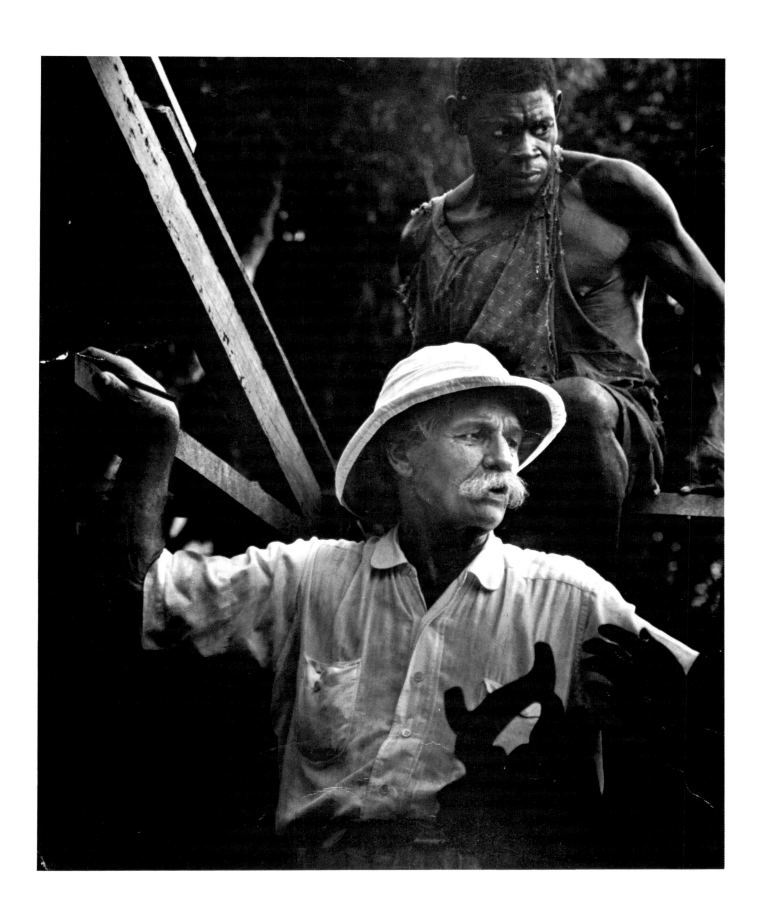

W. Eugene Smith 1954
Albert Schweitzer and a carpenter watch
construction of his general hospital in
Lambaréné, West Gabon, Africa.
LIFE November 15, 1954

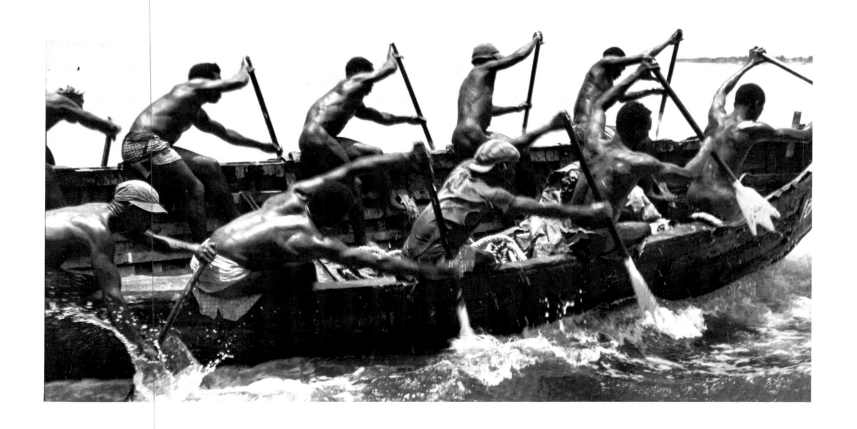

Alfred Eisenstaedt 1953
Gold Coast tribesmen drive cargo-carrying
canoe through surf between shore and ships,
Accra, British West Africa.
LIFE November 29, 1954

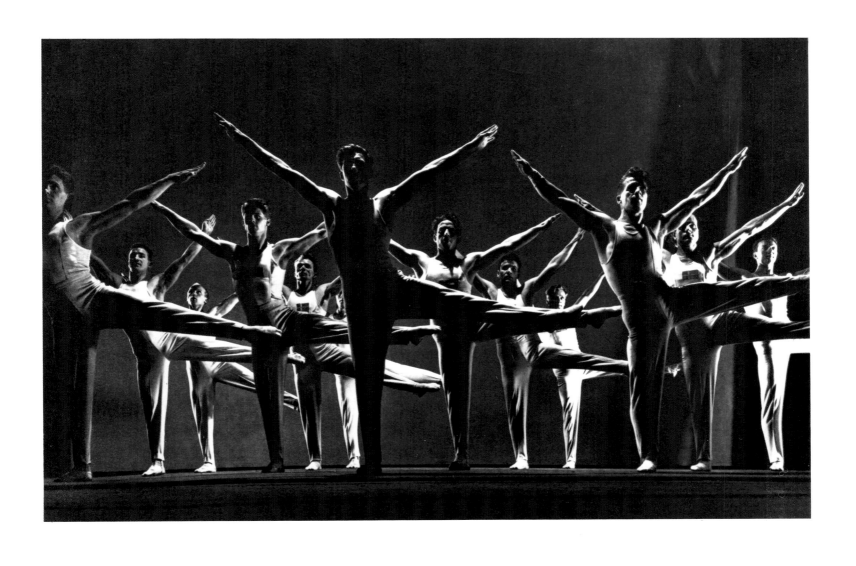

Gjon Mili 1954
Swedish gymnasts.

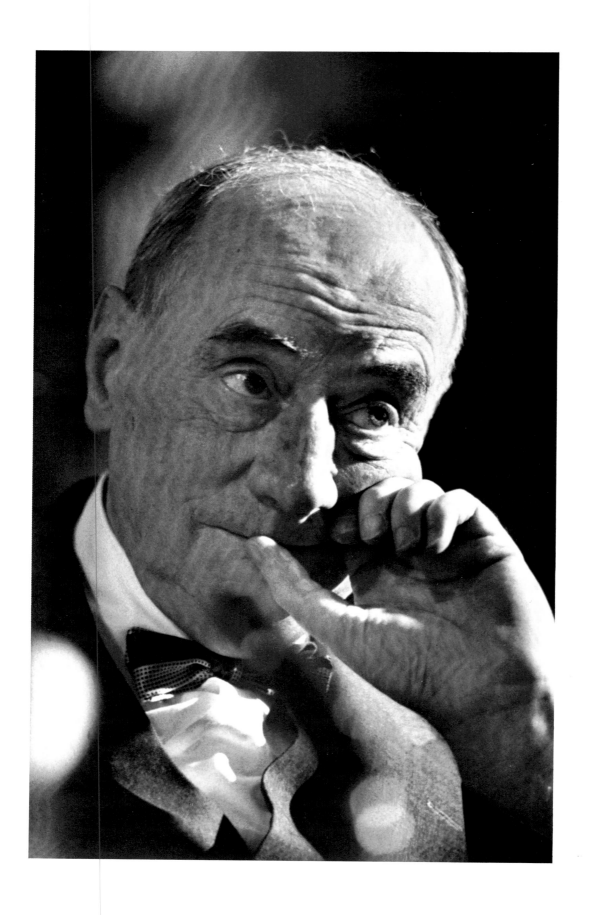

Yale Joel 1954
Army Counsel Joseph Welch wears a quizzical
expression as he listens to testimony at the
Army-McCarthy hearings.
LIFE October 17, 1960

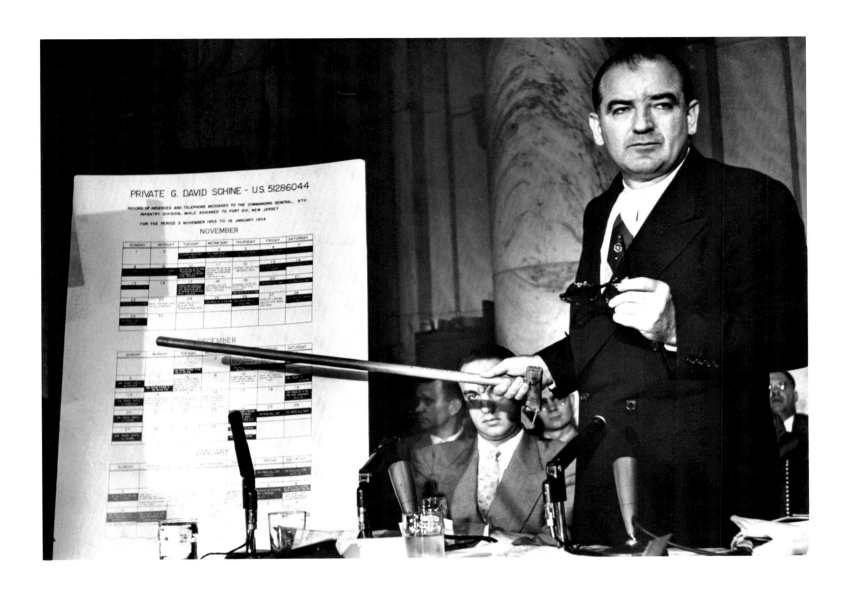

Hank Walker 1954
Senator Joseph McCarthy uses a chart to press a
point at Army-McCarthy hearings.

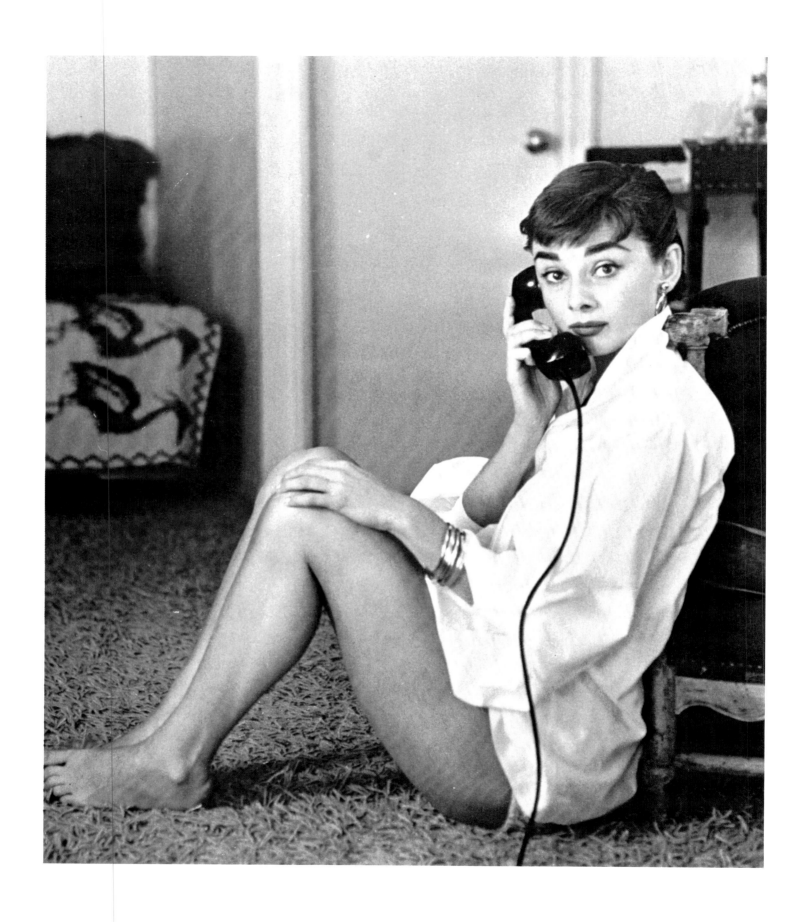

Mark Shaw 1953
Audrey Hepburn at home.
LIFE December 7, 1953 Cover

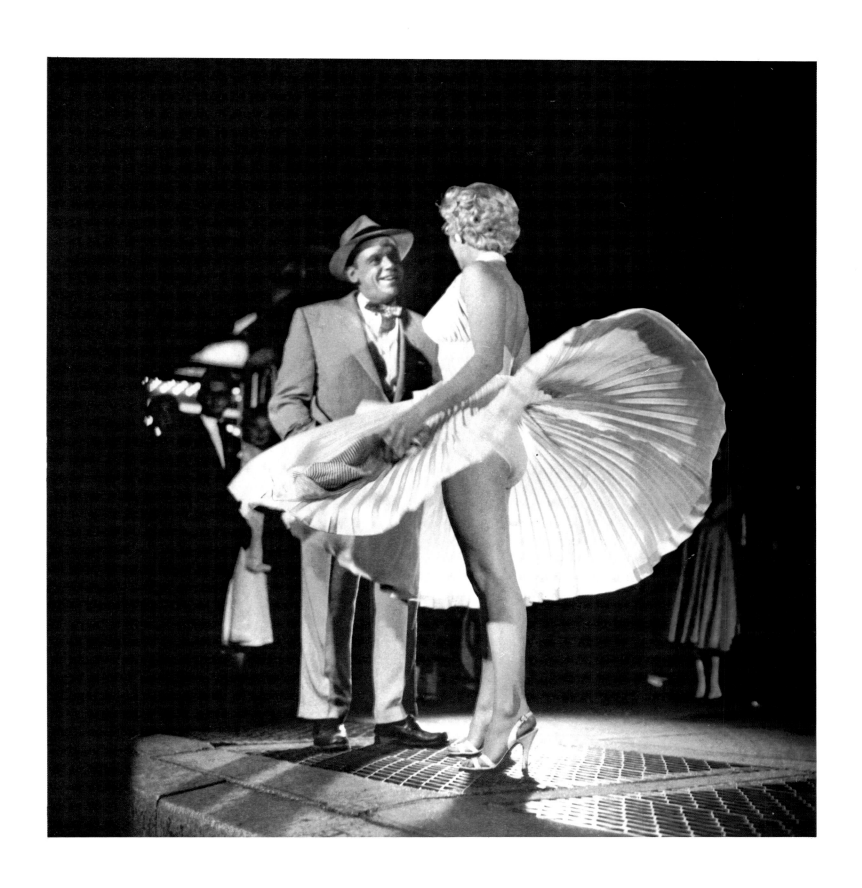

Sam Shaw 1954
Marilyn Monroe and Tom Ewell film a scene
from *The Seven Year Itch* on the corner of
Lexington Avenue and 51st Street, New York.
LIFE September 27, 1954

186

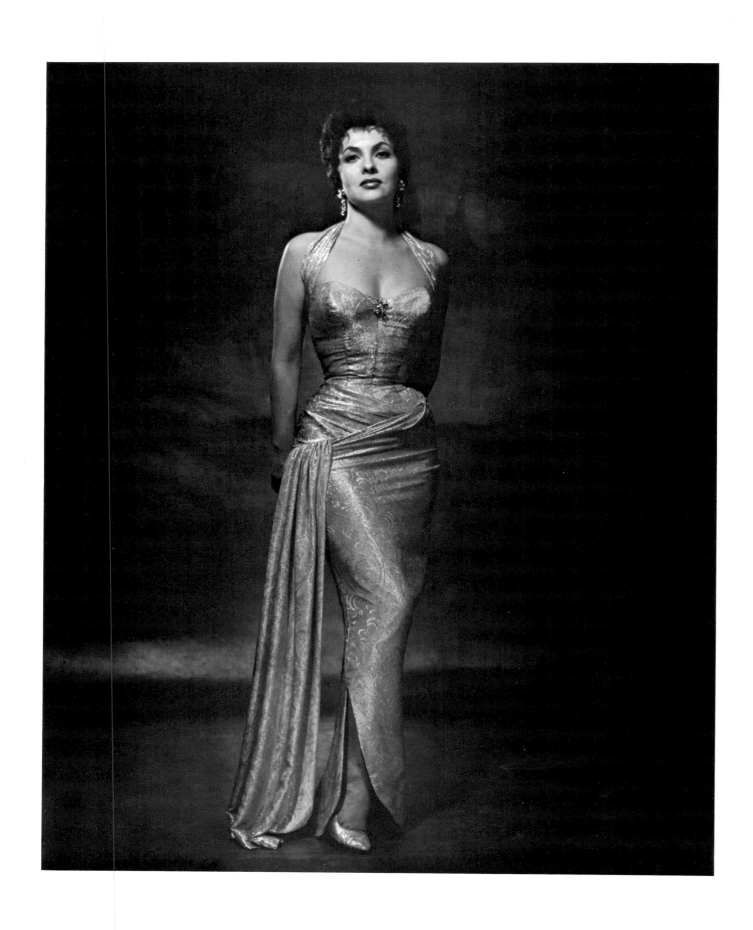

Philippe Halsman 1954
Gina Lollobrigida.
LIFE November 15, 1954

187

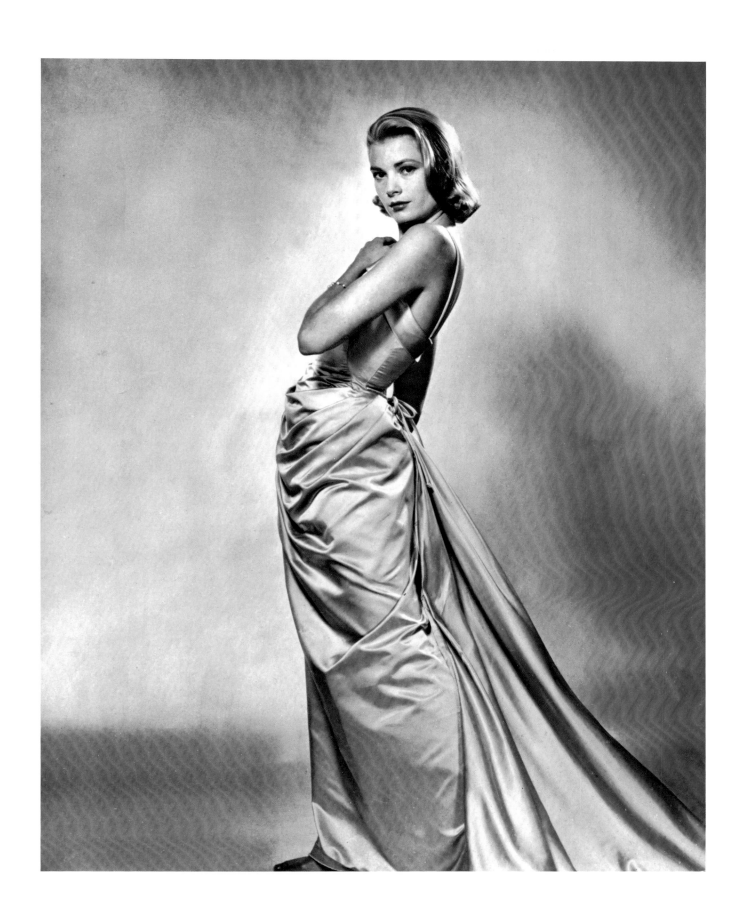

Philippe Halsman 1955
Grace Kelly, an Academy Award winner for her
role in *The Country Girl*.
LIFE January 16, 1956

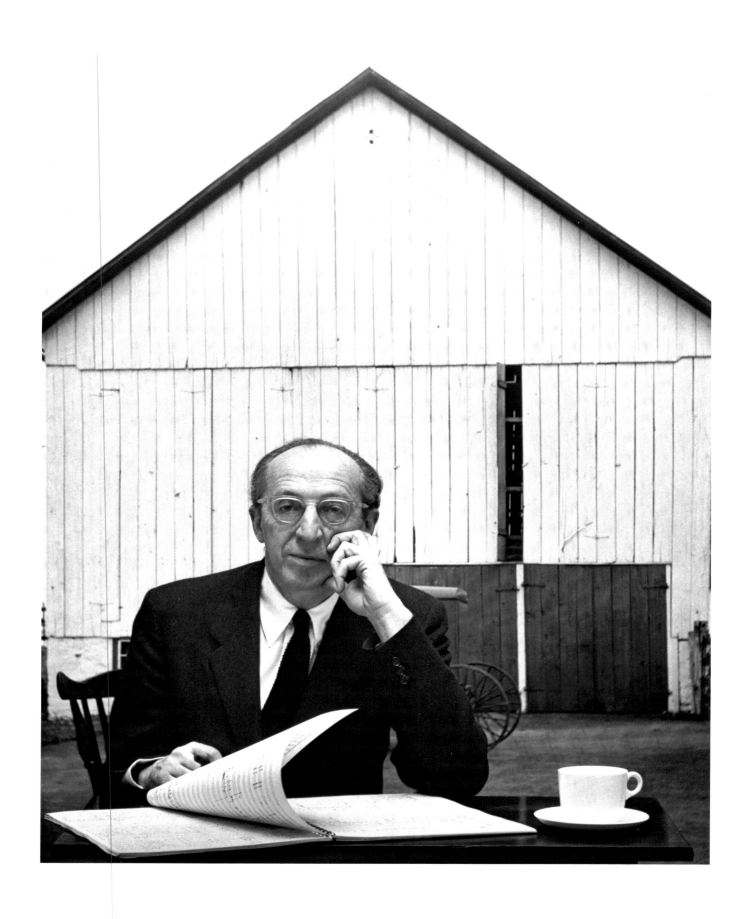

Gordon Parks 1955
American composer Aaron Copland.
LIFE May 21, 1956

189

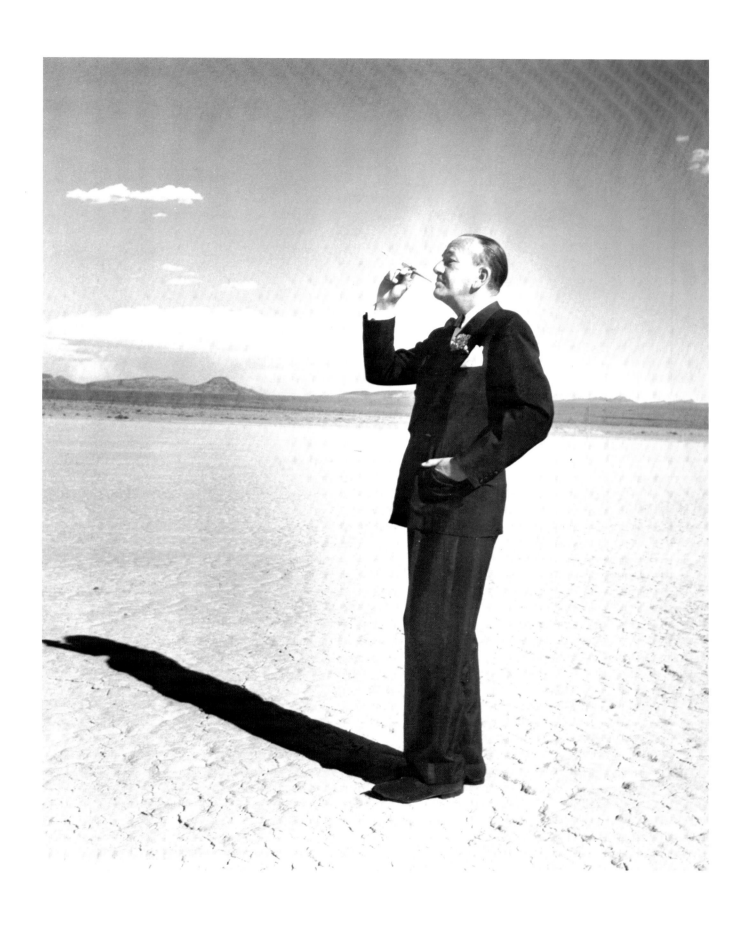

Loomis Dean 1955
Noel Coward in Las Vegas for a nightclub
engagement.

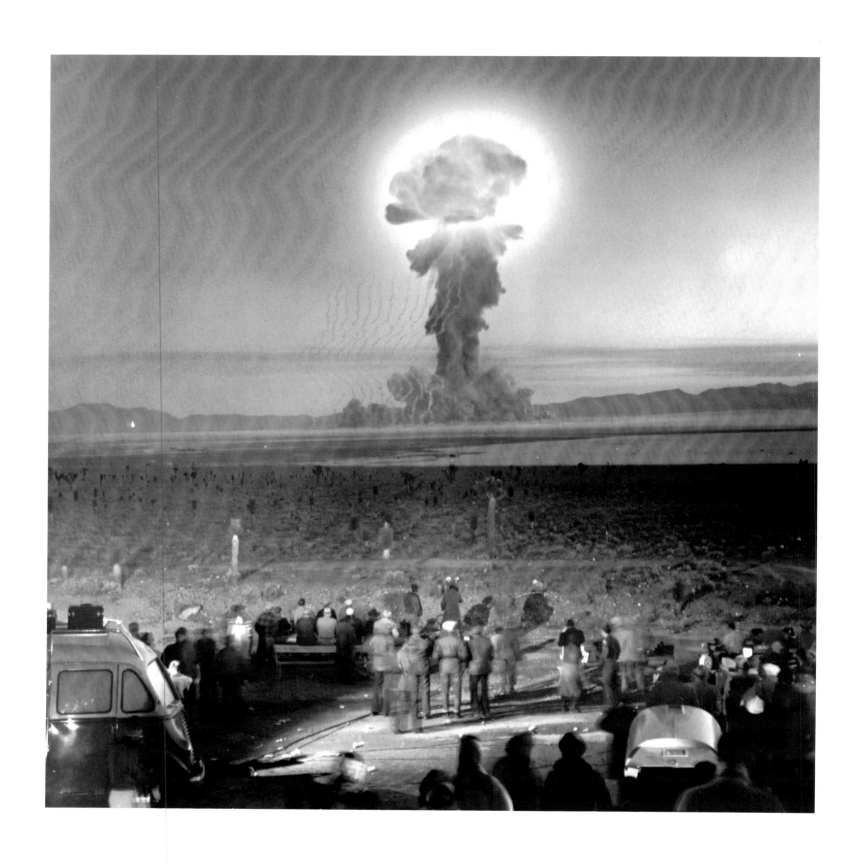

J.R. Eyerman 1953
During atomic bomb test, cloud rises from desert
floor, seven miles from observers in foreground
at Yucca Flat, Nevada.
LIFE March 30, 1953

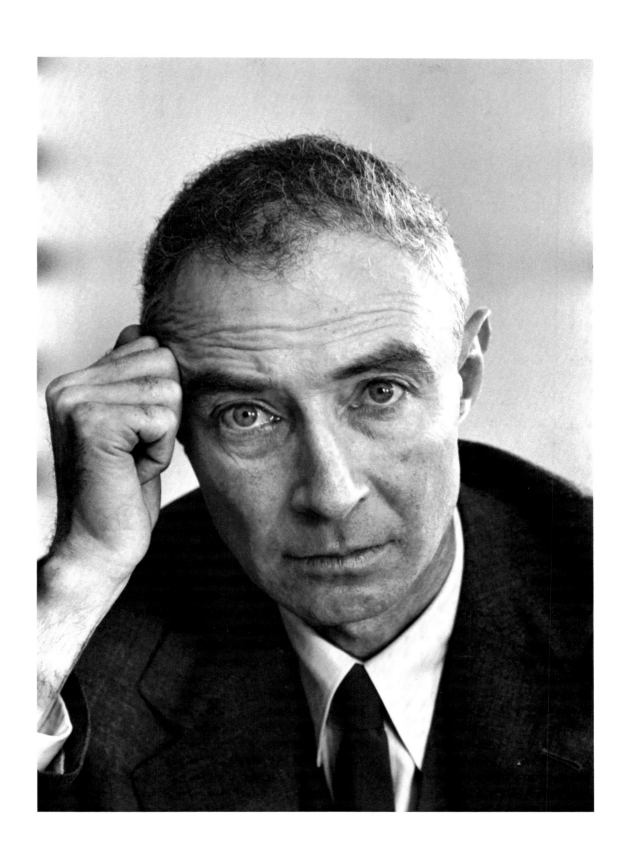

Alfred Eisenstaedt 1954
Consultant to the Atomic Energy
Commission, J. Robert Oppenheimer.

192

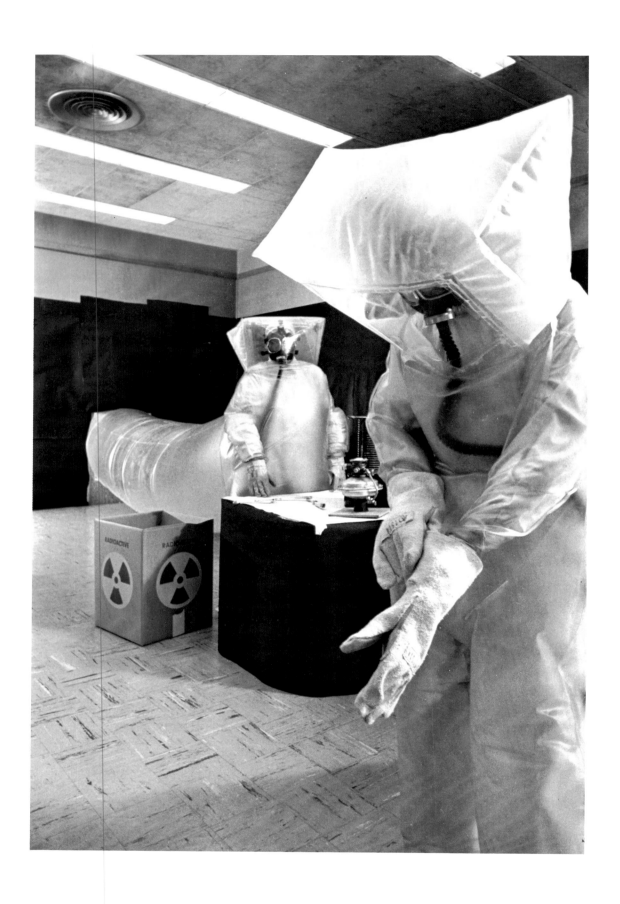

N.R. Farbman 1954
Suits worn by technicians at atomic energy
plant, Hanford, Washington.
LIFE April 5, 1954

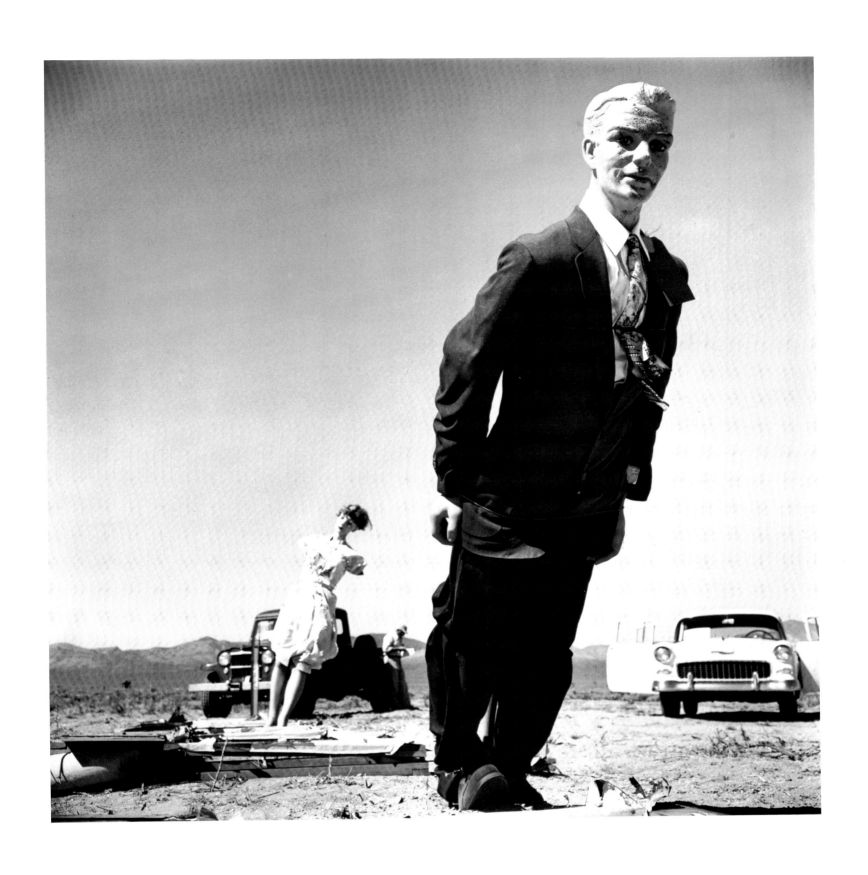

Loomis Dean 1955
Mannequins, used to gauge the effects of an
atomic bomb on the human body, at Yucca
Flat, Nevada.
LIFE May 16, 1955

194

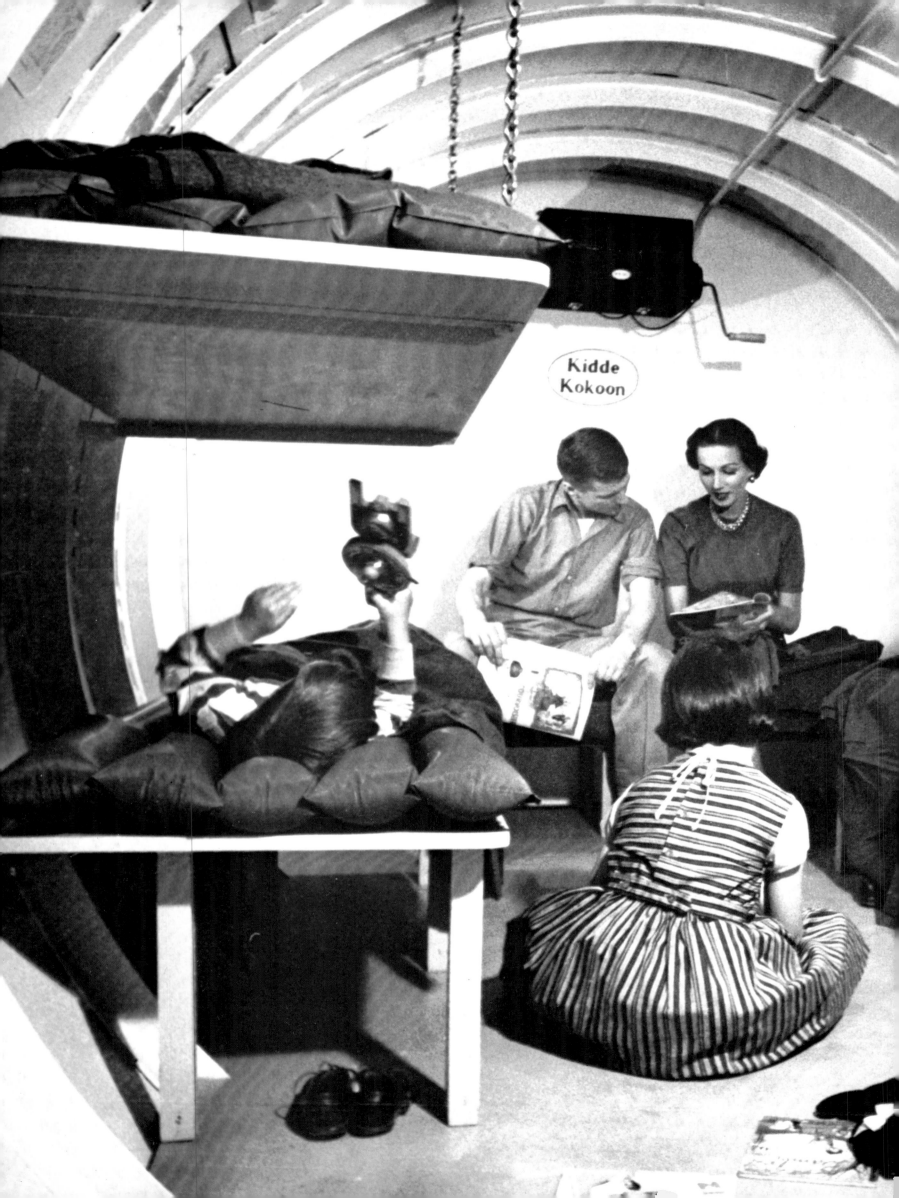

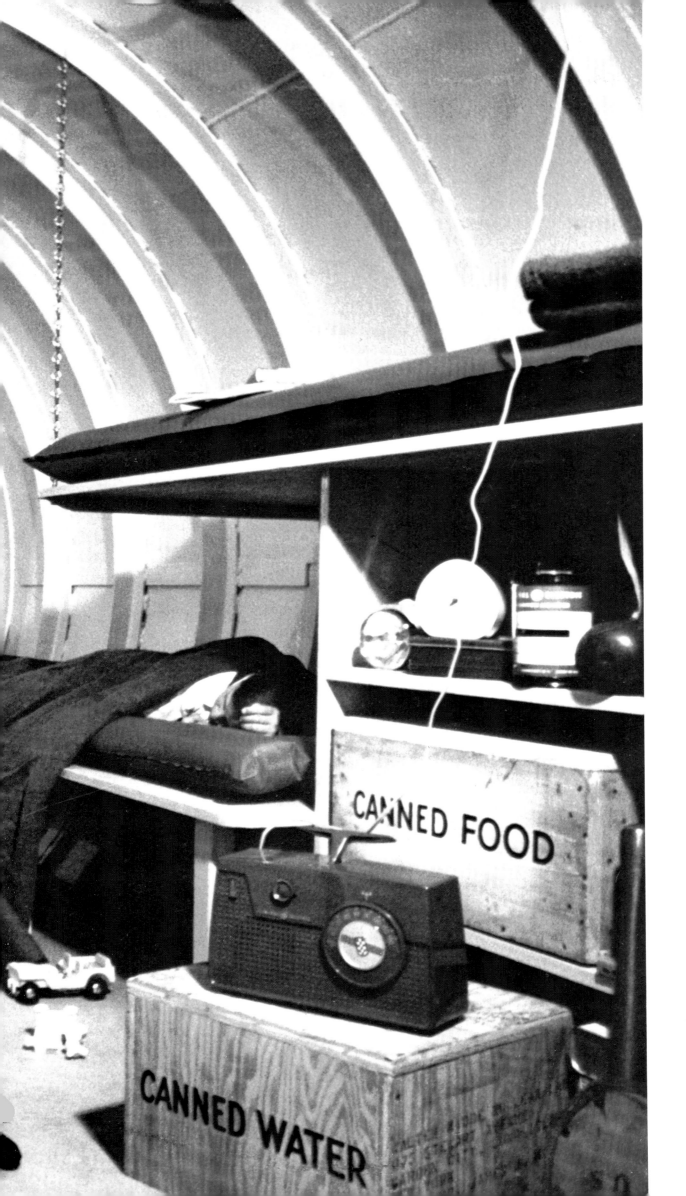

CANNED FOOD

CANNED WATER

Walter Sanders 1954
Radiation shelter,
Garden City,
Long Island,
New York.
LIFE May 23, 1955

195

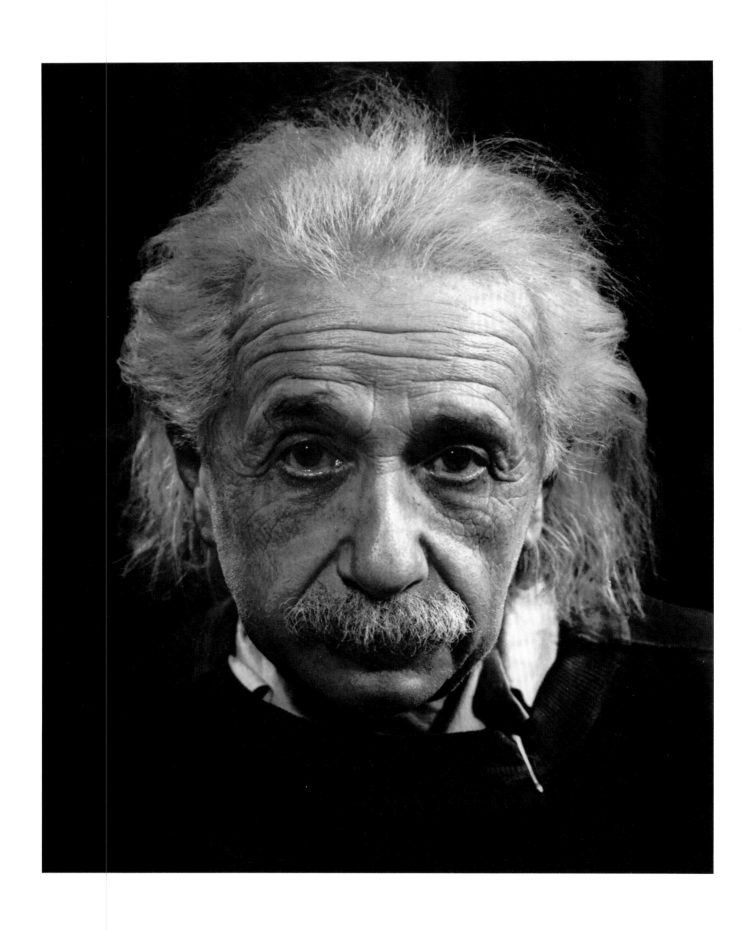

Philippe Halsman circa 1955
Albert Einstein.
LIFE May 2, 1955

196

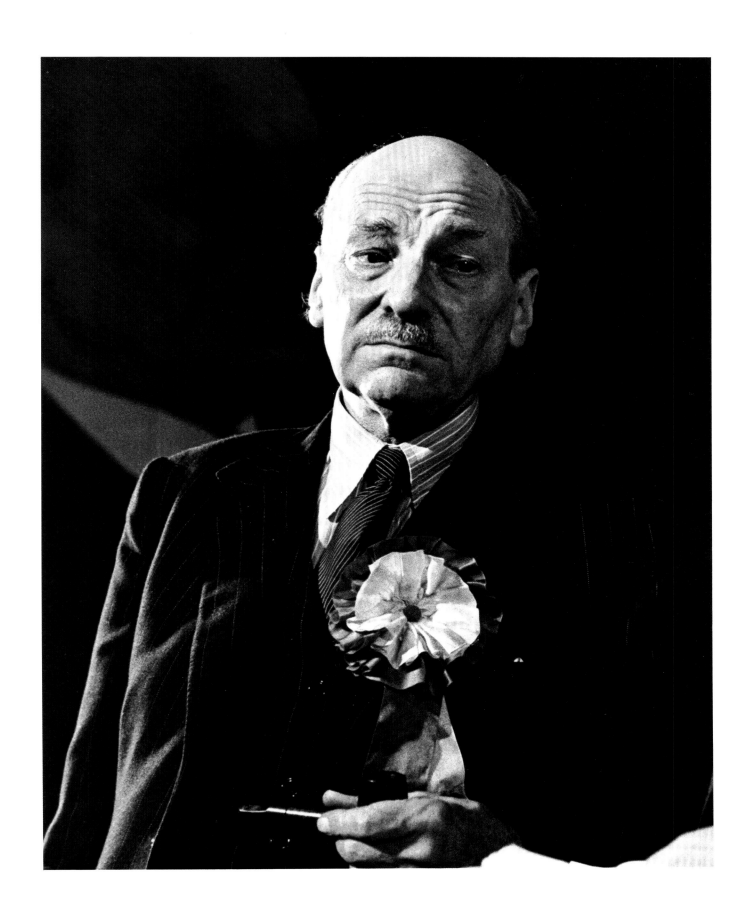

Larry Burrows 1955
Clement Attlee after his defeat by Anthony
Eden for the post of Prime Minister of Great
Britain.
LIFE June 6, 1955

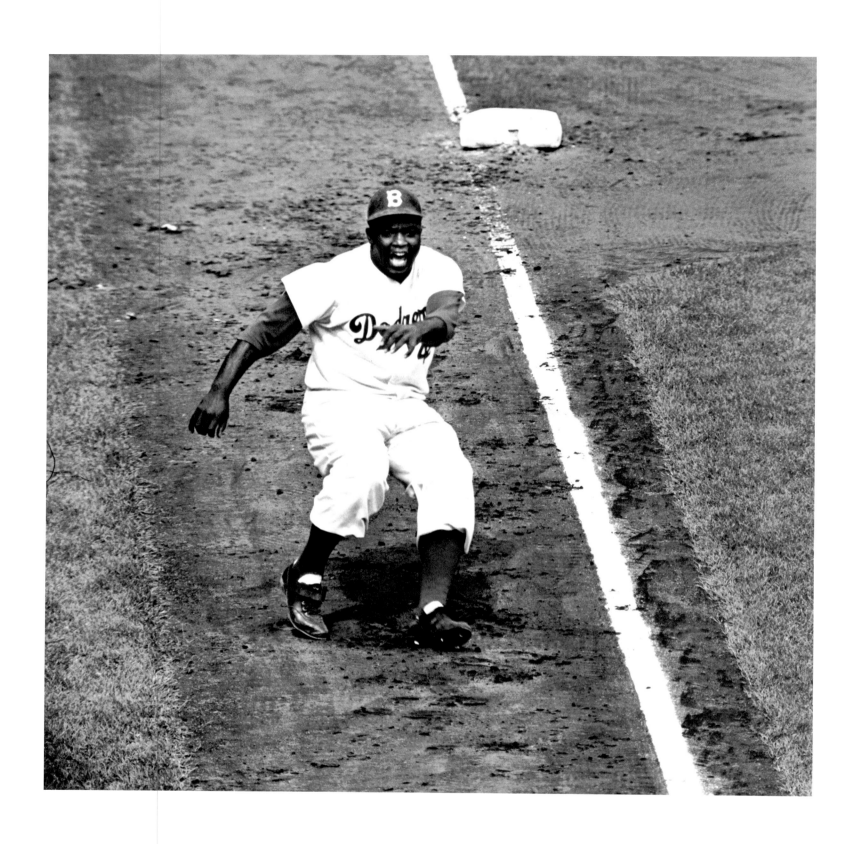

Ralph Morse 1955
Jackie Robinson spurring his Dodger teammates
on to victory over the Yankees in the 1955
World Series.
LIFE Bicentennial Issue, 1975

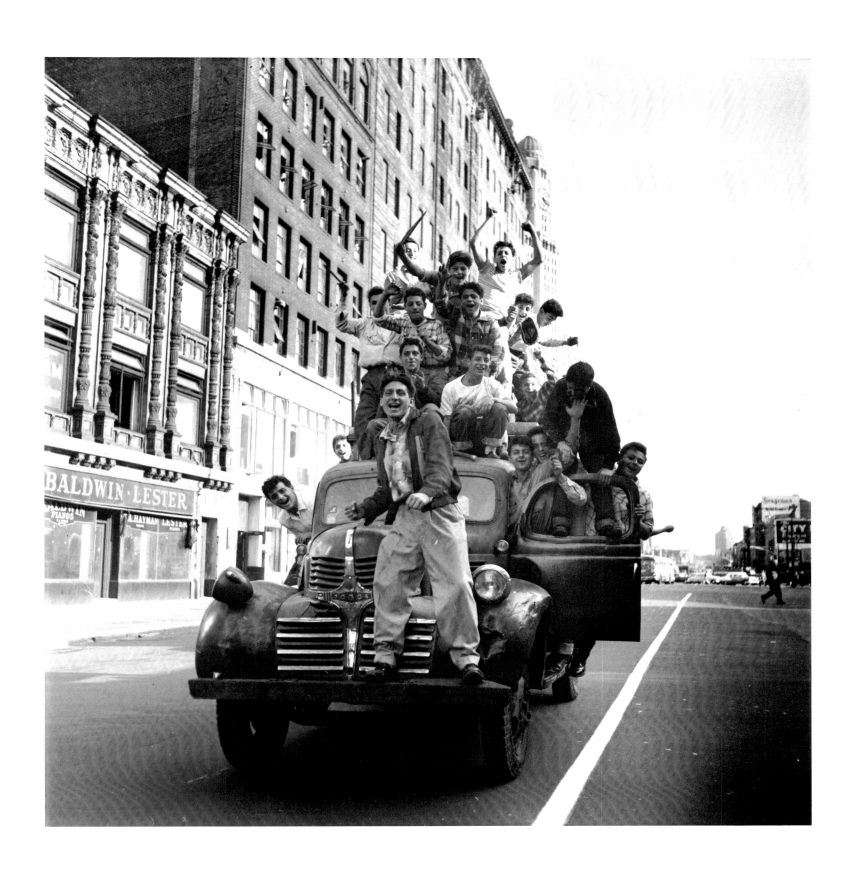

Martha Holmes, 1955
Dodger fans in impromptu celebration of their
1955 World Series victory.

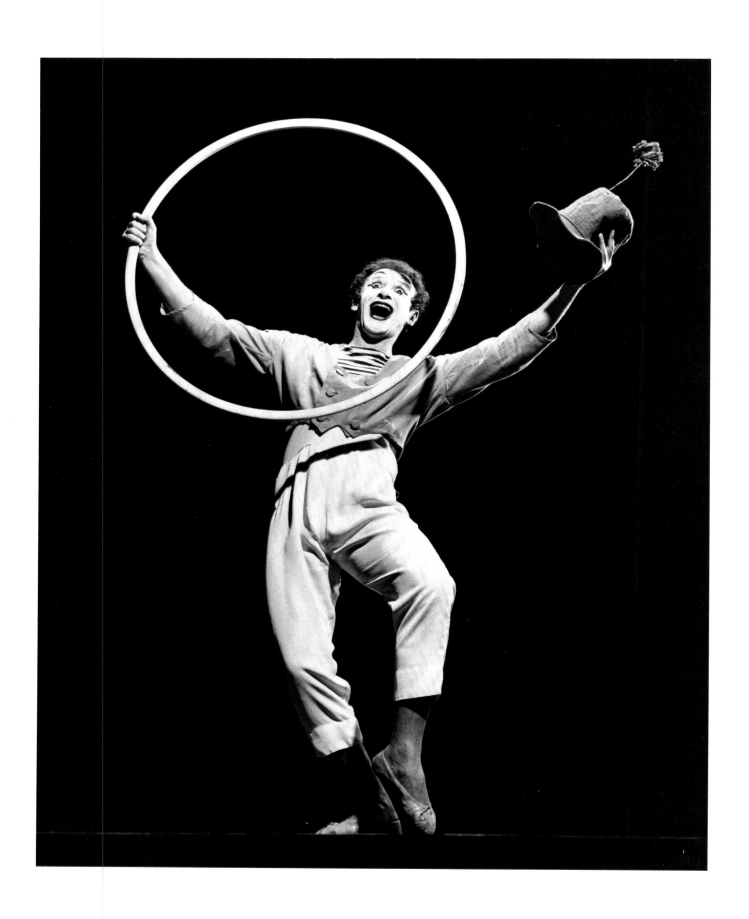

Gjon Mili 1955
French mime, Marcel Marceau, creates a
lion tamer for his audience.
LIFE October 10, 1955

INDEX TO PHOTOGRAPHERS

Original print of photograph on page 23 has been lost. This image was reproduced from a vintage print of an adjacent frame in the same picture essay.

Photographs on page 133 and page 188 were published in LIFE in black and white and were conversions from color.